The Via Latina Catacomb

WILLIAM TRONZO

The Via Latina Catacomb
Imitation and Discontinuity in Fourth-Century Roman Painting

Published for
THE COLLEGE ART ASSOCIATION OF AMERICA
by
THE PENNSYLVANIA STATE UNIVERSITY PRESS
UNIVERSITY PARK AND LONDON

1986

Monographs on the Fine Arts
sponsored by
THE COLLEGE ART ASSOCIATION OF AMERICA
XXXVIII

Editors, Shirley Blum and Carol F. Lewine

Library of Congress Cataloging in Publication Data
Tronzo, William.
The Via Latina catacomb.

(Monographs on the fine arts ; 38)
Includes bibliography and index.
1. Mural painting and decoration, Early Christian—
Italy—Rome—Themes, motives. 2. Mural painting and
decoration, Roman—Italy—Rome—Themes, motives.
3. Mural painting and decoration—Italy—Rome—Themes, motives.
4. Bible—Illustrations. 5. Mythology, Classical, in art.
6. Via Latina Catacomb (Rome, Italy)
I. College Art Association of America. II. Title. III. Series.
ND2757.R6T76 1985 751.7'3'09376 84-43089
ISBN 0-271-00389-8

Contents

List of Illustrations

Preface

PERHAPS no archaeological event of recent years has more altered our view of the development of Late Antique and Early Christian art in Rome than the discovery, slightly over a kilometer outside of the Porta Latina, of the underground tomb now commonly known as the Via Latina catacomb. The catacomb is, in the main, a fourth-century product and small by Roman standards, embracing only over a dozen cubicula or burial chambers. Yet these chambers are wonderfully varied in size and shape, with architectural motifs sculpted from the tufa (the porous, volcanic subsoil of Rome and its environs), or (less often) carved in marble and inserted into the tufa structure, and with wall paintings that show a most unusual mix of Christian and pagan elements and luxurious ornamental forms. Here, for example, we see for the first time in Christian art the tragic reluctance of Lot's wife, Jacob's visionary dream, and Elijah's triumph, not to mention the pagan subjects of Hercules and Minerva, Ceres and Persephone, and a remarkable convocation of learned gentlemen who appear to be discussing a corpse in their midst. Against the background of the other Roman catacombs whose architecture seems, by comparison, rather modest and awkward and whose decoration comprehends only a limited number of themes (overwhelmingly Christian at that), the Via Latina catacomb is not only smaller: it is a world apart.

It was only to be expected that such an uncommon find would stir up a certain amount of scholarly controversy. Yet in looking back over the discussion now we can see that it has been dominated by three major themes and preoccupations: the sources of the Christian imagery, especially the Old Testament subjects of the early cubicula (A–C); the meaning of the pagan imagery; and the chronology and significance of the styles of painting. These issues, of course, are important and must enter, in one way or another, into any serious discussion of the monument, as they will here. But given the extreme interest of the catacomb and the multiplic-

ity of its aspects, it would seem that the scholarly debate has been very selective indeed. Furthermore, these themes have often been treated in what would appear to be an arbitrary way or in reference to issues outside the immediate scope of the monument itself. Thus style and subject matter have always been treated separately, as have pagan and Christian topics, though these clearly have a bearing on one another. Similarly, the issue of the Christian imagery of the catacomb has been governed by the question of the existence and availability of illustrated manuscripts in Early Christian times; admittedly this is a question for which the catacomb provides essential evidence, though it is not the only problem, nor even the major problem connected with the imagery of the catacomb. It would seem, therefore, that the Via Latina catacomb has suffered a kind of scholarly dismemberment, and that it is revealed today only in curious and partial views.

The present work is an attempt to put some of the pieces back together again. Its central issue—the relationship between two cubicula, one of which was made as a copy of the other—is a problem relating to the structure and functioning of the monument itself. Thus it will not admit of an explanation in terms of a partial view, for instance, of style as opposed to iconography. Although probing this relationship will not lead us to every aspect of the catacomb—the question of pagan imagery will figure very little here—it will require us to treat architecture and plan, style and iconography, so that the catacomb will emerge as more of an ensemble. Moreover, it will be seen that this relationship is actually part of a much broader phenomenon in fourth-century Roman art, a phenomenon that would probably still be unknown were it not for the unique and eloquent witness of the Via Latina catacomb.

It remains to acknowledge my gratitude to the individuals and institutions that have given me help in the rather long course of preparing this short book.

I would like to thank first the one person who has been with this study as long as the author himself, Ernst Kitzinger. I can truly say that without his kind and sure guidance the present work would have been impossible: any value in it is due to the effort he has made to direct my thinking into a profitable area. This book has also benefited greatly from discussions I have had with Hugo Brandenburg, George M.A. Hanfmann, Herbert Kessler, Dale Kinney, Richard Krautheimer, Irving Lavin, William Loerke, and Florentine Mütherich.

My research was made possible by a grant from the American Academy in Rome supported by the American Academy, the Kress Foundation, and Harvard University. I am deeply grateful to the Academy, to its staff, and, in particular, to John D'Arms, director from 1977 to 1980, for making my stay in Rome so pleasant and profitable.

In Rome, Father Umberto M. Fasola, Rector of the Pontificio Istituto di Archeologia Cristiana, generously granted me free use of the superb facilities of the Institute and the services of a most knowledgeable guide to the Roman catacombs, Alberto Marcocci. In sharing with me his surpassing knowledge of Early Christian archaeology, Father Fasola allowed me to employ most efficiently the time I spent exploring *Roma sotterranea*.

The text was completed at Dumbarton Oaks Center for Byzantine Studies, whose incomparable research library made possible many late corrections and emendations; it has also been improved by my two editors at the College Art Association Monograph Series, Shirley Blum and Carol Lewine. Karin Einaudi was particularly helpful in obtaining photographs, and David Wright kindly stepped in at the last minute to fill a breach in illustrative material.

Last, but not least, I thank Gail Feigenbaum, whose good influence on the author has extended happily to the author's works.

This book is dedicated to my parents.

List of Abbreviations

AA	*Archäologischer Anzeiger*	*CSEL*	*Corpus Scriptorum Ecclesiasticorum Latinorum*
AArchSyr	*Annales Archéologiques de Syrie*	*DissPontAcc*	*Atti della Pontificia Accademia Romana di Archeologia, Dissertazioni*
AIPHOS	*Revue d'Archéologie et d'Histoire Annuaire de l'Institut de Philologie et d'Histoire Orientales et Slaves, Université Libre de Bruxelles*	*DOP*	*Dumbarton Oaks Papers*
		GBA	*Gazette des Beaux-Arts*
AJA	*American Journal of Archaeology*	*HJ*	*Historisches Jahrbuch*
ANSMN	*American Numismatic Society, Museum Notes*	*ICUR*	*Inscriptiones Christianae Urbis Romae*
ArtB	*Art Bulletin*	*IEJ*	*Israel Exploration Journal*
BA	*Bollettino d'Arte*	*IstMitt*	*Istanbuler Mitteilungen, Deutsches Archäologisches Institut, Abteilung Istanbul*
BACr	*Bullettino di Archeologia Cristiana*		
BMBeyr	*Bulletin du Musée de Beyrouth*	*JbAChr*	*Jahrbuch für Antike und Christentum*
BSR	*Papers of the British School at Rome*	*JbBerlMus*	*Jahrbuch der Berliner Museen*
BullComm	*Bulletino della Commissione Archeologica Communale, Roma*	*JdI*	*Jahrbuch des Deutschen Archäologischen Instituts*
BZ	*Byzantinische Zeitschrift*	*JHS*	*Journal of Hellenic Studies*
CahArch	*Cahiers Archéologiques*	*JÖB*	*Jahrbuch der Österreichischen Byzantinistik*
CRAI	*Comptes-rendus des séances de l'Académie des Inscriptions et Belles-Lettres*	*JRS*	*Journal of Roman Studies*
		JWarb	*Journal of the Warburg and Courtauld Institutes*

MAAR	Memoirs of the American Academy in Rome	PEFQ	Palestine Exploration Fund, Quarterly Statement
MdI	Mitteilungen des Deutschen Archäologischen Instituts	RAC	Reallexikon für Antike und Christentum
MDIK	Mitteilungen des Deutschen Archäologischen Instituts, Abteilung Kairo	RACr	Rivista di Archeologia Cristiana
MélRome	Mélanges d'archéologie et d'histoire, publiés par l'École Française de Rome	RendPontAcc	Atti della Pontificia Accademia Romana di Archeologia, Rendiconti
MemAccNapoli	Memorie dell'Accademia di Archeologia, Lettere e Belle Arti di Napoli	RIASA	Rivista dell'Istituto Nazionale di Archeologia e Storia dell'Arte
MemPontAcc	Atti della Pontificia Accademia Romana di Archeologia, Memorie	RM	Mitteilungen des Deutschen Archäologischen Instituts, Römische Abteilung
MM	Mitteilungen des Deutschen Archäologischen Instituts, Abteilung Madrid	RQ	Römische Quartalschrift für christliche Altertumskunde und Kirchengeschichte
MonAnt	Monumenti Antichi, Accademia Nazionale dei Lincei	SC	Sources Chrétiennes
MünchJb	Münchner Jahrbuch der bildenden Kunst	ST	Studi e Testi
		TAPA	Transactions and Proceedings of the American Philological Association
NBACr	Nuovo Bullettino di Archeologia Cristiana	VChr	Vigiliae Christianae
NS	Notizie degli Scavi di Antichità, Accademia Nazionale dei Lincei	ZNW	Zeitschrift für die neutestamentliche Wissenschaft und die Kunde der älteren Kirche

The Problem of the Replication of Cubiculum C in Cubiculum O

I T has often been observed that the last chamber in the Via Latina catacomb, cubiculum O, was made, to a large extent, as a copy of one of the early chambers of the catacomb, cubiculum C (see fig. 1).[1] The evidence for this is unmistakable. First, both rooms have the same architectural form, being roughly square in plan with a suppressed barrel vault, deep niches in the side walls, and a single arcosolium at the rear.[2] Then, the pictorial decoration of the side niches in the two rooms is virtually identical. In both rooms the Crossing of the Red Sea is painted on the right (figs. 2 and 3), and on the left there is a scene of a large crowd led by a figure who gestures with a staff towards a pedimented building on the right, while above may be seen the Column of Fire that accompanied the Israelites through the desert and Moses as he receives the Law on Mount Sinai (figs. 4 and 5).[3] The two versions of the Red Sea must

1. Michelangelo Cagiano de Azevedo, "Una singolare iconografia," 111ff.; Dina Dalla Barba Brusin, "Proposta per un'iconografia," 91ff. (with a most unlikely explanation for the left-hand scenes in C and O; on the scenes themselves, see below chapter 4, passim); Josef Fink, *Bildfrömmigkeit und Bekenntnis,* 35f. Other iconographic correlations can be made in the catacomb, though none so exact as to suggest unambiguously direct copying; see Cagiano de Azevedo, 118. The author, however, fails to mention one of the more interesting of these instances: on the facing walls of Ic the scenes of Moses at the Burning Bush and Job appear as they do on the walls of the framing arch in front of the arcosolium in cubiculum C.

2. But the builders of O also added certain em-

bellishments lacking in C, such as marble transennae to the entrance of the room and marble revetment to the low step in front of the arcosolium. The loculi cut into the niches of the two cubicula, in C on the right and in O on the right and left, represent a later usage. It may be noted that the architecture of cubiculum B, but not its decoration, was copied in cubiculum N, where the builders added marble capitals and column bases not found in their model.

3. The vignettes in the upper part of the painting in cubiculum C are misidentified by Kötzsche-Breitenbruch as a scene in which "Moses steigt zu einer Säule auf eine Anhöhe empor, von deren Kapitell eine dunkle Wolke ausgeht"; see *Die neue Katakombe,* 80.

be associated because their composition is closely similar, and yet quite unlike that of all other Early Christian examples of the scene.[4] The left-hand scenes are almost equally close, although, curiously enough, they may not represent the same event. In O the subject is clearly identifiable as the Raising of Lazarus on the basis of the beshrouded figure, who must be Lazarus, perched in the door of the building on the right. In C, on the other hand, this figure—the sole means of identifying that event—is lacking, giving rise to legitimate doubt that the same subject was intended.

The relationship between the two rooms is thus not uncomplicated, and for this reason it has engendered considerable scholarly debate. However, from the first notices of the catacomb in 1956, this debate, like the discussion of the monument as a whole, has been confined only to certain topics, such as the true subject of the left scene in the first room, the reasons for the addition of the figure of Lazarus to the left scene in the second room, and the relationship of both scenes to the Crossing of the Red Sea—in a word, to the meaning of the imagery shared by the two rooms.[5] The broader relationship—that is, the fact that the later room was made as a copy of the earlier one—has been ignored, or, perhaps more accurately, taken for granted. And it is not difficult to imagine why. Given the amount of exact repetition in Early Christian iconography, it is often assumed that copying, whether directly through the study of individual works or indirectly through the use of model books, was a common procedure in the early Middle Ages.[6] But instances where both a model and its copy have survived are quite rare, and, for the fourth century at least, no example other than the one in the Via Latina catacomb has yet come to light. The question then arises whether this connection in the catacomb might have been exceptional and the product of special circumstances.

Investigation reveals that this was indeed the case. More than anything else, it appears that the relationship between the two cubicula was determined by a decisive moment of discontinuity in the history of the catacomb. Discontinuity is revealed first in the physical situation of the two rooms: they belong to different phases of the construction, that is to say, to tracts built at different times and according to different plans; it is revealed in the painting styles of the two rooms, each with roots in a distinct and unrelated tradition; and it is revealed, finally, in imagery, which, though superficially similar, reflects widely different concepts and purposes. Furthermore, upon closer examination there emerges from these areas the picture of a single overriding development: the displacement of what was largely indigenous Roman Christian practice by a new tradition, essentially foreign in origin, imposed by a new class of Christian patron. I would like to suggest that this discontinuity was a necessary precondition for, and its underlying causes the essential explanation of, the act of imitation recorded in cubiculum O.

4. Ibid., 79ff., where the relevant comparative material is assembled.

5. These problems were first discussed by André Grabar in CRAI, 1956, 276f. See also chapter 4.

6. On the phenomenon of copying in Early Christian art, see Margarete Bieber, Ancient Copies, Contributions to the History of Greek and Roman Art, New York, 1977, 242ff., with a focus on sculpture. No general study of the problem is known to me. For the later Middle Ages, see, for example, Hanns Swarzenski, "The Role of Copies in the Formation of Styles of the Eleventh Century," Acts of the Twentieth International Congress of the History of Art, vol. 1, Romanesque and Gothic Art, Princeton, 1963, 7ff.; and Ernst Kitzinger, "A Virgin's Face: Antiquarianism in Twelfth-Century Art," ArtB, 62, 1980, 6ff. On model books, see the remarks of Kitzinger in The Mosaics of Monreale, Palermo, 1960, 43f., 84; R.W. Scheller, A Survey of Medieval Model Books, Haarlem, 1963; Hugo Buchthal, The "Musterbuch" of Wolfenbüttel and Its Position in the Art of the Thirteenth Century (=Byzantina Vindobonensia 12), Vienna, 1979; Catherine Balmelle and Jean-Pierre Darmon, "L'Artisan-mosaïste dans l'Antiquité tardive: réflexions à partir des signatures," Artistes, artisans et production artistique au moyen age, Rapports provisoires, Université de Haute Bretagne, Rennes, 1983, vol. I, 3ff.; and Alison Stones, "Written Guides and Pictorial Models in Secular Manuscript Illustration c. 1300," ibid., vol. II, 1571ff.

My purpose in the first instance is to explicate the relationship of the two cubicula. This relationship, however, is part of a larger picture in the catacomb, in Rome and in the empire, which must also be presented. My assumption is that these goals can only be accomplished by means of a comprehensive approach to the monument, that is, one that builds an interpretation on analysis of the archaeological condition, the architectural form, the style of painting, and the iconography of the catacomb. The plan, therefore, is as follows. Chapter II will set out the archaeological evidence through which the principal building phases of the catacomb can be recognized, and the evidence, chiefly stylistic, that yields fairly precise dates for each phase. This will supply what has been lacking in discussions of the catacomb heretofore, namely a firm chronological framework, and will establish a milieu for each cubiculum in terms of the builder's intentions as they may be inferred from the plan of the catacomb. Chapter III will consider the problem of pictorial style comprehensively. The essential point here will be to account for stylistic differences between the paintings in the two cubicula, which can only be accomplished by placing the styles in their proper context. Each style, therefore, will be traced to its source, a task that will entail a considerable exploration of the overall development of Roman painting in the fourth century. Chapter IV will concern the use of imagery. The aim will be to provide as comprehensive as possible an interpretation of the shared imagery of cubicula C and O with a view to determining its function in the two rooms. In the final chapter the results of these investigations will be assembled as the parts of a puzzle to elucidate not only the relationship of the two cubicula but also its larger context.

Since this book is a study of a single problem and not a general survey of the Via Latina catacomb, I have provided a description only insofar as it is necessary to my argument. A fuller description and a more general treatment of the ensemble are to be found in the basic publication of Antonio Ferrua, *Le pitture della nuova catacomba di via Latina* (Vatican City, 1960), which is also the source of the plan used here. To avoid confusion in references to other catacombs, I have employed wherever possible the system of Aldo Nestori, *Repertorio topografico delle pitture delle catacombe romane* (Vatican City, 1975). Room numbers that refer to Nestori are here preceded by "N."

This book was completed in 1982, and only rarely has it been possible to take into account the relevant literature that has appeared since then.

II

The Building of the Catacomb

IN order to grasp the significance of the location of the two cubicula, C and O, we must first understand how the Via Latina catacomb was built (fig. 1). Essentially two hypotheses have been put forward to explain the plan: first, that the catacomb was the unitary construction of a single moment built according to a master plan;[1] second, that it was constructed in increments of varying size (there is no general agreement on this point) as the need arose.[2]

Neither explanation, however, is entirely satisfactory. The first is untenable because it neglects the evidence of the various phases of building activity clearly and unambiguously recorded on the walls of the corridors and cubicula of the catacomb. This evidence is made use of by the proponents of the second view—principally Antonio Ferrua and Michelangelo Cagiano de Azevedo—but only up to a point. Ferrua recognized the first phase of the construction in the traces of plaster that cover portions of corridors 2 and 3.[3] But he failed to take note of the important renovation in cubiculum G and thus did not entirely understand or accurately present the subsequent building history of the catacomb.[4] It was Cagiano de Azevedo's singular contri-

1. Jocelyn Toynbee, *Death and Burial,* 242: "Both its small size and the overall regularity and symmetry of its plan suggest that we have an example [in the Via Latina catacomb] of a privately owned cemetery, planned as a whole before any excavation took place. . . ."

2. Cagiano de Azevedo, "Appunti e ipotesi," passim; Ferrua, *Le pitture,* 36ff.

3. Ibid., 16.

4. Ibid., 90–1. Ferrua judged from the plan that the catacomb was built as an ensemble of four clusters of cubicula—A and A′, B and C, D–F and I–O—and saw these clusters as evidence of four, possibly five, patron-age groups. These groups then shared the use of corridors 3, 4, and 6 for loculi tombs and the pool at the end of corridor 5. One assumes from Ferrua's analysis that cubicula A and A′ were built simultaneously, as were cubicula B and C, and then D–F. Presumably, however, the "famiglia grande ed opulenta" that created the largest area of the catacomb, cubicula I–O, did not build the rooms in a single operation but gradually over the course of time, since one family's need could not have been either so urgent or so predictable as to require this space.

bution to direct attention to these renovations; he erred only in drawing the wrong conclusion from them. He argued that cubicula D–G, in their original state, looked like cubicula B and C, which also resemble N and O, suggesting that the entire catacomb was constructed on the basis of a modular unit consisting of two linked cubicula.[5] Rooms that do not fit this pattern, such as cubicula L and M, would have been added later. But this development could not have been the case for several reasons. Cubicula D–G did not originally look like B and C because from the beginning D, unlike B, opened onto two other rooms beside G, namely E and F. Nor were cubicula L and M added later: the portions of corridor in front of and behind them do not align, so it is unlikely that they once formed a single continuous unit.[6] In any event, the premise upon which the second view is based, that of the need for additional space alone, is too narrow to explain how the catacomb came to look the way it does. Another factor was at work which is revealed in the plans employed in each phase of the construction. It will be useful, therefore, to define these phases closely.

THE FOUR PHASES OF CONSTRUCTION

We enter the catacomb today by means of a flight of steps that runs parallel to the Via Latina. The original entrance, walled up shortly after the catacomb was discovered, could not be rehabilitated because it lay directly underneath a modern apartment building.[7] Like its ancient counterpart, however, the modern entranceway opens onto a corridor, 2, that gives access, down four steps on the left, to another corridor, 3, that extends past two cubicula, A and A′, and shortly beyond that on the right, to a small, roughly hewn and undecorated square room, 2a, in dismal condition. A narrow passageway, now blocked by fallen earth, opens off the left wall of the room at the back.

 The small area I have just described encompasses the initial phase of the construction of the catacomb (fig. 6). The single most important proof of this is the evidence already cited by Ferrua: the simple coating of white plaster that covers portions of the walls of corridors 2 and 3. Several points about this plaster covering are important: that it wraps around the corners of 2 and 3;[8] that it extends up to but does not include the openings in corridor 3 of cubicula A and A′; and that it reaches down only to the level of the uppermost step at the beginning of 3. These facts suggest, as Ferrua originally speculated, that corridor 2 was excavated in the first phase of construction along with corridor 3, but only down to the level of the first step and back to the area just before A and A′. This is confirmed by another detail—a slight jag in the walls of 3 precisely where the plaster ends at the openings to cubicula A and A′. It is unlikely that the jag would have occurred if the builders had excavated the corridor in one operation. On the other hand, the jag could easily have been the result of work interrupted and taken up at a later point, which was undoubtedly the case with the excavation of 3. In addition, there is no reason to doubt that cubiculum 2a was also a part of this phase, even though it does not contain a plaster covering, because corridor 2 shows no trace of a remodeling around the entrance

5. Cagiano de Azevedo, "Appunti e ipotesi," 32ff.

6. These areas, however, have been made regular on the plan published by Ferrua.

7. Ferrua, *Le pitture,* 13. When the Pontificia Commissione di Archeologia Sacra undertook the excava-

tion, restoration, and preservation of the catacomb in 1955, it kept no record other than that found in Ferrua's book of the original condition of the catacomb.

8. Ibid., 16.

opening to the cubiculum. Phase I, therefore, consisted of the entrance of the catacomb, corridor 2, cubiculum 2a, and corridor 3, though only down to the first step and back to, but not including, cubicula A and A'.

From evidence in the catacomb we may also infer that the builders of Phase I planned to continue their construction but did not do so for some time, if indeed the original team was responsible for any later developments at all. A light in the ceiling of corridor 3 occurs well before the openings to A and A'. If this light had been put in at the time the rooms were excavated, or afterward, it would most likely have been situated in such a way as best to illuminate the entrances to the two rooms.[9] The fact that it does not do so indicates that it was installed before the rooms were built, or, perhaps, even envisioned. Since the rooms belong to the next phase of construction, the light must be associated with Phase I. But a light at this point would have been necessary only if the excavators had intended to continue the corridor, and so they must have planned. In this connection it should also be noted that the walls of 2 and 3 are covered with loculi that show, here and there, vestiges of the coating of white plaster noted earlier. All of the loculi could hardly have been cut and used immediately upon the construction of Phase I. On the other hand, the plaster could only have been applied after the loculi were filled, and before any further excavation in the catacomb occurred. Thus some time must have elapsed between the excavation of Phase I and subsequent activity on the site, long enough, in fact, for most, if not all of the tombs in the area belonging to Phase I to be used. And indeed, it is difficult to believe that the involvement of the builders responsible for that phase continued thereafter. To judge from the arrangement, these builders preferred a more or less untidy configuration of cubicula and corridors: witness the corridor opening off the wall of cubiculum 2a. What took place in the next stage of construction, however, was decidedly different in plan.

When the work of excavation began again, corridor 3 was deepened first with a flight of four steps and then with a flight of 15 steps broken by a landing, and extended its full length up to and including cubicula B and C. At the same time cubicula A and A' were opened at the point where the excavators began the extension of corridor 3 (fig. 7). The evidence for these activities is straightforward: there is no trace of an interruption of work along the walls of 3; the ceiling height remains roughly constant throughout the entire length of the corridor; and the walls of the corridor are densely packed with loculi, distributed all over in the same way without any discernible pattern. At this juncture, however, two points should be clarified.

It is apparent that the excavators created the landing in the corridor in the second flight of steps in order to accommodate the future expansion of the catacomb along an axis approximately parallel to the Via Latina. When they reached the landing they could then have turned and excavated corridor 4 before the portion of corridor 3 that leads to B and C or in the two directions simultaneously. Both possibilities seem unlikely. Corridor 4 is distinguished from corridor 3 by two features: the ceiling of corridor 4 is considerably lower than that of corridor 3, and the loculi placed along the walls of corridor 4 are arranged in four evenly spaced rows. Admittedly the difference in ceiling height is not decisive. But it stands to reason that if 4 was opened before or at the same time as the portion of corridor 3 that leads to B and C, the arrangement of loculi in corridors 3 and 4 would be basically the same.

Another point concerns the place of A and A' in the overall sequence of excavation. Cagiano de Azevedo has suggested that both cubicula were formed much later than the extension of

9. Ibid., 24.

corridor 3 in an effort to gain space within the catacomb.[10] This hypothesis may be discarded simply on the grounds that the arrangement of loculi in corridor 3 presupposes the existence of A and A′. The loculi placed in the area immediately surrounding the openings to the two rooms, an area roughly equal in size to the width of the rooms projected onto the walls of the corridor, are significantly smaller and shallower than any of the other loculi in corridor 3. This arrangement could only have been the result of an effort by the excavators to avoid breaking into the rooms. There is no reason to doubt and every reason to believe that the loculi in this area were among the first cut when the corridor was extended. Since cubicula A and A′ must antedate the loculi, it seems plausible to connect the excavation of the rooms with the extension of the corridor. Corridor 3 and cubicula A, A′, B, and C therefore must make up a second phase of the Via Latina catacomb.

The excavators of Phase II made provision for the extension of the catacomb by placing a landing in the middle of the flight of steps in corridor 3 and by making shallow indentations in the walls of the corridor at the point of the landing.[11] These indentations served to reserve for future openings space that otherwise would have been taken up by loculi. For reasons now obscure, only one of the two possibilities was pursued.[12] From the opening on the right in the landing of corridor 3 excavation continued uninterrupted through corridor 4 to include cubicula D–F and the area beyond (fig. 8). This region was excavated in Phase III; it remains to define its precise extent.

The pivotal room in Phase III, cubiculum D, has suffered considerable damage and undergone extensive restoration since 1955. Nonetheless, we can be sure of much of the original form of the room. Enough of the ceiling has survived to show that the room was once groin vaulted. The lower edge of the vault rests on an arch on each wall. The arches meet at the corners of the room. In each front corner of the room a column supports the conjoined arches. At the rear of the room the columns are missing, but they must have been a feature of the original plan. While the right rear corner is completely covered by the restorer's wall, the left corner, though also extensively restored, still retains a rectangular block of tufa that protrudes from the base of the wall.[13] The block is of a piece with the wall and, because of its size, can only be construed as the base of a column. If a column was placed in this corner, then, logically speaking, another column must also have been put in the right rear corner of the room, thus making four the number of columns originally supporting the groin vault of D.

The openings in D that lead to cubicula E and F show no trace of alteration. These rooms, then, can be associated with the excavation of D. The opening in the rear wall of D is covered by the aforementioned restoration on the right; on the left, portions of the original wall surface

10. Cagiano de Azevedo, "Appunti e ipotesi," 32.

11. The indentation to the left—the one that still survives—is now concealed by a modern wall.

12. One explanation for this is suggested by the position of the catacomb vis-à-vis the Via Latina: while corridor 3 runs perpendicular to the Via Latina, corridor 4 runs parallel to it. The major clusters of cubicula in the catacomb can thus be inscribed in three rectangular strips running back longitudinally from the edge of the street. Relatively little is known about the acquisition of property for tombs along the thoroughfares outside the walls of Rome. But to judge from the configuration of extant tombs above ground in Rome and Ostia it may be inferred that property was acquired in parcels that

began at the edge of the road and extended backward; see Guido Calza, La necropoli, 15ff.; Jocelyn Toynbee and John Ward Perkins, The Shrine of St. Peter, 28; Russell Meiggs, Roman Ostia, 455ff. Such a procedure may have pertained to tombs that were built below ground as well. Thus the direction the catacomb took at this point may have been due to the availability of property to the right or left of the strip that contained Phases I and II.

13. Neither Ferrua (Le pitture, 25) nor Cagiano de Azevedo ("Appunti e ipotesi," 33) noted this block of tufa; both assumed that the cubiculum had only two columns.

are still visible. This surface can be traced from D into the area that contains the flight of three steps behind the room. The area of the wall near the floor, however, bears evidence of another renovation, this one clearly ancient in origin, which consists of two parts: a low wall that projects approximately half a meter across the opening to the steps and a small tract of brick masonry that has been inserted into the tufa flush with the wall surface (figs. 9 and 10).[14] I shall discuss the significance of this repair presently.

In order to complete our picture of this phase of construction it remains to determine to what the rear opening in D originally gave access. As Cagiano de Azevedo noted, the area behind D, cubiculum G, shows traces of an extensive reworking.[15] Like D, G is nearly square in shape. All four walls of G contain an opening: in the front, to D; in the rear, to H; on the left, to a corridor, 6, that contains loculi; and on the right, to a corridor, 5, that leads to a rectangular pool. A column on a high base is positioned in each of the rear corners of the room, but no trace of a column has survived in either of the front corners. The two rear columns support arches that rise to meet the ceiling. Three of the arches, on the rear and side walls, have survived intact. For reasons of architectural logic, an arch at the top of the front wall may be assumed even though the area is now wholly masked by a modern restoration. G contains a large square light that occupies the entire area of the ceiling (fig. 11). The edge of the ceiling around the light, however, shows that the room was once groin vaulted.

The fact that the room was renovated in antiquity is revealed most clearly in the ceiling. It would have made no sense for the builders to take the trouble to form a groin vault and then destroy almost every trace of it with a light; so it must be assumed that these two features were not planned simultaneously. And since the light could not have preceded the groin vault it must represent a change in plan that followed the construction of the vault. Each of these elements, moreover, is appropriate to one and only one location in a catacomb: the vault could only have been made for a cubiculum, and the light, for a corridor or passage. G, therefore, was first designed as a cubiculum and then at a later point turned into a passage, as the room stands today.

The original form of G may be reconstructed as follows. As a cubiculum, G would not have had openings in its side walls to the corridor of loculi (6) or the pool (5). These therefore must be later additions. Likewise, the opening in the rear could not have given access to H. In all likelihood the rear wall of G originally contained an arcosolium, as Cagiano de Azevedo has already suggested.[16] The four arches below the groin vault rested on columns set against the rear wall and remained unsupported on the front wall of the room. The present floor must represent the original ground level of the room, for if it had been altered at a later point, the columns or their bases would have reflected the change. Cubiculum G, or G[1] to be more precise, thus combined elements of D, the groin vault and the four supporting arches, with elements of E, the rear arcosolium framed by two columns.

Since G was first conceived not as a passageway but as the terminal chamber in a group of cubicula, the third phase of the construction of the catacomb, which includes corridor 4 and cubicula D–G[1], must have ended at this point. But the pause in the building was only slight, for if our reconstruction of G is correct we can deduce, in addition, the moment at which the room was transformed. The plaster in G continues without interruption into corridors 6 and H.

14. The low wall is formed of an aggregate of tufa and cement. The tract of masonry is made of bricks, yellowish brown in color, which vary in width from approximately 3 to 4.5 cm. The mortar beds also vary in width from 2 to 3 cm.

15. Cagiano de Azevedo, "Appunti e ipotesi," 33f.
16. Ibid., 34; Cagiano de Azevedo also suggests the likely possibility that the right side wall of G contained an arcosolium.

Cubiculum G, therefore, must have been altered between the time when it was first excavated and the time when it was covered with plaster. It stands to reason that D–F did not remain without a plaster coating for very long. Nor is it likely that the excavators would have covered the cubicula with plaster and left G empty. The alteration of G then took place very soon after D–G^1 was created—and what it entailed was the building of the rest of the catacomb.

From G^2 on there is no trace of discontinuity at any point in the excavation nor any break in the plaster coating covering the walls of the rooms (fig. 12). Given the poor condition of many areas in this part of the catacomb, it is impossible to trace the plaster in a single continuous line. Nonetheless, it can be followed around every corner from cubiculum to cubiculum, linking one room to the next from G^2 to O. The renovation of G^1, that is, G^2, three corridors (H, 5, and 6), and seven cubicula (I–O) therefore compose Phase IV. With this development our investigation into the construction of the catacomb is concluded; but before we turn to the problem of chronology and an analysis of the plans as embodied in the different phases, it will be useful to summarize our results.

The Via Latina catacomb was developed in four stages. It was begun with the excavation of a flight of steps that gave access to two short corridors and a small cubiculum (fig. 6). The walls of the corridors were filled with loculi and then covered with a single coat of plaster. The cubiculum was never used. To all appearances, after these developments had taken place the excavators abandoned their project or, at least, their original plan. Some time afterward the excavation was begun again with the extension of corridor 3 and the addition of four cubicula: A, A′, B, and C (fig. 7). The excavators of this second phase also made provision for the expansion of the catacomb along an axis parallel to the Via Latina. The arrangement of loculi in corridor 3 suggests that some time must have elapsed between the completion of 3 and the excavation of the next corridor. Of the two possibilities for expansion provided by the excavators of 3, only one was taken up in the third phase: a corridor, 4, was opened in the right wall of corridor 3 at the point of the landing in the flight of steps. The corridor terminated in a group of four rooms, D–G^1 (fig. 8). But before the rooms had been plastered a radical revision in plan took place inaugurating the fourth and last phase. The terminus of the complex, G^1, was converted into a passageway, G^2, behind which a broad hall, H, was thrown open. The hall formed a monumental entrance to another group of cubicula, I–O, lined up along an axis established by corridor 4 (fig. 12). Finally, a corridor leading to a pool (5) and a corridor to house loculi (6) were created to accompany this, the last group of rooms.

CHRONOLOGY

Our next task, to define a chronological framework for these developments, is one that has divided scholars into two principal camps. One group has supported the early dating proposed by Ferrua, who cites evidence of architectural form, epigraphy, painting style, and iconography to attribute the entire complex to the period ca. 315/20–350.[17] Others, however, have concurred with scholars such as Dorigo and Deichmann who advocate, largely on the basis of painting style, a dating in the later fourth or even fifth century for the later rooms in the

17. Ferrua, *Le pitture,* 86ff.; and following Ferrua's chronology, Kollwitz, "Die Malerei," 89ff., 147ff., and

Josef Fink, in a review of Kötzsche-Breitenbruch, *Die neue Katakombe, RQ,* 79, 1977, 248ff.

catacomb.[18] The truth of the matter is that both views are partly correct. Close inspection of the evidence bears out Ferrua's early dating for the beginning of the catacomb and a later dating, though not quite as late as that proposed by Dorigo and Deichmann, for the end of the work. But—and this is the most important point—when this inspection is undertaken with our present understanding of the phases of construction, it yields a chronology for the catacomb much more precise than any hitherto obtained.

As Ferrua has observed, the architectural form of the catacomb at once provides a broad indication of chronology.[19] Early rooms, such as cubicula A, A', and B, fit easily into an early-fourth-century context, while later rooms, such as cubiculum I—which is comparable, though not identical in form to the Tomb of the Baker in the catacomb of Domitilla dated to ca. 350 on the basis of an inscription found nearby—seem more appropriate to the mid to late fourth century.[20] This dating is supported by the single item of the appurtenances of the catacomb—the lamps, marble slabs used to face tombs, marble capitals and column bases, marble plaques with inscriptions—that has more than merely general chronological significance.[21] One third of the way along corridor 6 is an inscribed plaque carved with the Constantinian monogram, a feature first generally used only in the mid-Constantinian period.[22] The monogram was also popular in the later fourth century when, it would seem, the part of the catacomb to which the plaque belongs was created.[23]

To refine this chronology, however, we must turn to other evidence, namely, the painted decoration of the catacomb, specifically its style. Admittedly, this decoration could have been applied at any time after construction because it was painted *al secco*. That some time may occasionally have elapsed between construction and decoration is suggested by the fact that two cubicula, A' and Ib, were plastered but never painted, and two others, 2a and Ia, were never plastered. Nonetheless, because decoration must have preceded use and use could hardly have lagged very far behind construction, the date of the earliest decoration in each phase must be reasonably close to the date of the phase itself. Since the construction of Phase I cannot be an issue here, for the obvious reason that it contains no painted decoration, two moments, then, are important: the beginning of Phase II on the one hand, and, because the next two stages were built virtually simultaneously, the beginning of Phase III/IV on the other.

18. Wladimiro Dorigo, *Pittura tardoromana*, 221ff.; F.W. Deichmann, "Zur Frage der Gesamtschau der frühchristlichen und frühbyzantinischen Kunst," *BZ*, 63, 1970, 50f. Among those who support a later dating are M. Simon, "Remarques sur la Catacombe," 327ff. (citing Josi's chronology of 350–70); André Grabar, *Beginnings of Christian Art*, 231 (after 350); Cagiano de Azevedo, "Appunti e ipotesi," 31ff. (320–79); Kötzsche-Breitenbruch, *Die neue Katakombe*, 13f. (between Constantine and Theodosius I); Beat Brenk, *Spätantike und frühes Christentum*, 135, nos. 56 and 57 (second half of the fourth century); Harald Mielsch, "Zur stadtrömischen Malerei," 186f. (dating cubicula B and C ca. 350).

19. Ferrua, *Le pitture*, 86. See Kollwitz, "Die Malerei," 34, on the chronological significance of architectural changes in the catacombs, and the remarks of Pasquale Testini, *Le catacombe*, 123ff., on the development of the catacombs generally.

20. For a general view of the Tomb of the Baker, see F. Marchi, *I monumenti delle arti cristiane primitive*, Rome,

1844, pl. XXIII; Wilpert, *Le pitture*, pls. 142.2, 193–195. Kollwitz remarks on the date of the tomb, "Die in einem Nebengang gefundene Inscrift von 364 kann sicher nicht mehr als ein allgemeiner Anhaltspunkt für den Ausbau der Region sein. Aber auch aus ikonographischen Gründen würde man zu einem Datum kurz nach der Jahrhundertmitte kommen," "Die Malerei," 138. On the relationship of catacomb architecture to above ground building, see below, chapter 4.

21. These objects are described by Ferrua in *Le pitture*, chapter 2, passim and esp. 86f., concerning their significance for the dating of the catacomb. For the inscriptions, see also *ICUR*, ed. Antonio Ferrua, n.s. VI, Vatican City, 1975, 38ff., and A. Ferrua, "Iscrizioni pagane nelle catacombe di Roma, Via Latina II," *Epigraphica*, 23, 1961, 3ff.

22. Ferrua, *Le pitture*, 31, fig. 18; Pasquale Testini, *Archeologia cristiana*, Rome, 1958, 354ff.

23. See, for example, *ICUR*, n.s. VI, nos. 15768 (dated to 376), 15772 (dated to 377) and 15778 (dated to 395).

Although style provides the clearest indication of date for the cubicula, it should be emphasized at the outset that on analysis only certain features of the decoration yield results sufficiently specific to justify any conclusions about chronology. The first important evidence comes from the catacomb of Petrus and Marcellinus, from Region Y or the Region of the *Quattuor Coronati* (fig. 31), the area developed around it, and Region Z. These regions are related to cubicula A–C in the Via Latina catacomb not only in plan—square or rectangular cubicula disposed at regular intervals along corridors filled with loculi tombs—but also in decoration.[24] Regarding the latter, analogies occur in three areas: ornament, figure style, and wall design.

Since ornament is used sparingly in the decoration of cubicula A–C, the fact that one unusual motif is found in two rooms, B and C, is all the more revealing. The motif, which frames the left arcosolium in B and the front and rear facing arches that support the vault in C (fig. 13), consists of a series of half-ovals that outline a semicircular cluster of leaf-like forms. In B, the half-ovals are punctuated with an additional triad of "leaves" and framed below by a fragmentary rinceau that is particularly badly formed. In C, the motif has been rendered with jewellike details: groups of red and blue disks appear suspended between the half-ovals, which are also embellished with the same form within the oval border. The motif is most rare. It is not based on a traditional ornamental form and thus has no extensive prehistory in classical art. Nor is it common in Late Antique art, where only a handful of examples are known. Two of these occur in Region Y of Petrus and Marcellinus, in cubicula N66 (fig. 14) and N78, where, in both instances, they are used to decorate the narrow portion of wall in between loculi tombs.[25]

Regarding figure style, there are several points of similarity between the Via Latina catacomb and the Catacomb of Petrus and Marcellinus. The same loose and fluid technique of painting is employed in both cubicula A–C and Regions Y and Z: in the head of a seated figure in cubiculum N58 of Region Y, for example, details are applied in a dark brown color on a light ground with free brushstrokes in much the same way as in the paintings of the arcosolia of B (figs. 36 and 37); moreover, the result is often strikingly similar, as witness a comparison between the heads of Cain in cubiculum B (fig. 15) and of Moses in the lower right panel of the entrance wall in cubiculum N57 (fig. 16).[26] Further affinities are revealed in certain details not, to my knowledge, found in any other wall painting. The painter in cubiculum N78 of Region Y placed a triangular piece of drapery below the lower border of a male orant's tunic, thus creating a nonsensical garment.[27] The same drapery is found on the small boys identified as Joseph's

24. On the regions in Petrus and Marcellinus, see R. Kanzler, "Scavi nel cimitero dei santi Marcellino e Pietro sulla Via Labicana," *NBACr*, 20, 1914, 65ff.; Enrico Josi, "Scoperte nel cimitero dei Santi Marcellino e Pietro sulla Via Labicana," *NBACr*, 24/25, 1918/19, 78ff.; G.P. Kirsch, "Un gruppo di cripte dipinte inedite del cimitero dei Ss. Pietro e Marcellino," *RACr*, 7, 1930, 203ff.; idem, "Cubiculi dipinti del cimitero dei Ss. Pietro e Marcellino sulla via Labicana," *RACr*, 9, 1932, 17ff.; idem, "Un cubicolo con pitture profane inedite nella catacomba dei Ss. Pietro e Marcellino," *RACr*, 10, 1933, 263ff.; Paul Styger, *Römische Märtyrergrüfte*, II, 215ff.; Antonio Ferrua, "Lavori e scoperte nelle catacombe," *Triplice omaggio a S.S. Pio XII*, II, Vatican City, 1958, 55ff.; idem, "Paralipomeni di Giona," *RACr*, 38, 1962, 18; idem, "Una nuova regione"; Kollwitz, "Die Malerei," 45ff., 76ff.

25. Kirsch, "Un cubicolo," figs. 1 and 2 (cubiculum

N66), and Ferrua, "Una nuova regione," 1968, fig. 17 (cubiculum N78). Interestingly enough, a third example is found in the first room of the "Cappella Greca" in the catacomb of Priscilla, whose date and stylistic context are much debated; see Kollwitz, "Die Malerei," 93ff.; Francesco Tolotti, *Il cimitero di Priscilla* (=*Collezione "Amici delle catacombe"* 26), Vatican City, 1970, 258ff.; and Luciano de Bruyne, "La 'Cappella Greca' di Priscilla," *RACr*, 46, 1970, 291ff.

26. For the seated figure in cubiculum N58 of Region Y, see Wilpert, *Le pitture*, pl. 94; Johannes de Wit, *Spätrömische Bildnismalerei*, pl. 17.3; Kollwitz, "Die Malerei," fig. 11. See also the Moses of cubiculum N64 (Wilpert, pl. 98; De Wit, pl. 18.2; Kollwitz, fig. 7); the Moses of cubiculum N67 (De Wit, pl. 13.2; Kollwitz, fig. 38); and the standing figure of cubiculum N59 (see De Wit, pl. 14.1; Kollwitz, fig. 44).

27. Ferrua, "Una nuova regione," 1968, 49, fig. 18.

Brothers in B. The eyes of the figures in B (fig. 15) and Region Y (fig. 16) are rendered in the same distinctive way, with a black dot that would normally have been used to mark the pupil in the center of the eye placed in the area of the lacrimal gland. This detail, which produces a disconcerting cross-eyed look, is paralleled on certain reliefs made in Rome in the late third and early fourth centuries, which provide, in effect, corroborating testimony for our chronology (fig. 17).[28]

Finally, there are parallels in overall design between certain cubicula in Region Y in the Catacomb of Petrus and Marcellinus and A and B in the Via Latina catacomb, although the architectural conditions in each area are quite different. In cubicula N57, N58, and N64 of Region Y, the entrance wall is pierced by the door opening and the side and rear walls contain tiers of loculi.[29] The space thus left over for decoration varies: on the entrance wall it consists of two broad vertical portions of wall surface bisected horizontally into large rectangular panels, while on the other three walls only the narrow horizontal strips between loculi remain and these are filled with ornamental motifs. In cubicula A and B, the surface area of the side and rear walls is essentially the same as that of the entrance wall.[30] But the entrance wall is still divided into two large rectangular panels as in the cubicula of Region Y, even though the other walls in the rooms have a tripartite division.

Given these interconnections which extend to quite minor details, one would assume that the two areas in Petrus and Marcellinus and the three cubicula of Phase II in the Via Latina catacomb were contemporary in date.[31] There is general agreement that Region Y was begun in the early fourth century, perhaps in the middle of the first decade as Kollwitz has suggested, and was continued until mid-century. Region Z was begun slightly later, in the beginning or middle of the second decade and finished soon thereafter.[32] The closest stylistic analogies to cubicula A–C occur in rooms from the middle of Region Y, rather than from its beginning or end, and in Region Z.[33] This connection would suggest a date in the second or perhaps even the third decade of the fourth century, for which certain further considerations provide support.

Compared to other early-fourth-century paintings, the decorations of Regions Y and Z are thoroughly traditional in both style and subject matter: well-known episodes from the Old and New Testaments are illustrated in the laconic manner of third-century Christian art. In one respect, however, many of the later cubicula of Region Y and the sole cubiculum of Region Z are highly unusual: they contain a wealth of ornamental motifs virtually unknown except in the Via Latina catacomb, and in this regard Regions Y and Z far outstrip the Via Latina in lavishness of display. Beside the half-oval motif previously mentioned, there are: concentric

28. Margarete Gütschow has compared the peculiar drillwork on the loculus plaque of Elia Afanasia, dated to the late third century, to painting in the catacomb of Petrus and Marcellinus; see "Eine Reliefplatte aus der Katakombe des Praetextatus," *RACr*, 9, 1932, 137, and idem, *Das Museum der Prätextat-Katakombe*, 153ff., pls. XLIIIf.

29. Wilpert, *Le pitture*, pls. 93 (N58), 98 (N64), 101 (N57). See also cubiculum N16 of Region X, which is closely related to the cubicula of Region Y; Wilpert, *Ein Cyclus christologischer Gemälde aus der Katakombe der Heiligen Petrus und Marcellinus*, Freiburg im Breisgau, 1891, 9ff., pl. V; idem, *Le pitture*, pl. 69; Kollwitz, "Die Malerei," 54, fig. 17.

30. For the entrance walls, see Ferrua, *Le pitture*, pls. IX, X, XVIII, and XIX.

31. One might also assume that the same workshop operated in the two catacombs, but for the fact that no single hand turns up in both places. Little is known about workshop practice in the catacombs (see Testini, *Le catacombe*, 282ff.), although recent studies have clarified other aspects of the organization of the catacombs; see Testini, 221ff.; Jean Guyon, "La vente des tombes," 549ff.; and Elena Conde Guerri, Los "*fossores*."

32. Kanzler, "Scavi nel cimitero," 75; Kirsch, "Cubiculi," 36; Kollwitz, "Die Malerei," 46f., 59ff.; Ferrua, "Una nuova regione," 1970, 82f. Luciano de Bruyne, "La peinture cémétériale constantinienne," 176ff., argues against Kollwitz's dating, but unconvincingly.

33. Namely, cubicula N57, N58, N59, N64, N66, N67, N78.

ovals with dotted borders that alternate with rosettes (cubicula N56, N57, N62, N67, N69, N78, fig. 18); a twisted ribbon rendered as a series of shell-like shapes and concentric ovals (cubicula N56, N57, N64, fig. 18); a broad spiral with loops at either end outlined by a dotted border (cubicula N66, N78); rosettes made out of broad fleshy leaves that alternate with rosettes made out of spiraling tendrils (cubicula N77, N78); and large addorsed "C" shapes that alternate with rosettes (cubiculum N78).[34] Many of the motifs, like the half-oval, appear to be new creations of the early fourth century (certainly the configurations are new even if some components, like the rosette, are traditional forms). Thus they betoken an exuberant creativity that could hardly be accredited to a workshop given the task of painting humble cubicula in a Christian catacomb. A more likely source for these inventions was another workshop associated with the same site—the one that must have decorated the basilica of Petrus and Marcellinus and the adjoining mausoleum now named for Helena, but probably originally built to serve as the tomb of Constantine the Great.[35] Although the decoration of these buildings has not survived, the accounts of mosaics now long lost and the traces of fittings for marble revetments still visible on surviving interior walls leave little doubt of its surpassing splendour.[36] That such decoration exerted some influence on the painters of Regions Y and Z, who may indeed have copied rare ornamental motifs from it, is not inconceivable. The construction of the two buildings between 312 and 324, moreover, coincides with the dates already suggested for the decoration of the middle rooms of Region Y and for Region Z.[37]

The dating of the middle group of Region Y and Region Z, and hence cubicula A–C, to the years 315–25 is reinforced by other evidence. The decoration of the soffits in cubiculum C with vines, busts, and putti resembles the design in a vault situated in one of the few securely dated portions of the Catacomb of Calixtus, the Eusebius Region, of ca. 305–15.[38] Another example of this design occurs in an arcosolium in Domitilla, whose early date may be inferred from its proximity to the so-called Tomb of Ampliatus.[39] This latter tomb, moreover, shows a group of Apostles seated around Christ that is virtually identical in style and composition to the decoration of the rear wall of cubiculum A.[40] The arcosolium of the "Madonna orans" in the *Coemeterium Maius,* dated to the years 315–25 on the basis of epigraphic evidence and archaeological context, provides both direct and indirect testimony to the date of A–C.[41] It shows an otherwise common ornamental motif, the kymation, used in a particular way—as a framing element in its own right (fig. 19). As De Bruyne has observed, this usage is essentially different from

34. The concentric oval motif also appears on the vault of cubiculum 4 in the catacomb of Marcus and Marcellianus (unpublished); the twisted ribbon, on the vault of the entranceway to cubiculum 17 of the *Coemeterium Maius* (unpublished); a motif similar, though not identical, to the broad spiral occurs in the exterior decoration of arcosolium N1 in the catacomb of Priscilla (see Foto Pri N5/6); and the addorsed "C" shapes, in cubiculum N43 of the catacomb of Petrus and Marcellinus (see Kirsch, "Cubiculi," fig. 6).

35. F.W. Deichmann and A. Tschira, "Das Mausoleum der Kaiserin Helena und die Basilika der Heiligen Marcellinus und Petrus an der Via Labicana vor Rom," *JdI,* 72, 1957, 64.

36. A. Recio, "Una posible escena musiva paleocristiana vista por Bosio en el mausoleo de Sta. Helena," *RACr,* 53, 1977, 137ff. Deichmann and Tschira, fig. 20, offer a schematic reconstruction of the decoration of the

basilica based on the surviving holes that held clamps supporting the marble revetment.

37. Deichmann and Tschira, 64.

38. G.B. de Rossi, *Roma sotterranea cristiana,* vol. III, 58, pl. VI and 43ff., on the date of the region; also Styger, *Römische Märtyrergrüfte,* 111ff.; Kollwitz, "Die Malerei," 41f.

39. Wilpert, *Le pitture,* pl. 148; Kollwitz, "Die Malerei," 126ff.; Pasquale Testini, "Nuove osservazioni sul cubicolo di Ampliato in Domitilla," *Atti del IX Congresso Internazionale di Archeologia Cristiana,* Rome, 1975 (=*Studi di Antichità Cristiana* 32), Vatican City, 1978, vol. I, 142ff.

40. Wilpert, *Le pitture,* pl. 148.2; Ferrua, *Le pitture,* pl. XI.

41. Umberto M. Fasola, "Topographische Argumente zur Datierung der 'Madonna orans' in Coemeterium Majus," *RQ,* 51, 1956, 137ff.

that of the third century, as witness the decoration of a ceiling in the Lucina Region of Calixtus where the kymation occupies a subordinate position in the frame (fig. 20).[42] The kymation of the "Madonna orans," moreover, closely resembles one in cubiculum C (fig. 13). The side walls in cubiculum A, on the other hand, are close in design to the front of an arcosolium in the catacomb of Marcus and Marcellianus, whose date is indicated by the essential similarities its figures bear to the "Madonna orans."[43]

Thus, every indication points to a date in the period ca. 315–25 for cubicula A–C. With this frame of reference we may now turn to the rest of the Via Latina catacomb. As we shall see, there can be little doubt that one workshop decorated the rooms of the last phases, III and IV. But it appears to have done so in two stages, beginning first with the rooms of Phase III and then moving to those of Phase IV.

Two decorative features constitute the most decisive chronological testimony in cubicula D–F. First, there are the landscapes in F (fig. 21) and the decorative motifs in all three cubicula. These are rendered in a coarse, chalky style that cannot otherwise be documented in Rome before ca. 340.[44] The style appears in cubicula and arcosolia in the *Coemeterium Maius* (N8, N12, N15) that can be dated to this period on archaeological grounds; it is found in a region of the catacomb of Domitilla (N67, N69, N72, N75, fig. 22) that belongs to mid-century on the basis of epigraphic and iconographic evidence; and it occurs in the catacomb of Petrus and Marcellinus (N52, N53) in an area whose date may be inferred from the evidence of the development of the catacomb.[45] This style continues well into the third quarter of the fourth century, as indicated by a cubiculum in the catacomb of Commodilla dated to 375–80 on topographic and epigraphic grounds.[46] But D–F are not so late in date. The soffit of the rear arch in D bears an ornamental motif—a series of ovals and rosettes—for which there is no evidence after ca. 350.[47] Thus a date ca. 340–50 may be proposed for these cubicula in the Via Latina catacomb.

42. De Bruyne, "La peinture cémétériale," 162. Louis Reekmans, *La tombe du pape Corneille et sa région cémétériale* (=*Roma Sotterranea Cristiana* 4), Vatican City, 1964, 53f., 192f., fig. 71.

43. See Luciano de Bruyne, "Arcosolio con pitture recentemente ritrovato nel cimitero dei Ss. Marco e Marcelliano a Roma," *RACr*, 26, 1950, 195ff. The date proposed by De Bruyne for this painting, in the fourth or fifth decade of the fourth century, is certainly too late. As the author himself observes, the painting of the arcosolium is closely similar to the "Madonna orans" which Fasola has dated to the years 315–325 (supra n. 41). The arcosolium must belong to the same period. Its decoration, moreover, finds iconographic parallel in cubiculum A of the Via Latina catacomb in the Adoration of the Magi and the four episodes from the story of Jonah.

44. Mielsch, "Zur stadtrömischen Malerei," 187, speaks about an "Erstarrungsform der 'impressionistischen' Stilstufe," which I would correlate with this style.

45. For the cubicula from Domitilla, see Wilpert, *Le pitture*, pls. 200.2–3 (cubiculum N67); 196, 197.1–2 (N69); 117.2 (N72); 198, 199 (N75); *Coemeterium Maius*, pls. 166.2, 222.1 and 3 (N8); 172.2, 220, 221 (N12); 223, 224.1–2 (N15); Petrus and Marcellinus, 166.1, 167 (N52); 58.2, 102.2, 165 (N53). The mid-fourth-century date of the area, termed Region Z, of the catacomb of

Domitilla to which these cubicula belong is discussed by Kollwitz, "Die Malerei," 135ff. Cubicula 8, 12, and 15 of the *Coemeterium Maius* are also mid-fourth century in date; see Enrico Josi, "Coemeterium Maius," *RACr*, 10, 1933, 7ff., where comparisons with paintings dated to the mid to late fourth century are cited. Cubicula 52 and 53 of Petrus and Marcellinus, however, are earlier in date. The cubicula are found on a corridor extending from Region Y that was built after the Agape Region had been developed in the second through fourth decades of the fourth century; see Kollwitz, "Die Malerei," 62ff. The cubicula probably date to ca. 340.

46. Antonio Ferrua, "Scoperta di una nuova regione della catacomba di Commodilla II," *RACr*, 34, 1958, figs. 11, 12, 16–19, 21, 24–30; the chronology is discussed by Ferrua, 40ff.

47. The latest dated example of the ornament known to me is from cubiculum N4 in the catacomb of Marcus and Marcellianus (unpublished). The remarkably rich series of dated inscriptions in the area immediately surrounding the cubiculum yields a clear picture of the date of the room; see *ICUR*, ed. Antonio Ferrua, n.s. vol. IV, Vatican City, 1964, s.v. "Coemeterium ad viam Appiam," 360ff. To judge from this evidence the area must have been opened before the earliest inscriptions, which date to 331–352. Since cubiculum N4 is located relatively close to the entrance of the region, a date ca. 350 may be proposed for its decoration. See also Patrick

As for cubicula G²–O, evidence suggests a date at the end of this period or slightly later. The aforementioned cubiculum in the catacomb of Commodilla, dated to 375–80, provides parallels for three vault designs in this group of cubicula, namely, the unusual pattern of circles and connecting loops on the rear portion of the vault of the left arcosolium in N; the scale pattern on the vault of the entrance to O (figs. 23 and 24); and the coffer pattern on the vault of the left arcosolium in I (figs. 25 and 26).[48] Furthermore, the pattern on the front portion of the vault in the left arcosolium in N is virtually identical to one found in the mosaic decoration of the ambulatory vault of Sta. Costanza dated to ca. 350 (figs. 27 and 28), and the pattern of the ceiling of N proper is close to one in a cubiculum in the catacomb of Marcus and Marcellianus dated by epigraphic evidence to ca. 350.[49] An ornamental motif in L, consisting of hearts stacked one on top of the other, is only otherwise attested in the fourth century in the Calendar of 354.[50] As for the painting of figures, the style of the resting Jonah in M (fig. 29) and the winged putto on the left of the entrance wall of N finds a parallel in the style of a Perseus and Andromeda discovered on the Via del Teatro di Marcello in 1929 (fig. 30).[51] Although the latter

Saint Roch, "La région centrale du cimetière connu sous le nom de: 'Cimetière des saints Marc et Marcellien et Damase,'" RACr, 57, 1981, 209ff. Saint Roch relies on the incorrect chronology of Wilpert for the painting and hence proposes a date too early for the cubiculum (cubiculum Ai in his plan), although he too believes that the nucleus of the area of the catacomb to which the cubiculum belongs was begun sometime in the second quarter of the fourth century.

48. Ferrua, "Scoperta" (supra n. 46), 5ff. The relevant decoration is found in cubiculum a (Ferrua's numeration). The rear portion of the vault of the left arcosolium in N is comparable to the vault of the rear arcosolium of a (Ferrua's fig. 20); the vault of the entrance to O, to the vault of the right arcosolium (Ferrua's fig. 15); and the left arcosolium in I to the vault of the cubiculum (Ferrua's fig. 14). The date of the cubiculum is discussed by Ferrua, 40ff. The scale pattern noted here is also close to one found on the vault of the left arcosolium in a cubiculum in the catacomb of Gordianus and Epimachus dated to the mid-fourth century or slightly later on topographic grounds; see Antonio Ferrua, "Un nuovo cubicolo dipinto della via Latina," RendPontAcc, Serie III, 45, 1972–73, 171ff. The scale pattern also occurs in cubicula N4 and N7 of Marcus and Marcellianus (see Wilpert, Le pitture, pls. 177.1 and 245.1), N40 and N45 of Domitilla (pls. 127.2 and 229–30), N9 of Pontianus (pl. 173.1) and N3 of Thecla (barely visible in pl. 235) and on the vault of the corridor in front of loculus N4 in the Coemeterium Jordanorum (unpublished); see Umberto M. Fasola, "Le recenti scoperte nelle catacombe sotto Villa Savoia. Il 'Coemeterium Iordanorum ad S. Alexandrum,'" Actas del VII Congreso Internacional de Arqueologia Cristiana, Barcelona, 1969 (=Studi di Antichità Cristiana 30), Vatican City-Barcelona, 1972, 273ff. See also Harald Mielsch in the catalogue of the exhibition held in Palazzo Braschi in March, 1976, Affreschi romani dalle raccolte dell'Antiquarium Communale, Roma, 1976, pl. XXXII.3 (vault of a nympheum on the Via del Teatro di

Marcello), and Doro Levi, Antioch Mosaic Pavements, vol. I, 440ff.

49. The connection between the design of the front portion of the vault of the left arcosolium in N and the first segment of the mosaic of the ambulatory vault of Sta. Costanza has often been noted; see Kötzsche-Breitenbruch, Die neue Katakombe, 14. For the mosaic, see Guglielmo Matthiae, Mosaici medioevali delle chiese di Roma, Rome, 1967, 10f., fig. 1. The date of the mausoleum is discussed by Henri Stern, "Les mosaïques de l'église de Sainte-Costance à Rome," DOP, 12, 1958, 160ff. The same pattern occurs on the vault of cubiculum N3 of the catacomb of Thecla; see Photo Tec E14, and Umberto M. Fasola, "La basilica sotterranea di S. Tecla e le regioni cimiteriali vicine," RACr, 46, 1970, pl. II (N3=P). The vault in the catacomb of Marcus and Marcellianus is illustrated in Wilpert, Le pitture, pl. 162.1. For the epigraphic evidence dating the decoration see ICUR, n.s. vol. IV, 361, no. 11757 (dated 359); see also 360, nos. 11752–3 (dated 344 and 345 respectively).

50. Ferrua, Le pitture, pl. CIX. Henri Stern, Le calendrier de 354, 321ff., pls. VI.2, VIII.2, and XI.2. Stern argues, obviously without knowledge of the paintings in the Via Latina catacomb, that the motif is of oriental derivation. Mielsch (Affreschi romani, 198 n. 184) suggests, quite incorrectly, that this ornament might be related to the motif, clearly circular, decorating the corner of the wall with the Dea Roma in the excavations on the Via della Consolazione. The niche of a late-first- or early-second-century columbarium discovered in the excavations of the Autoparco at the Vatican is framed by a heart-shaped motif similar in form to the motif in L. I would like to thank Dr. Margarete Steinby of the Finnish Academy in Rome for kindly allowing me to see the tomb and the complex, as yet unpublished, to which it belongs.

51. Mielsch, Affreschi romani, 53ff., pls. XXXIff. (with bibliography); Maurizio Borda, La pittura romana, fig. on 364.

painting cannot be dated by its location—the building in which it was situated was constructed in the early second century and renovated sometime in the fourth—Harald Mielsch has argued convincingly on the basis of stylistic evidence from the catacombs that it belongs to the third quarter of the fourth century.[52] The resting Jonah and the putto share with the Perseus and Andromeda a precise modeling that gives the form of the body a curiously smooth and shiny appearance. Similarly, contours in all of these figures are stressed by dark shades, while the roundedness of particular forms is indicated by a series of short parallel hatch lines. Precisely delineated contours and firm modeling are also characteristic of the *Dea Roma,* a painted figure of the late fourth century discovered in a nympheum on the Via della Consolazione but long since lost.[53] To judge from the photographs, moreover, this figure was especially close to the Perseus and Andromeda in facial structure—all in particular have the same large almond-shaped eyes. Taken together, therefore, these observations suggest a date in the third quarter of the fourth century for the decoration of G²–O.

The only date thus lacking is the one for the initial phase of construction of the catacomb. The evidence available at this point simply does not permit us to define this chronology closely. The most important consideration is that some time must have elapsed between the completion of Phase I and the beginning of Phase II, which would put Phase I at ca. 300 or perhaps even earlier. Be that as it may, the dates we have obtained for the two cubicula, C and O, ca. 315–25 and 350–70, are sufficient for our discussion of their paintings. And even with regard to construction, the catacomb as a whole is, after all, now largely dated. Phases II–IV make up the largest and most significant area of the catacomb as it stands today; the fact that they represent, in effect, two periods of building activity, ca. 315–25 and 340–50, becomes even more significant in light of the following analysis.

THE TWO PLAN TYPES AND THEIR ANTECEDENTS

When we seek the proper context within which to view the first two building phases of the Via Latina catacomb, we need look no further than Rome. The plan and the architecture of Phase I, whose date cannot be determined with precision, as well as the plan and architecture of Phase II, are, with minor exceptions, characteristic of the Roman catacombs as they were developed in the late third and early fourth centuries. Parallels to the rather disorderly arrangement envisaged by the builders of Phase I in other Roman catacombs are too numerous to mention,[54] while the plan of Phase II, in the arrangement of single and double cubicula at regular intervals along a corridor that contains loculi, is, as we have already observed, identical to the one employed in Region Y of the catacomb of Petrus and Marcellinus (fig. 31), which is its precise contemporary in date.[55] The architecture of both phases is also familiar from this context. For instance, cubicula V_{IV}, AV_I, and av_8 in the catacomb of Priscilla, cubicula b and c in the catacomb of Commodilla, and cubicula a and i′ in the catacomb of Marcus and Marcellianus all

52. Mielsch, *Affreschi romani,* 56.

53. Antonio M. Colini, *RendPontAcc,* Serie III, 21, 1945–46, 22; Stern, *Le calendrier de 354,* 129, 345, pl. 27.1–3; Norman Neuerburg, *L'architettura delle fontane e dei ninfei nell'Italia antica* (=*MemAccNapoli* 5), Naples, 1965, 216f., fig. 51; Mielsch, *Affreschi romani,* 197f., pls. 99, 100.1.

54. See, for example, the central area of the catacomb of Priscilla (Tolotti, *Il cimitero* [supra n. 25], pl. II; Nestori, *Repertorio,* fig. 9); the *Coemeterium Maius* (Fasola, "Topographische Argumente" [supra n. 41], pl. 19; Nestori, *Repertorio,* fig. 9); and the catacomb of San Sebastiano (Nestori, *Repertorio,* fig. 19a).

55. Above, pp. 12–15.

have the same simple, cubic form as our cubiculum 2a.[56] Both a hypogeum discovered on the Via Labicana in 1923—most likely a third-century pagan construction—and the early-fourth-century hypogeum of Trebius Justus have, like A and A′, a square plan with three arcosolia; the pagan hypogeum matches the two cubicula, moreover, in its shallow barrel-vaulted ceiling.[57] Elements of B are paralleled in the catacombs of Domitilla (double arcosolia), Apronianus (stucco relief), and Vibia (four corner columns).[58] In fact, the only features for which no Roman parallels have yet come to light are the pediments supported by brackets in B and the side niches in C;[59] and these elements notwithstanding, it seems reasonable to assume—since the major features of Phases I and II clearly derive from a Roman tradition—that the planning spirit behind them was Roman in origin.

The case of the last two phases of construction is more problematic. To be sure, many of the same elements found in the early construction of the catacomb are perpetuated here. The group N–O is, after all, a copy of B–C. But these elements are now submerged in what appears to be another system and an altogether new order. First, there is the arrangement itself. Triangular and radial configurations of cubicula in D–G[I] and Ia–h have replaced, to a large extent, the simple serial disposition characteristic of the early phases of the catacomb. And then there are new components: antechambers—cubicula such as D, I, and L that do not contain nor were ever meant to contain tombs—and a broad hall, H, free of any tombs, largely because the loculi were all consigned to a corridor, 6.

The use of a triangular or radial arrangement of cubicula around an antechamber, a broad

56. For the cubicula in Priscilla, see Tolotti, *Il cimitero,* pl. I (plan); for Commodilla, see Antonio Ferrua, "Scoperta di una nuova regione della catacomba di Commodilla I," *RACr,* 33, 1957, fig. 1; and for Marcus and Marcellianus, see Saint Roch, "La région centrale" (supra n. 47), pl. 1.

57. For the hypogeum on the Via Labicana, see *NS,* 1926, 70ff. For the hypogeum of Trebius Justus, see G. Wilpert, "Die Malereien des Grabkammer des Trebius Justus aus dem Ende der konstantinischen Zeit," *Konstantin der Grosse und seine Zeit,* ed. Franz Dölger, Freiburg i. Br., 1912, 276ff., and M. Petrassi, "Torna alla luce l'ipogeo di Trebio Giusto," *Capitolium,* 51/2–3, 1976, 17ff. In architectural form cubicula A and A′ also resemble a cubiculum in the catacomb of Gordianus and Epimachus dated on topographic grounds to the mid-fourth century or shortly thereafter; see Ferrua, "Un nuovo cubicolo" (supra n. 48), 171ff.

58. The architectural features of B have many parallels. For double arcosolia I cite the so-called crypt of Ampliatus in the catacomb of Domitilla; Pasquale Testini, "La cripta di Ampliato nel cimitero di Domitilla sull'Ardeatina," *RACr,* 28, 1952, 77ff. Testini's date for the crypt—shortly after the mid-second century—though, seems too early. Stucco relief is used in a cubiculum in the catacomb of Apronianus that has been destroyed(?); see Marchi, *I monumenti* (supra n. 20), pl. 22, and Enrico Josi, "Cimitero cristiano sulla via Latina," *RACr,* 16, 1939, 42, figs. 4–5. Other instances of the use of stucco relief are cubiculum N2 in the catacomb of Panfilo (see Josi, "Il cimitero di Panfilo," *RACr,* 1, 1924, 15ff., and 3, 1926, 51ff.); the Cappella Greca (see De Bruyne, "La 'Cappella Greca' " [supra n.

25], 291ff.); the "Platonia" under San Sebastiano (see Styger, *Römische Märtyrergrüfte,* 151ff., pls. 69–70). On the use of stucco in Late Antique decoration in general, see the remarks of Harald Mielsch, *Römische Stuckreliefs* (=*RM* Ergänzungsheft 21), Heidelberg, 1975, 93ff. Four corner columns occur in cubiculum Va in the catacomb of Vibia (see Antonio Ferrua, "La catacomba di Vibia," *RACr,* 47, 1971, 38ff., fig. 5); in a cubiculum in the catacomb of Sant'Agnese (see Marchi, *I monumenti,* pl. XIX); in cubicula in the catacomb of Apronianus (see Josi, "Cimitero cristiano," 217ff); cubicula N1 and N2 in the catacomb of Via Yser (see Marchi, *I monumenti,* pl. XXXIII); cubiculum N25 in the catacomb of Priscilla (see Tolotti, *Il cimitero* [supra n. 25], figs. 13.5–8 [here cubiculum C[I]]); cubiculum D in the catacomb of Panfilo (see Josi, "Il cimitero di Panfilo" [1924], 56, fig. 12); and cubiculum N3 in the catacomb of Marcus and Marcellianus (see Saint Roch, "La région centrale," [supra n. 47], 228ff., figs. 1 and 2). The columns in the latter example were not cut from the tufa as in B but formed from terra cotta fragments and cement and then covered with narrow marble plaques.

59. The issue of the side niches in C will be taken up again in chapter 4. The rear wall of the arcosolium in cubiculum C also contains a small niche whose purpose is unclear. The only parallels known to me are in the catacomb of Calixtus (see Reekmans, *La tombe du pape Corneille* [supra n. 42], 56, figs. 33–35), where similar niches are cut into the small sides of arcosolia—Reekmans compares them to motifs on third-century sarcophagi—and at Pécs (see Friedrich Gerke, "Die Wandmalereien," 115).

hall, and a corridor reserved for loculi cannot be paralleled in Rome. No other catacomb contains evidence of it.[60] If we then turn to the areas outside of Rome where a tradition of catacomb or tomb architecture is known, there emerges only one site which can supply comparanda to all of the unusual features in the second part of the catacomb. It is a site, moreover, whose ancient tombs today are not well known, namely, the city of Alexandria.[61]

The underground tombs or catacombs of Alexandria have never been systematically studied, nor is a great deal known about their chronology and development.[62] But excavations in the late nineteenth and early twentieth centuries have uncovered in and around the city extensive remains of tombs hewn from the living rock, and there can be little doubt that they form a true sequence extending from Hellenistic times through Late Antiquity. Furthermore, they make repeated use of certain forms that are directly relevant to the plan of the second part of the Via Latina catacomb. For instance, in the catacomb of Mex (fig. 32), an early member of this series dated to the Augustan period, several features of Phase III/IV appear: a single major axis of development; an entranceway and a broad hall; loculi isolated from the spacious niche tombs in two corridors set perpendicular to the major axis; and niche tombs arranged around square or circular antechambers.[63] Corridors reserved for loculi recur in Kom-esh-Shugafa and the Wescher catacomb; a radial grouping of cubicula in Kom-esh-Shugafa and the tomb in the Antoniadis Garden; antechambers in Kom-esh-Shugafa, the Wescher catacomb, Sidi Gaber, Shatbi, Anfushi, and Mustafa Pasha; and hallways unencumbered by tombs in Kom-esh-Shugafa.[64] These features must have constituted part, though by no means all, of the traditional repertory of architectural forms employed by Alexandrian architects in the building of underground tombs. Doubtless, too, certain tomb types, such as the peristyle type represented by the catacomb of Mex, originated in Alexandria.[65]

60. Cf. Ferrua's remarks, "Il vano D fu concepito come ambiente di disimpegno e non destinato a sepoltura; difatto nessuna tomba troveremo in esso. Lo stesso dobbiamo constatare anche del seguente vano G, del grande ambulacro H, del vestibolo L e di altri ambienti minori, fatto questo veramente nuovo nella tipologia delle catacombe romane," *Le pitture*, 25. Cubicula without antechambers are arranged in a triangular configuration in the catacombs of Priscilla (Tolotti, *Il cimitero*, pl. I: cubicula V_{VII}–V_{IX} and V_X–V_{XII}; Nestori, *Repertorio*, fig. 9); Petrus and Marcellinus (Nestori, fig. 14); Marcus and Marcellianus (Nestori, fig. 26); and the hypogeum under the "Casale dei pupazzi" (Antonio Ferrua, "Un piccolo ipogeo sull'Appia antica," *RACr*, 39, 1963, fig. 1; Nestori, fig. 21). In this context, it is instructive to compare G^2–O to a purely Roman endeavor that was also built in one operation, such as the pagan hypogeum on the Via Labicana. In the hypogeum, individual chambers and arcosolia are simply lined up along a single corridor as in Region Y of Petrus and Marcellinus; see Marchi, *I monumenti* (supra n. 20), 45ff, pls. VI and VII. Marchi's plan bears correction on one point: the mosaic decoration of the floor never extended into the two rectangular chambers on the right marked "M." To judge from the mosaics, the hypogeum was built in the fourth century; see Marion Blake, "Mosaics of the Late Empire," 122f., pl. 33.1–3.

61. Cf. the brief yet prescient remarks of Charles Picard, *CRAI*, 1956, 278.

62. The sole general study is Rudolf Pagenstecher's *Nekropolis* (1919).

63. Ibid., 134ff.

64. For Kom-esh-Shugafa, see Theodor Schreiber, *Die Nekropole von Kôm-esch-Schukafa* (=*Expedition Ernst Sieglin, Ausgrabungen in Alexandria* I), Leipzig, 1908, Textband, 18ff., and Tafelband, pl. IV. For the Wescher catacomb, see J.P. Richter, "Die Wescher-Katakombe im Jahre 1876. Mitteilungen und Untersuchungen," ibid., Textband, 30ff. and Beiblatt I. For the tombs at Sidi-Gaber and in the Antoniadis Garden, see Hermann Thiersch, *Zwei antike Grabanlagen bei Alexandria*, Berlin, 1904, 2ff., 6ff., fig. 1 and pl. IV; and Pagenstecher, *Nekropolis*, 112ff. For Shatbi, see Evaristo Breccia, *La necropoli di Sciatbi*, Cairo, 1912, pl. I, and Pagenstecher, 116ff. For Anfushi, see Pagenstecher, 116ff. For Mustafa Pasha, see Achille Adriani, "La nécropole de Moustafa Pacha," *Annuaire du Musée Gréco–Romain d'Alexandrie*, 1933–34/1934–35 (1936), pls. XXIX and XXX. See also, Hermann Thiersch, "Zwei Gräber der römischen Kaiserzeit in Gabbari (Alexandria)," *Bulletin de la société archéologique d'Alexandrie*, 3, 1900, 7ff.

65. On the "Peristylgrab," see Pagenstecher, *Nekropolis*, 126ff.

The question then arises whether the unusual features of the second part of the Via Latina catacomb can be attributed to an Alexandrian source. Further support for this derivation comes from one motif in cubiculum F, the large doors painted on the walls between the front and rear arcosolia.[66] The motif, of course, was common in the illusionistic decoration of early Roman times, but in the fourth century the only known Roman example is the one in the Via Latina catacomb.[67] Painted doors, however, also occur with great frequency in the decoration of Alexandrian tombs, the only difference being that while figures are shown entering and leaving the doors in the Via Latina catacomb, there are no figures associated with the motif in Alexandria.[68]

On the other hand, certain of the unusual features of the second part of the catacomb occur in places other than Alexandria. The triangular arrangement of cubicula is characteristic of tombs in Palestine, as witness the necropolis of Beth She'arim (fig. 33).[69] This tomb complex, dating from the second to the fourth centuries, consists of separate units whose interior chambers are frequently arranged in a triangular configuration. Furthermore, the tombs are preceded by antechambers whose facades are embellished with architectural elements such as moldings, arches, and columns. To judge from the necropolises of Palmyra, a plan consisting of a tripartite arrangement of tomb chambers around an antechamber was also common there; a famous example is the second-century Tomb of the Three Brothers.[70] This type of Palmyrene tomb has precedents going back to the Hellenistic period, though its origins have been attributed to Alexandria.[71] Given the fact that related forms are found in an area ranging from Egypt to Palestine and Syria, therefore, as well as the incomplete state of our knowledge, it would be imprudent to draw a finer line around our source.

We must also remember that the second part of the Via Latina catacomb bears some relation to the first, so in any case it could not have been a pure transplant, whatever eastern source may have been involved. An indigenous, that is, Roman, element is also revealed in the arrangement of loculi, which lie parallel to the wall surface—in the East loculi are generally arranged

66. Ferrua, Le pitture, pl. LIII.

67. See, for example, Phyllis Williams Lehmann, Roman Wall Paintings from Boscoreale in the Metropolitan Museum of Art (=College Art Association Monographs on Archaeology and Fine Arts 5), Cambridge, MA, 1953, 95f., pls. XI, XV, XVII; and H.G. Beyen, Die pompejanische Wanddekoration vom zweiten bis zum vierten Stil, The Hague, 1938, vol. I, pl. 21, figs. 44 and 46 (Pompeii, House of Apollo, and Rome, Domus Aurea). While the motif had a purely decorative function in domestic contexts, it often had a symbolic significance in Roman funerary art; see Britt Haarløv, The Half Open Door: A Common Symbolic Motif within Roman Sepulchral Sculpture, Odense, 1977, esp. 72ff., where many references are given to the image of the door in Christian literature. The question then arises as to the meaning of the motif in the Via Latina catacomb. On the one hand, the painted doors, in conjunction with the real entrance, suggest that the cubiculum be understood like a garden pavilion perforated at regular intervals by large openings, as in the so-called Temple of Minerva Medica; see L. Crema, "L'Architettura romana," Enciclopedia classica, Sezione III, Archeologia e storia dell'arte classica, vol. XII, pt. I, Turin, 1959, 634f. This would be in keeping with the illusionistic architectural design of the room.

On the other hand certain texts, such as John 10:9, suggest that the motif may have been symbolic in a Christian sense; Renate Pillinger, Die Tituli Historiarum oder das sogenannte Dittochaeon des Prudentius, Vienna, 1980, follows this line of interpretation (but most unconvincingly).

68. Pagenstecher, Nekropolis, figs. 56–59, 61. See also Maurice Dunand, "Tombe peinte dans la campagne de Tyr," BMBeyr, 18, 1965, pl. XI.2, fig. 8.

69. Benjamin Mazar, Beth She'arim I; Nahman Avigad, Beth She'arim III. Report on the Excavations During 1953–58. Catacombs 12–23, Jerusalem, 1976.

70. Robert Amy and Henri Seyrig, "Recherches dans la nécropole de Palmyre," Syria, 17, 1936, 229ff.; Michał Gawlikowski, Monuments funéraires de Palmyre, Warsaw, 1970, 107ff. For the Tomb of the Three Brothers, see Carl Kraeling, "Color Photographs of the Paintings in the Tomb of the Three Brothers at Palmyra," AArchSyr, 11–12, 1961–62, pls. 1ff.

71. Similar painted tombs are also found at Marissa; see John P. Peters and Hermann Thiersch, Painted Tombs in the Necropolis of Marissa, London, 1905.

perpendicular to the wall—as well as in the form of cubiculum I.[72] Hexagonal and octagonal cubicula like I occur in the Roman catacombs of Domitilla, Priscilla, S. Sebastiano, Calixtus and Marcus and Marcellianus (though as tombs and not as antechambers).[73] Because of these connections with forms both local and foreign, the second part of the Via Latina catacomb may best be described as a design based on eastern sources, most likely from Egypt, Palestine or Syria, which have been adapted to the tradition of the city of Rome.

The final problem, and indeed, because of the obvious limitations of our evidence, the most difficult to resolve, is why a plan like that found in the second part of the catacomb would have been used in Rome, which had, after all, a long tradition of catacomb architecture of its own. The most likely explanation—it seems to me—is that the builder of the second part of the catacomb used a plan different from the norm because he had a different purpose in mind. F.W. Deichmann has suggested that the Via Latina catacomb, unlike the other Roman catacombs, was developed essentially as a commercial endeavour, and this notion is plausible indeed.[74]

Deichmann spoke of the monument as a whole. But in light of the foregoing analysis, and for two additional reasons, his suggestion seems more likely to apply to the second part of the catacomb than to the first. To begin with, it is possible, but not capable of proof, that the notion of such an enterprise was tied to the plan used in the second part. Among eastern tombs whose plans proved relevant to Phase III/IV there is one, the Tomb of the Three Brothers in Palmyra, that is known to have been a commercial enterprise.[75] The plans of Phases I and II, on the other hand, are, as we have seen, close to those used in monuments that were not commercially based.

But it also seems that the builders attempted to isolate G^2–O as a separate ensemble within the catacomb, so it may have been only these rooms that were constructed for commercial purposes. The evidence comes from the remodeling of G^1. Besides the alterations to the architecture of the room, this renovation involved two other changes to which I referred earlier: the insertion of a tract of brick masonry into the left wall of G and the building of a low wall at the top of the steps between D and G. The tract of masonry clearly represents a repair, perhaps of damage done to the wall in the remodeling of G. But the low wall must have served another purpose. The fact that it juts out across the top of the steps and partly blocks the passage between D and G suggests that it functioned as a kind of partition between the two rooms or the two areas to which these rooms belong, or as a kind of sign demarcating or protecting the area behind it. Support for the latter interpretation comes from a painting on the front of the wall that shows the faint outline of a winged human figure holding his right arm aloft (figs. 9 and 10). Figures like this, albeit in terra cotta relief rather than painted plaster, are known from the Roman tombs of the Isola Sacra at Ostia, where they presumably served as

72. Loculi in the Jewish catacombs of Rome, however, are set perpendicular to the wall; see Hermann Wolfgang Beyer and Hans Lietzmann, *Die jüdische Katakombe der Villa Torlonia in Rom*, Berlin-Leipzig, 1930; Harry J. Leon, *The Jews of Ancient Rome*, Philadelphia, 1960, 46ff.; Umberto M. Fasola, "Le due catacombe ebraiche di Villa Torlonia," *RACr*, 52, 1976, 7ff. Of interest in this context is a small hypogeum on the Via Latina discovered in the late nineteenth century (now lost?). The central area of the hypogeum consists of a square room that gives access to three ancillary tomb spaces with loculi set perpendicular to the wall surface; see "Scoperta d'un ipogeo cristiano presso il quinto miglio della via Latina," *BACr*, 1876, 32ff. and 153f.

73. Nestori, *Repertorio*, figs. 19a (San Sebastiano), 25 (Calixtus), 26 (Marcus and Marcellianus) and 28 (Domitilla). For Priscilla, see Tolotti, *Il cimitero* (supra n. 25), 237ff. I know of only one other example of the deeply recessed double arcosolia of I, in an undecorated and unpublished cubiculum in the catacomb of Domitilla near the basilica of Sts. Nereus and Achilleus.

74. F.W. Deichmann, "Zur Frage" (supra n. 18), 51f.

75. Kraeling, "Color Photographs" (supra n. 70), 14.

signs to identify or to protect tombs or their occupants.[76] If the low wall was built to display a kind of sign, it would mean that the area behind it, namely G^2–O, was considered a separate ensemble. And the plan of the group reveals, upon examination, a certain inner logic that bespeaks the intention to make it as self-sufficient a unit as possible within the context of the catacomb: the individual cubicula of G^2–O are varied in form, yet they make a coherent whole; the transformation of G created a monumental entrance that was followed by a broad hall (H); the character of the hall and of all subsequent portions of corridor as passageways was preserved by consigning the loculi to a narrow corridor off G; and finally, a pool was created to serve the rooms.

An analysis of the evidence has thus demonstrated that the Via Latina catacomb was the result of four phases of construction. The phases fall in three periods: of the late third or early fourth century (I), ca. 315–25 (II), and ca. 340–50/70 (III/IV). But they divide more significantly into two groups with regard to plan: I and II belong to a local Roman tradition; III/IV represent a tomb arrangement unknown elsewhere in Rome and formulated, in my hypothesis, under eastern influence. Rather than the somewhat loose association of cubicula usually seen in the Via Latina catacomb, there is thus this important relationship; it is the one, as we shall see in our further investigation of cubicula C and O, that carries across both the style and the subject matter of the decoration of the catacomb.

76. Calza, *La neropoli,* 247ff., figs. 148–58. Two terracotta plaques bearing unusual representations (a partridge and an aedicula) inserted into the facade of the tomb of the Caetenii in the Vatican necropolis appear to be related to these examples from Ostia; see Toynbee and Ward Perkins, *The Shrine,* 48f., pls. 9–10. It is interesting to observe that winged figures similar to the one in the Via Latina catacomb occur in the tombs of Beth She'arim where they are also found in areas connecting two rooms; see Mazar, *Beth She'arim I,* 81f. and fig. 9.

III

Painting Styles

THE salient stylistic differences between cubicula C and O occur in two areas. To begin with, there is the style of the figures and scenes, which can best be described by putting paintings from each room side by side. In the Crossing of the Red Sea in cubiculum C (fig. 2) one grasps the essential action not in details—for even Moses' staff seems insignificant, isolated in the center of the painting—but in the totality of barely distinguishable forms. Individual figures do not emerge from the two masses with which the artist has composed his picture, but blur into the background in a receding arc so as to suggest depth and space. In the Crossing of the Red Sea in cubiculum O (fig. 3), the prevalent tendency is towards linear structure: strong contours, large, precisely rendered details, and dramatic gestures and poses define form and carry expressive weight. Much emphasis is put on the figure of Moses, whose size and now bold gesture make him the unmistakable pivot of the action. Space has shrunk accordingly—the artist has eschewed techniques like overlap to such an extent that the two crowds in the painting are made up largely of disembodied heads hanging in the air.

Then there is the design of the decorative framework, which is appreciated by contemplating the rooms as a whole. In C (fig. 34), the overall design is a frail lattice set against a white background, a grid of red lines that emphasizes all junctures between walls and ceiling. Birds and flowers float in the spaces between the red lines, which also enframe figures and scenes or merely stand empty. In O (fig. 35), the decorative framework imposes an order on the room that can only be described as architectural. A dado wraps around the lower walls; above it are framed pictures and the ceiling on which appear, here and there, forms reminiscent of coffering. Individual features also seem to have physical substance: the dado, for instance, is painted to resemble marble revetment.

To account for these differences, however, is considerably more difficult than to describe

them. For the shift from C to O, a shift from a rather naturalistic, impressionistic, and non-architectural conception of form to an abstract, linear, and architectural one, bespeaks not a coherent stylistic development, but a profound change in direction, an about face, a radical transformation of principles. Our aim in the following discussion is to make sense out of this change, and in order to do so we will need to know where each style came from. Since this is a large task, much of our discussion will be devoted to the problem of origins, although, for reasons that one might anticipate from the analysis of the construction of the catacomb, the first room and its group will be somewhat easier to deal with than the second: the roots of the first lie largely in the tradition of the city of Rome for which the evidence is comparatively ample and concentrated, while those of the second ultimately lie outside Rome and must be reconstructed on the basis of remains that are fragmentary and dispersed.

THE "ROMAN" TRADITION (CUBICULUM C AND ITS GROUP)

Since cubicula A–C are close in date, if not exact contemporaries, we may begin by asking whether the painters who decorated these rooms were related, and, if so, whether there is any indication of their working procedure. In this regard, important evidence comes from the figures and scenes in which it is possible to detect two characteristic manners or hands.

The first manner emerges most clearly in the arcosolia of B. Of the 14 scenes painted there, nearly all are rendered in monochrome, primarily in brown or yellow, but enlivened here and there with red, green, and black. Figures are generally bloated and full, their anatomy slurred in large curves (fig. 36). In places—especially in heads, hands, and feet—contours are feathery and imprecise; other areas—the curve of the back and the lower torso—are shaped by a single sweep of line. A third dimension is not plotted carefully by modeling with gradations of color, but simply alluded to in the juxtaposition of opaque darks and lights. Furthermore, details of drapery, facial features, and hair seem to disintegrate upon close examination: they are all delineated in dark brown that rests without transition on a light ground. Certain characteristic details are particularly striking. Adam and Cain (fig. 15), the three Angels, Joseph, "Joseph's Brothers," and Ephraim and Manasse all have the disconcerting crossed eyes noted earlier. The lower portions of seated or reclining figures—Joseph, Abraham, and Jacob (fig. 37)—have an elliptical, cocoon-like shape. Likewise, the lower portions of striding figures—Balaam and Lot—bulge out emphatically to one side. The torsion with which the artist has rendered stationary figures is equally unsuccessful. In both Ephraim and the Creator, the lower part of the body is nearly frontal while the upper part is twisted at an angle to the picture plane. The slope of the shoulder (in each of these examples, on the beholder's right) is far too broad to suggest the projection of the form back into space.

Although this manner is best documented in cubiculum B, it also occurs in cubicula A and C. The figure of Job in C, for example, has the same uneasy pose—the unsuccessful turning of the upper body—and crossed eyes as the figures in the arcosolia in B. Even closer to these figures is the Shepherd in the vault of the rear arcosolium in C whose head resembles that of the foremost of "Joseph's Brothers" in B. In A, the cocoon-like shape of the lower portion of Noah is familiar from the figures of Abraham, Jacob, and Joseph in B.

A second manner predominates in cubiculum C. If turning figures in the first manner seemed awkward, in the second they appear to move with far greater ease, as witness Abraham (fig. 77), Moses at the Burning Bush (fig. 74), and the youthful figure with the scroll (fig. 76) in C. These figures, like those in the two lunettes of C (figs. 2 and 4), are proportionately much taller than the figures in B. One has the impression that they were constructed out of elongated cylindrical forms. Furthermore, the paintings of C, in contrast to those of B, employ a full range of color—blue,

yellow, green, white, red, and brown. Shadows are often rendered in a light blue and, interestingly, the left side of many figures is shaded with blue. Characteristic also are the clear and intense eyes of the figures, the dark brown fan-shaped fold of the tunic drawn in at the waist, the small, sharp shadows placed at the feet, and the schematic modeling of legs in dark reddish brown.

Like the first manner, the second also appears in the other cubicula. In B, the figure identified as the personification of the Deluge is close in appearance to the female orant in C, while in A, the crowd in the scene identified variously as the Sermon on the Mount or Moses' speech before the Israelites of Deuteronomy 31:28 repeats the form of the Multitude in C; and in A and C, the figures of Moses striking the rock are similar, notably in the position of the head, the contour of the torso and the crescent shape of the sleeve.

It would be necessary to posit only one painter if the two manners thus defined could be explained in terms of another factor, such as the influence of iconographic models. But given the fact that both manners are found in all three rooms, such an explanation would seem unlikely indeed. It defies all probability that a single artist would have used two different sets of models—for so they would have to be conceived—in all of the decoration. Each manner, therefore, may be attributed to a painter who formed part of a workshop in which at least two artists were employed.

We may conclude our discussion of this workshop with one final observation. In the decoration of A–C, no individual manner or level of expertise or quality can be associated exclusively with one part of the decoration or another, for instance, the wall design and ornamental motifs as opposed to the figural and scenic representations. One need only compare the oxen represented in the Ascension of Elijah or in the so-called Entry of Jacob into Egypt to the bull, sheep, or goats in the landscapes painted on the socle of B to verify this statement. This suggests two points: individual painters were virtually interchangeable regarding skill and style and the tasks within the decoration of the rooms were not exclusively defined and apportioned.

Our analysis up to this point and our chronological investigation in the previous chapter have had what might be described as a microscopic orientation; when we take a macroscopic view in order to place the painting of cubiculum C and its group in a broader context, we become aware of its predominantly conservative, city-Roman cast.

This quality is revealed first in the design of the room as a whole and is perhaps most clearly demonstrable in cubiculum B (figs. 38 and 39). The decorative scheme of B is a simple one consisting of a grid of red lines on a white ground that bisect the entrance wall on either side of the door opening and divide the side and rear walls into three sections. Narrow interior lines enframe individual panels in the two upper sections of the side and rear walls. The ribs of the groin vault divide the ceiling into four segments, each of which contains a rectangular panel with a curved top framed by a red and green border. Red lines with narrow interior framing lines also divide the front and rear portions of the two arcosolia into four sections.

The design of B finds a close parallel in certain wall paintings discovered in excavations under the Lateran Basilica. These paintings were found in a corridor beneath the apse of the church and dated between 180 and 220 (fig. 40) and in an edifice that was partly destroyed sometime after 193 to make way for the *Schola Curatorum* of the *Castra Nova Equitum Singularium* and hence dated ca. 180–90 (fig. 54).[1] The resemblances are numerous: the use of an overall white

1. For the painting underneath the Lateran apse, see Wirth, *RW*, 141f., figs. 72 and 73 (dated ca. 220); Antonio M. Colini, *Storia e topografia del Celio*, fig. 290; Luciano de Bruyne, "L'importanza," 85ff., figs. 4–7 (dated ca. 180); Harald Mielsch, "Verlorene römische Wandmalereien," *RM*, 82, 1975, 128 n. 82; Hetty Joyce, *Decoration of Walls*, 80f., fig. 84 (dated ca. 190). For the painting of the Lateran domus, see Enrico Josi, "Scoperte nella basilica constantiniana al Laterano," *RACr*, 11, 1934, 351ff., figs. 9–11; G. Lugli, "Notiziario Regione II. Caelemontium," *BullComm*, 62, 1934, 163f.; Colini, 343ff., fig. 285; De Bruyne, 81ff., 101f., figs. 1–3 (dated ca. 180); Joyce, 41 and n. 124, fig. 34 (dated ca. 190).

ground; the tripartite division of the wall surface; the addition of narrow framing lines to the panels of the two upper zones of the walls; and the application of concentric patterns to the ceiling. But, as Fritz Wirth first observed in his fundamental study of post-Pompeian wall decoration, the important point is that the Lateran paintings were not an isolated phenomenon.[2] Mention may be made here of three comparanda: the Sacellum of Silvanus in Ostia (dated before 215); the early-third-century tomb of the *Gens Octavia* on the Via Trionfale (where the design is applied in an architectural context much like that of cubiculum B); and the second phase of the "Sacello delle Tre Navate" in Ostia.[3] It was the existence of examples such as these that led Wirth to give the design of the Lateran paintings the status of a style which he called the "band system" ("Streifendekoration"). Wirth concluded, furthermore, that this style flourished in Rome ca. 170/80–220. The only problem with Wirth's analysis is the single assertion he makes by implication: that the band system declined ca. 220, when it was superseded by another format, the linear style, that pervaded Rome in the third and early fourth centuries.[4] As Harald Mielsch has shown, the band system occurs in several post-Severan contexts (a frescoed room discovered near Sta. Pudenziana dated to the second quarter of the third century; a decoration in Ostia IV.2.14 painted over a Severan level).[5] These and a number of closely related variants (the third phase of room VII in the House of the Muses in Ostia dated 218–35; the cubiculum of the Good Shepherd in the Catacomb of Domitilla of ca. 250) indicate that the band system never entirely fell out of fashion before the decoration of cubiculum B.[6]

Two points about this design, therefore, are noteworthy: first, that it arose in the Late Antonine/Severan period; and second, that it remained in continuous use in Rome from that time until at least the creation of cubicula A–C. In other words, there is no implication of a revival in the appearance of the design in the Via Latina catacomb. What the evidence discloses about the lineage of the other elements of design in the three rooms confirms this pattern even though it cannot be traced with the same precision. A simplified version of the wall design in B, having two zones rather than three, was employed in C as it was also in a second-century tomb from the Via Portuense.[7] There are precedents for the design of the vault of C in the late-second-century vault of Tomb 143 in the Isola Sacra.[8] The vault of the arcosolium of C

2. Wirth, *RW,* 134ff.; Mielsch, "Verlorene römische Wandmalereien," 127f.

3. For the Sacellum of Silvanus, see Wirth, *RW,* 139f., fig. 71; Joyce, *Decoration of Walls,* 42, fig. 35. For the tomb of the *Gens Octavia,* see G. Bendinelli "Via Trionfale. Ipogei sepocrali scoperti presso il km. IX della via Trionfale (Casale del Marmo)," *NS,* 1922, 428ff. The frescoes of the tomb have been detached and are now in the Museo Nazionale delle Terme. Clearly related, though earlier in date, is the decoration of a tomb found in Grottarossa; see idem, "Tomba a camera con pitture, trovata a Grottarossa ("Saxa Rubra") sulla Via Flaminia," *NS,* 1927, 298ff. For the "Sacello delle tre navate," see G. Becatti, *I mitrei* (=*Scavi di Ostia 2*), Rome, 1954, 69ff., fig. 16. The development of the band system is also treated by Joyce, 40ff., as part of her "linear" group.

4. Wirth, *RW,* 165ff.

5. Mielsch, "Verlorene römische Wandmalereien," 126ff., pl. 23.2 (Sta. Pudenziana); the fresco from Ostia (IV.2.14) discussed by Mielsch, 127f., is unpublished.

6. For room VII of the House of the Muses, see Bianca Maria Felletti Maj and Paolo Moreno, *Le pitture della casa delle Muse,* 13f., 62ff., figs. 11–13. For the cubiculum of the Good Shepherd, see Wilpert, *Le pitture,* pl. 10; De Bruyne, "L'importanza," 103ff., figs. 15 and 16. The decoration of the cubiculum gives no indication that more than one artist was employed, as has been argued, and the stylistic proximity of the design of the upper part of the walls of the room to the decoration of the small villa under San Sebastiano establishes a date ca. 250 for the cubiculum. See also the early-fourth-century decoration of the entrance to the basilica of St. Thecla; Umberto M. Fasola, "La basilica" (supra chap. 2, n. 49), 232, fig. 24.

7. Salvatore Aurigemma, "Colombari romani della via Portuense," *BA,* 38, 1953, fig. 1; Bianca Maria Felletti Maj, "Via Portuense. Necropoli romana," *NS,* 11, 1957, fig. 10. The scheme employed here, with the edges of walls and vaults demarcated by red lines, resembles the design of the tomb of Clodius Hermes (Wirth, *RW,* pl. 24), and the late-second- or early-third-century hypogeum Polimanti (F. Mancini, *NS,* 16, 1919, 49ff., fig. 5).

8. Guido Calza, *La necropoli,* 377f., pl. VII; Joyce, *Decoration of Walls,* 83, fig. 88.

resembles an early-third-century ceiling detached and now preserved in the Tabularium on the Capitoline Hill.[9] And the vault of A is closely similar to the early-third-century ceiling of the large main cubiculum in the Neapolitan catacomb of San Gennaro.[10] The only element that appears to have originated in the fourth century is the wall design of thick red and green lines in A, for which there are no third-century precedents.[11] But in A, as in B, the side and rear walls of the room are divided into three zones and the entrance wall into two zones; in both cubicula plant and animal motifs fill the socle zone on the side and rear walls and baskets flanked by birds occupy the side compartments in the vaults of the arcosolia.

The style of the figures corroborates this development. The "disintegrated" modeling in A–C is particularly revealing since it is a phenomenon characteristic of Roman painting from the Severan period on.[12] The Late Antonine head of Medusa in the tomb of Clodius Hermes (fig. 41) under the church of San Sebastiano may serve to set the stage for this development.[13] In the bold technique and the freedom and fluidity of style the Medusa is much like the paintings of cubicula A–C. But, even though the Medusa's features are applied in rapid brushstrokes in dark color on a light ground, light and shade are deployed to give the sense of an integral form, a sense generally lacking in the Via Latina catacomb. Much closer to A–C is the head of one of the large standing figures in the Hypogeum of the Aurelii on the Viale Manzoni, dated to ca. 200, where the boldness of technique is accentuated (fig. 42).[14] The head is made out of swatches of color loosely assembled to delineate lips, cheeks and eyes. Its shape and contours can only be dimly sensed because highlights and shadows are not consistently and rationally applied. Similar qualities are evident in a painting found in a small tomb on the Via Ostiense dated to the first quarter of the third century (fig. 43).[15] And in this instance, as in A–C, the artist has used, here and there, a broad sweep of unbroken line with calligraphic effect. It is interesting to note, in addition, that one of the other effects preferred by the painter of C, a light blue shadow applied to the left side of the figure, first appears, insofar as I have been able to determine, in the first half of the third century.[16]

9. Colini, *Storia e topografia*, 240, fig. 198.

10. Umberto M. Fasola, *Le catacombe di S. Gennaro*, pl. II, figs. 14 and 15. Certain elements of the Neapolitan ceiling in turn are anticipated in a painted ceiling discovered in Rome and dated to the second quarter of the second century; see Irene Jacopi, "Soffitto dipinto nella casa romana di 'Vigna Guidi' sotto le terme di Caracalla," *RM*, 79, 1972, 89ff., fig. 2. See also the ceiling of cubiculum N9, now inaccessible, in the catacomb of Pontianus; Antonio Bosio, *Roma Sotterranea*, Rome, 1737, vol. I, pl. XLVIII. On ceiling design in general in the catacombs, see Paul Markthaler, "Die dekorativen Konstruktionen," 53ff.

11. An analogous use of thick red and green lines occurs in cubiculum N2 in the catacomb of Ciriaca, of the mid-fourth century (Wilpert, *Le pitture*, pl. 205), cubiculum N3 in the catacomb of Marcus and Marcellianus of the second half of the fourth century (Wilpert, pl. 153.1), and cubiculum N5 in the catacomb of San Sebastiano, of the first half of the fourth century (Wilpert, pl. 158.1).

12. Wirth, *RW*, 142ff., 183ff.; Levi, *Antioch Mosaic Pavements*, vol. I, 536ff.; M.J. Vermaseren and C.C. van Essen, *The Excavations in the Mithraeum*, 173ff.; Bianca Maria Felletti Maj, "Problemi cronologici," 27ff.

13. Wirth, *RW*, 142, fig. 74; Klaus-Dieter Dorsch, "Zur Malerei im vorderen Kammerteil des Clodius–Hermes–Grabes unter S. Sebastiano, Rom," *RQ*, 78, 1983, fig. 8.

14. Carlo Cecchelli, *Monumenti cristiano-eretici di Roma*; G. Bendinelli, "Il monumento sepolcrale degli Aureli al viale Manzoni in Roma," *MontAnt*, 28, 1922, 290ff. On the date, see Bernard Andreae in Theodor Kraus, *Das römische Weltreich* (=Propyläen Kunstgeschichte, N.S. 2), Berlin, 1967, 211f. (ca. 200). The date proposed in the more recent study by Nikolaus Himmelmann, of ca. 210, seems to me to be too late; see *Das Hypogäum der Aurelier am Viale Manzoni, Ikonographische Beobachtungen*, Mainz, 1975, 9.

15. Maria Floriani Squarciapino, "Pitture di una tomba sulla via Ostiense," *BullComm*, 75, 1953–55, 109ff., figs. 1–3, pl. I. The stamps found on the terracotta plaques used to separate the bodies in each of the three arcosolia of the tomb are dated between the second and third centuries.

16. Cubiculum N22 of the catacomb of Calixtus; see Wilpert, *Le pitture*, pl. 27.3. The date of the room is discussed by Kollwitz, "Die Malerei," 36ff. Figures are also shaded with blue on the vault of cubiculum N7 in the *Coemeterium Jordanorum*; see Umberto M. Fasola,

Figure style, like wall design, thus represents an element of continuity with the Roman past—but what of the scenes themselves? Here I refer not to the laconic images of Jonah, the Good Shepherd, and the orant that decorate the arcosolium in C nor to the scenes of the story of Jonah on the walls of A—for these simply come from the conventional repertory of Roman catacomb art—but to the other Old Testament scenes in the arcosolia of A and B and on the walls of C whose source is less certain.[17] It has often been claimed that these scenes were derived from illustrated manuscripts. The explanation has been used to account for the fact that the Old Testament events they represent rarely if ever appear elsewhere in third- and early-fourth-century monumental art nor are they clearly expressive of the theme of salvation that bulked so large in the decoration of the catacombs.[18] The manuscript question as such, however, would not be within the scope of the present inquiry (at least not when formulated in purely iconographic terms as has been the case even in the most complete study to date by Lieselotte Kötzsche-Breitenbruch) were it not for the fact that this question has stylistic implications, as yet unarticulated, with which we must come to terms.[19]

The first problem that arises concerns the type of manuscript that might have served as the source of the scenes in the Via Latina catacomb: Was it a codex or a roll? If a codex, then one important and apparently unique aspect of the scenes would be explained—their descriptive amplitude. This quality is achieved by the rather elaborate compositions employed—figures and groups are often arranged as if they overlapped in successive planes and according to two distinct viewpoints, a frontal point of view, as in Balaam and the Angel, and a birdseye view, as in Jacob's Blessing—but also by the sketchily painted landscape elements forming a bucolic setting that is often, though not always, expressly noted in the Biblical text.[20] Above all, elaborate compositional structures and landscape elements distinguish the scenes from contemporary catacomb painting, which has been aptly termed signitive by Wladimir Weidlé.[21] In the imagery characteristic of Roman catacombs in the third and early fourth century only the figures essential to an understanding of the action are portrayed, often without a setting of any sort. It is possible, however, to imagine the presence of these elaborate compositions and landscapes in an illustrated codex, for they are a part of what Weitzmann has called the "Codex

"Le recenti scoperte" (supra chap. 2, n. 48), pl. CXI, fig. 10. It is interesting to note that, in the hellenistic fresco decoration of Tomb I of the Mustafa Pasha complex in Alexandria, figures are surrounded by broad bands of wash, here light brown in color, to set them off from the background; see Blanche R. Brown, *Ptolemaic Paintings and Mosaics,* 52f., pl. XXIV.1.

17. These scenes include the Drunkenness of Noah, Isaac blessing Jacob, and Moses addressing the Israelites (?) in cubiculum A; the Expulsion of Adam and Eve, Adam and Eve with Cain and Abel, the Vision of Abraham at Mambre, the flight of Lot, Jacob's Ladder, Joseph's Dream, Joseph and his Brothers(?), the Entry of Jacob into Egypt, Jacob's Blessing of Ephraim and Manasse, Jacob's Blessing(?), the finding of Moses, Balaam and the Angel, Phineas with Zambri and Cozbi, Samson and the foxes, Absalom, the Ascension of Elijah, and Tobias in cubiculum B; and Moses at the Burning Bush, the Crossing of the Red Sea, and the scene here identified as Joshua bringing the Israelites into the Promised Land, in cubiculum C.

18. Simon, "Remarques," 327f.; Kollwitz, "Die

Malerei," 89ff. Ferrua, however, rejects the manuscript solution in favor of a monumental source; see *Le pitture,* 97ff. On the themes of early catacomb painting, see Wladimir Weidlé, *The Baptism of Art,* 10ff., and Ernst Kitzinger, "Christian Imagery: Growth and Impact," *Age of Spirituality: A Symposium,* ed. Kurt Weitzmann, New York, 1981, 141ff.

19. Kötzsche-Breitenbruch, *Die neue Katakombe,* passim. The author's conclusions are questioned by Dieter Korol, "Zum Bild der Vertreibung Adams und Evas in der neuen Katakombe an der Via Latina und zur anthropomorphen Darstellung Gottvaters," *JbAChr,* 22, 1979, 175ff., who accepts nonetheless the possibility of a manuscript source for the Old Testament imagery in the catacomb. See also the remarks of Helmut Buschhausen on other sources of the imagery, "Die Katakombe an der Via Latina zu Rom," *JÖB,* 29, 1980, 293ff., and the review of Kötzsche-Breitenbruch by Josef Fink in *RQ,* 72, 1977, 248ff.

20. No mention is made of the location of the Blessing of Ephraim and Manasse in the Bible.

21. Weidlé, *Baptism of Art,* 10f.

Style."[22] But this assumption presents a chronological difficulty, for there is no evidence that the Codex Style was practiced as early as the first group of rooms in the Via Latina catacomb. The earliest traces of this style are from the later fourth and fifth centuries.[23] If one argued for a codex source, then one would be compelled to posit an earlier appearance of the Codex Style than has hitherto been assumed, something I imagine not all students of medieval manuscript illustration would accept.

On the other hand, there was the roll, which is thought to have contained the Old Testament text replete with illustrations at least by the time of the Jewish diaspora.[24] Since all of the relevant scenes in the Via Latina catacomb are from the Old Testament, the roll seems a more likely model for the paintings than the codex. But the style of these illustrations is problematic. Rolls were presumably decorated with scenes of limited scope, that is, with few figures, and lacking a defined setting. This format Weitzmann has called the "Papyrus Style."[25] If the painters of the catacomb had used a roll as a model, we would have to assume that they added the elements foreign to the papyrus style, namely, composition and landscape. But there is no evidence outside of the Via Latina catacomb that these elements were still a part of the wall painters' repertory in the early fourth century. Large-scale landscape painting is rare in the first half of the third century and unknown in the second half, as are large-scale figural paintings of any sort.[26] The reasons for this development are unknown; it may have been due, in part, to the popularity of linear-style wall designs that could not easily accommodate elaborate picture painting. Whatever the cause, there can be little doubt that by the early fourth century these elements had long been out of use.

A similar point can be made with regard to the relationship between the paintings in the lunettes and the vaults in the arcosolia of B. In the lunettes of the two arcosolia, the figures are

22. Kurt Weitzmann, *Illustrations in Roll and Codex* (=Studies in Manuscript Illumination 2), Princeton, 1947, 83ff., 97ff.; idem, "Book Illustration of the Fourth Century," in *Studies in Classical and Byzantine Manuscript Illumination*, 97ff.

23. Weitzmann, "Book Illustration," 100ff., revising a chronology he had proposed earlier; see *Roll and Codex*, 83f. On the codex, see C.H. Roberts and T.C. Skeat, *The Birth of the Codex*, London, 1983. Hugo Buchthal did not resolve this chronological difficulty when he proposed an early model for the Vatican Virgil; see his review of J. de Wit, *Die Miniaturen des Vergilius Vaticanus* in *ArtB*, 45, 1963, 372ff. and idem, "A Note on the Miniatures of the Vatican Virgil Manuscript," *ST*, 236, *Mélanges Eugene Tisserant*, VI/I, 1964, 167ff.

24. Weitzmann, "The Illustration of the Septuagint," translated in *Studies*, 45–75, and "The Question of the Influence of Jewish Pictorial Sources on Old Testament Illustration," in *Studies*, 76–95.

25. Weitzmann, *Roll and Codex*, 47ff.; idem, "Book Illustration," 97.

26. Among the few large-scale landscapes dated to the third century are the lunettes in the cubiculum of the Good Shepherd, of the mid-third century; see above, n. 6. Large-scale figural compositions include the paintings in the Hypogeum of the Aurelii, dated to ca. 200 (see above, n. 14), and the nympheum of the insula found under the church of Ss. Giovanni e Paolo (see Wirth,

RW, 8off., pls. 13, 15 [ca. 130–45]; Wladimiro Dorigo, *Pittura tardoromana*, 62f., CP 4 [late second-early third century]; Joyce, *Decoration of Walls*, 59ff., fig. 63 [third quarter of the third century]). Joyce dates the painting almost certainly too late. The archaeological evidence she cites makes it only unlikely that the painting would belong to a period before the third century. I might also mention here the frescoes recently discovered under the church of Sta. Maria Maggiore, for they form a monumental calendar consisting of narrow panels inscribed with the days of the months and large landscapes that portray activities appropriate to the season: see F. Magi, *Il calendario dipinto sotto Santa Maria Maggiore* (=*MemPontAcc*, Serie III, 11), Vatican City, 1970, who proposed a fourth-century date. In a review of this publication, however, Harald Mielsch advanced a convincing argument for an early-third-century date on stylistic, iconographic, and textual grounds; see *Gnomon*, 48, 1976, 499ff. This dating is supported by the masonry analysis of Dr. Margarete Steinby, who has kindly made her unpublished data available to me, and in two further studies: M.R. Salzman, "New Evidence for the Dating of the Calendar at Santa Maria Maggiore in Rome," *TAPA*, 111, 1981, 215ff., and Inabelle Levin, "A Reconsideration of the Date of the Esquiline Calendar and of Its Political Festivals," *AJA*, 86, 1982, 429ff. See also below, n. 65.

smaller vis-à-vis the field of composition and set in a deeper space than the figures in the scenes of the walls and vaults (figs. 36 and 37). The distinction is one that ultimately derives from the Second Pompeian Style, where portions of the wall were opened illusionistically as if they were views to the outside world, while other areas of wall and ceiling were maintained as flat surfaces.[27] Such a differentiation in the treatment of the surfaces of a room survived long after the Second Style itself had passed away; it occurs, for instance, in a late Hadrianic tomb from Caivano where the lunette on the rear wall is decorated with a large landscape set in a deep space but the vault of the room has flat ornamental motifs and small landscapes set in shallow spaces (fig. 44).[28] Similarly, in the second-century Tomb of the Three Brothers at Palmyra, the lunette contains a large figural composition in an illusionistic space while the vault is decorated with a flat repeat pattern of hexagons taken from the design of a coffered ceiling.[29] But there is no evidence besides cubiculum B itself that this once-customary method of the wall painter's craft had survived into the third not to mention the fourth century. If the painter of B had been aware of the distinction, he would most likely have recognized it as an archaism, which raises wide-ranging questions as to his purpose. In any event, to explain the Old Testament imagery in the first part of the catacomb on the basis of an illustrated roll is to assume a rather complicated view of the artistic process that brought these images into being.

Other explanations, however, are possible. One is that the images were created *ad hoc* on the basis of verbal instructions. But if so, it would still be necessary to account for the old fashioned aspects of style: why would an artist of the early fourth century have created new pictures in a mode that was no longer popular? On the other hand, it is possible that the paintings in the catacomb were based on a model in the same medium. Here one would have to imagine the model from a period when the characteristics we have focused on to such an extent were still current, i.e., the early part of the third century or earlier.

This situation, which involves the creation of another hypothetical work of art, would be difficult to accept were it not for the rather striking resemblances between the first part of the catacomb and one monumental decoration from the first half of the third century, the Synagogue at Dura Europos. There are similarities not only in the choice of episodes—both show Jacob's Vision, Jacob's Blessing of Ephraim and Manasse, the Sacrifice of Abraham, the Finding of Moses, Moses at the Burning Bush, Moses receiving the Law, the Crossing of the Red Sea, and, possibly, Joshua—but also in the two types of illustration they preserve: single subjects, such as Jacob's Vision, and larger narrative sequences involving, in both instances interestingly enough, the Crossing of the Red Sea.[30] Considering the utter isolation of the Via Latina catacomb in this respect, we must at least allow for the possibility that these similarities were more than merely coincidental. Yet given the great differences in location, purpose, and

27. Kitzinger, *Byzantine Art,* 58, n. 31.

28. Wirth, *RW,* 87f., fig. 43, pl. 18; Olga Elia, "L'ipogeo di Caivano," *MontAnt,* 34, 1931, 420ff.; Joyce, *Decoration of Walls,* 37, fig. 28.

29. J. Strzygowski, *Orient oder Rom,* Leipzig, 1901, 11ff.; Carl Kraeling, "Color Photographs" (supra chap. 2, n. 70), 14ff. on the date of the tomb, pls. 1ff.

30. Kötzsche-Breitenbruch, *Die neue Katakombe,* 77ff., 82f. Joseph Gutmann identifies the now-fragmentary second band on the south side of the Synagogue as the Crossing of the Jordan with the Ark under Joshua, a scene that is directly relevant, in my hypothesis, to the decoration of the left niche in C; see "Programmatic Painting in the Dura Synagogue," in *The Dura-Europos Synagogue: A Re-evaluation (1932–1972),* ed. Gutmann, Missoula, Montana, 1973, 141, and below, chapter 4. See also Michelangelo Cagiano de Azevedo, "Iconografie bibliche," 133ff., esp. 141f., though he accepts rather uncritically the theory of a manuscript model; Theodor Klauser, "Der Beitrag der orientalischen Religionen, insbesondere des Christentums, zur spätantiken und frühmittelalterlichen Kunst," *Atti del Convegno Internazionale sul tema: tardo antico e alto medioevo,* (=*Accademia Nazionale dei Lincei,* Quaderno 105), Rome, 1968, 54ff.

religious affiliation, one could hardly imagine a direct relationship between the two monuments. And the aforementioned parallel scenes often do not match in iconography and differ in significant details.[31] But it would also be difficult to imagine an indirect relationship between them. For the reasons cited above it is unlikely that an illustrated manuscript could have served as an intermediary.[32] To posit other lost wall paintings, on the other hand, is to raise questions—Where were they located? For what context were they made? If originally Jewish, how and why were they taken up by Christians? If Christian, why were they related to Jewish works?—that we cannot hope to answer with the evidence available to us.[33] Nonetheless, of all possible explanations for the imagery in the first part of the catacomb, this is the most coherent from the point of view of the artistic process, and hence the most satisfactory: that the imagery in cubicula A–C derives from a monumental source that ultimately goes back to a time when the style of the scenes was in the wall painters' current repertory.

It can thus be demonstrated that the individual elements of A–C, when it is possible to trace their history, have roots in the late second and early third centuries; with wall design and figure style, moreover, it is clear that these roots are in Rome. But there is something in the scenes themselves—namely, their descriptive amplitude—that does not quite fit the Roman context. Although the source of this aspect of the decoration is, as we have just discussed, difficult to locate, it is likely to be outside of Rome. The paintings of A–C thus occupy a slightly anomalous position, being predominately within the Roman tradition on the one hand, while standing somewhat apart from it on the other.

What is lacking is any indication that the style of the Via Latina catacomb was the product of a revival—on the contrary, everything has implied continuity. At the same time, however, the painters of A–C achieved a result that was clearly distinct from that of their predecessors. To illustrate this point, we may compare the figure of Elisha on the left in the scene of the Ascension of Elijah in cubiculum B (fig. 45) to a figure from the Late Antonine period, a

31. Kötzsche-Breitenbruch, *Die neue Katakombe,* 77ff., 82f.

32. M.L. Thompson is also skeptical about a manuscript model for the Dura Synagogue; see "Hypothetical Models of the Dura Paintings," in *The Dura Europos Synagogue,* 31ff.

33. Kurt and Ursula Schubert claim that direct Jewish influence in the Via Latina catacomb is proven by the presence of rabbinical elements in the decoration; see "Die Vertreibung," 173ff.; and Ursula Schubert, *Spätantikes Judentum,* 11f. See also Günter Stemberger, "Die Patriarchenbilder," 19ff. An alternative explanation for the scene of the Expulsion of Adam and Eve in cubiculum B is presented by Korol, "Zum Bild" (supra n. 19), 178ff., esp. n. 17, who offers important criticism of the Schuberts' interpretation.

Other scholars have argued for broader patterns of influence in Jewish and Christian pictorial representation based, for instance, on the shared function of the image as a proof of God's powers of redemption; see Bezalel Narkiss, "The Sign of Jonah," *Gesta,* XVIII, 1979, 63ff., and Henri Stern, "Quelques problèmes," 104ff. An interpretation in a similar vein has been offered for the Dura Synagogue, particularly the second band of decoration on the rear wall; see *The Synagogue:*

Studies in Origins, Archaeology and Architecture, ed. Joseph Gutmann, New York, 1975, xviii.

On the problem of Jewish sources of Christian art see, for example, Kurt Weitzmann, "Question of Influence," 76ff. (with bibliography). Regarding connections in wall painting specifically, see Georg Kretschmar, "Ein Beitrag," 295ff., who draws attention to several striking thematic and compositional parallels between the rear wall of the Dura Synagogue and later Christian decorations, notably the Justinianic mosaics in San Vitale in Ravenna and in the monastery of St. Catherine's on Mount Sinai, parallels which he attributes to the use of model books. André Grabar has also discussed Jewish influence in the realm of monumental art; see "Recherches sur les sources juives de l'art paléochrétien," *CahArch,* 11, 1960, 41ff.; 12, 1962, 115ff.; 14, 1964, 49ff.

The possibility of Jewish influence on Christian art is called into question by Hugo Brandenburg, "Überlegungen zum Ursprung der frühchristlichen Bildkunst," *Atti del IX Congresso Internazionale di Archeologia Cristiana,* Rome, 1975, (=*Studi di Antichità Cristiana* 32), Vatican City, 1978, vol. 1, 331ff., and Carl Kraeling, *The Christian Building,* 216f.

masked actor from the House of Asinius Rufinus in Acholla dated to 184 (fig. 46).[34] The two are clearly related and, although they come from different places, must be derivatives of the same type. Both are rather fat with short, stubby arms and distinctly large heads. Both, too, are painted with quick, broad brushstrokes that merely imply bodily and facial features and spatial relations. Yet beside the robust actor, tensely poised and highly expressive, Elisha seems slack and vacant. It is as if the force that gave agitated life to the one had been drained away in the other.

A parallel change may be observed in wall design. The band system had, in its original form, a rather complex character (figs. 40 and 54). It was pervasively ambiguous, offering no firm point of orientation to the viewer.[35] This was due partly to the white ground—the nature of wall and ceiling as architectural entities was completely masked by a white screen—and partly to the colored strips that covered every surface. The space implied between these strips is not well defined or easily identified. It is, at once, an airy and vague atmosphere in which decorative motifs seem to float, and a flat matrix upon whose surface the motifs seem fixed. In cubicula A–C (figs. 34, 38, and 39) this ambiguity has been resolved. Each element in the decoration, the scenes from the Old Testament, the ornament, the putti, and so on, virtually fills the field in which it is situated. In place of empty but active space, there is a static arrangement, a dense, monotonous array from floor to ceiling. In thus altering the form of the band system, the painters of the Via Latina catacomb have tipped the balance in favor of a flat matrix, a static, two-dimensional design.

It is clear, finally, too that these changes do not, strictly speaking, involve error or incompetence and hence cannot justly be attributed solely to the executant artist. Rather they have to do with the coarsening of an ideal—for by comparison with precedents the style of A–C truly lacks vigor; it has a shopworn quality—and this must have been the result of a gradual process, a decades' long development that, in turn, must have been marked by a considerable narrowing of the creative horizon.[36]

THE "TETRARCHIC" TRADITION (CUBICULUM O AND ITS GROUP)

In the second part of the catacomb, as in the first, there can be little doubt that the rooms were painted by one workshop; again, it is the figure style that shows this most clearly. The stylistic characteristics mentioned earlier apropos of the Crossing of the Red Sea in O—the boldness of conception; the use of large figures whose emphatic gestures, clearly silhouetted against the background, attract immediate attention; the firm, strong contours and the shallow space—are equally evident in the large-scale figural and scenic representations in the other rooms. To illustrate these interconnections it will suffice to point out a few additional key parallels: the distinct physiognomic resemblance between the female bust in the arcosolium of O (fig. 47)

34. See the catalogue of the exhibition *Les mosaïques romaines de Tunisie,* Brussels, 1964, no. 41, fig. 44. On the date of the house, see G.-Ch. Picard, "Deux sénateurs romains inconnus," *Karthago,* 4, 1953, 122f.; Suzanne Gozlan, "La maison de Neptune à Acholla-Botria (Tunisie)," *Karthago,* 16, 1971–72 (1973), 76f.

35. Felletti Maj, "Problemi cronologici," 36ff.; C.C. van Essen, "Studio cronologico," 174ff. See also the remarks of Giovanni Becatti on the transformations in domestic architecture in this period, "Case ostiensi," 102ff. and 197ff.

36. See below, chapter 5.

and the head of Tellus in E (fig. 48)—both have a similar oval shape and virtually identical features comparable down to the precise colors employed;[37] the recurrence of the gesture of the uplifted arm and extended hand in Tellus (fig. 48) and in the resting Jonah in M (fig. 29), or the covered and exposed hands of Samson in F, the Evangelist(?) in I and Moses in O;[38] and the repeated use of cusp-shaped shadows beneath the feet of standing figures like Samson, the Evangelist, the Soldiers in M, Hercules and Admetus in N, and Balaam in O (fig. 94). It is apparent that one workshop painted all of the rooms of the second part; upon closer examination it is also clear that in two important respects this workshop was set up differently from the one that operated in the first part of the catacomb.

To begin with, more painters were involved. This fact is hardly surprising, since cubicula D–O are more numerous and by and large more spacious than cubicula A–C. If we limit ourselves at first only to large figural painting, we may note three manners that emerge with particular clarity. The first is marked by an almost total absence of shading, giving the figures a curiously flat appearance as in the two lunettes in D and in the scene of Christ and the Samaritan Woman in F (fig. 49). The second, revealed in cubiculum I in the Philosophers, the Seasons (fig. 50), and the Orants, has to do with figures that have, by contrast, an almost physical presence generated by modeling with gradations of color. And in the third, as witness the Samson in F, the Evangelists and the figures in the lunettes in I, and the Persephone in O (fig. 91), modeling is welded to a two-dimensional structure so that figures seem made up of almost abstract geometric shapes. These manners embody artistic points of view sufficiently different from one another to suggest the activity of three painters in the large figural scenes of the decoration. But the possibility that other hands were involved cannot be excluded; indeed this would seem likely, given the fact that subgroups and variations—nearly impossible to classify—exist within the manners that can be clearly defined.

The second point has to do with the rest of the decoration. In contrast to what might be called the grand style of the large-scale representations, much of the remaining decoration, which includes the architectural framework and most of the decorative motifs, is rude and inept. The discrepancy between the two categories is illustrated, for instance, in comparisons between the figural motifs surrounding the rear arcosolium in F and the figures in the lunette; between the putti holding wreaths above the arcosolia in N (fig. 51) and the figures within or beside the arcosolia themselves (fig. 52); and between the putti on the side walls of Ih and the "Philosophical Discourse" in the lunette. In the former category violent brushwork obscures form, natural proportions are neglected, and several viewpoints are combined within one figure. Furthermore, the palette is limited to a few colors—brown, red, and green—with emphasis given to an especially muddy and opaque brown. The large-scale paintings have none of these qualities. Forms are clearly delineated with a sure brush, proportions and perspective are consistent, if not entirely rational, and the range of the palette is wide. Therefore it seems

37. On the identification of the bust in O, see Ferrua, *Le pitture*, 84. Similar busts occur in a tomb dated to the second quarter of the fourth century discovered in the Gargaresc district near Tripoli (A. Di Vita, "L'ipogeo di Adamo ed Eva a Gargaresc," *Atti del IX Congresso Internazionale di Archeologia Cristiana,* Rome, 1975 [= *Studi di Antichità Cristiana* 32], Vatican City, 1978, vol. 2, 199ff., fig. 21), and in a tomb in the Roman necropolis discovered on the Via Portuense (Aurigemma, "Colombari romani" [supra n. 7], 348ff., fig.

10). The figure of Tellus in E was originally identified by Ferrua as Cleopatra; *Le pitture,* 61. Margherita Guarducci suggested the more likely identification of Tellus ("La 'Morte di Cleopatra,' " 259ff.). Guarducci's identification has generally been accepted; see Josef Engemann, "Tellus," 147f., in reply to the objections of Josef Fink, "Ikonographische Miszellen," 163ff.

38. The identification of the standing figures in I is problematic; the meaning suggested here is based on the fact that the number of figures is four.

reasonable to conclude that the work within the rooms of the second part of the catacomb was divided between craftsmen painting in a grand style, who were apportioned the most significant part of the decoration, and their less skilled colleagues, who were assigned the rest.

This hierarchical organization need not imply a difference in time in the application of the various levels of decoration. The opposite, in fact, seems to have been the case. In cubiculum E, for example, where the decoration is remarkably well preserved, the figures on the left side of the room are painted over the decorative framework. This means that the framework was painted first and the figures second. On the right side of the room the framework overlaps the figures (left) or is interrupted by them (right), which means that the framework followed the figures.[39] In addition, the large head of Medusa on the vault in E is not centered within the frame that surrounds it—not a task, after all, that would have been difficult to accomplish— while the other elements of the design are correctly centered within their frames.[40] This can only mean that Medusa was painted first and the decorative surround afterward. At least two painters, therefore, worked on the room simultaneously, one beginning on the left side with the decorative framework and the other on the right side with the large figures. When they finished their sections they then crossed over to the other side of the room to complete the decoration. The figure painter, moreover, must have been quicker than his colleague because he was able to paint two surfaces (the right wall and the ceiling) to his colleague's one (the left wall).

The final point that emerges from all of this is obvious but worth articulating. A single, hierarchically organized workshop, larger than the one that operated in the first part of the catacomb, painted the rooms of the second part of the catacomb. As is well known, the themes of the second part, unlike those of the first, vary considerably from room to room: in D, E, half of I, and N they are pagan; in F, the other half of I, L, M, and O they are Christian. Thus the workshop of the second part functioned without regard to the religious content of its subject matter, although, as we shall see, its ties to Christianity were tenuous indeed.

Let us begin our analysis of these decorations, then, with the overall design of the rooms. As I mentioned earlier, architectural imagery predominates in cubiculum O. This is also the case for the other rooms of the second part which, like O, have walls covered with fictive marble revetment and vaults decorated, by and large, with painted coffers. These designs also seem in places to occupy real space. For instance, in cubiculum E the vault of the arcosolium is painted with grey and white squares that imitate deep coffers partly covered by shadow (see fig. 48) and the base of the socle around the room is decorated with lines that curve at the top, simulating the projection of the base from the wall.

In discussing these designs it will be useful to bear in mind the distinction made by Irving Lavin in a study of the early Constantinian painted ceiling at Trier.[41] Lavin observed that architectural imagery is used in Roman painting in two essentially different ways: on the one hand, to give the impression of a real architectural form, an actual structure that would be part of the room, as in the late first century B.C. painting from the House of the Griffins on the Palatine or, on the other hand, to create a fantasy realm where the laws of the real world do not pertain, as a mid-first-century A.D. decoration from the house of M. Lucretius Fronto in Pompeii (V,4,11) illustrates.[42] Lavin termed these approaches the structural and the non-structural. In the case of the second part of the Via Latina catacomb, the decoration clearly involves the structural approach.

39. Ferrua, *Le pitture,* pl. XLV.
40. Ibid., pl. XLIV.
41. Irving Lavin, "Ceiling Frescoes in Trier," 97ff.

42. Ibid., 106ff., fig. 31; Bernard Andreae, *The Art of Rome,* fig. 60.

In Rome and in the West generally, however, the structural style has always been considered something of an anomaly and its appearance in the fourth century the result of special circumstances. These circumstances have been defined in terms of influences from the Greek East and of the "Classical Revival" of the early Constantinian period. The argument, formulated by Gerke and Lavin, is based upon two assumptions: first, that in the Latin West the structural style lapsed with the passing of the Second Pompeian Style in the late first century B.C., while it continued in the Greek East as a living tradition through Late Antiquity; and second, that the structural style was characteristic of Roman painting in its "Classical" phase during the First and Second Pompeian Styles and that its reappearance in the early fourth century was in keeping with the "Classical Revival" of the early Constantinian period.[43] New evidence, however, has now come to light that compels us to revise these assumptions, for it yields a picture different from the one previously assumed in terms of both origins and motivations.

The first point concerns origins. There can be little doubt, as Gerke and Lavin have argued, that the structural style that arose in the West in the fourth century did not develop out of a local tradition. That the Western tradition up to the end of the third century was predominantly non-structural in orientation was convincingly demonstrated by Wirth, whose conclusions on this point were affirmed in Joyce's recent study.[44] Additional support comes from our analysis of cubicula A–C, which showed that the non-structural style was still vital in the first quarter of the fourth century in Rome.

In the East, the situation has never seemed so clear cut. To begin with, far fewer paintings have survived there, and with so little documentation it has been impossible to draw anything but the most rudimentary picture of development. Moreover, very little of the Eastern material has come from metropolitan areas. Rostovtzeff's studies, which have provided the essential basis for our understanding of Eastern painting, have centered on a group of tombs in southern Russia, and Gerke and Lavin have added examples from Palmyra, Silistra, Dura Europos, and Pécs, besides those from Alexandria.[45] We know that the provinces were conservative, some-

43. Lavin, "Ceiling Frescoes," 106ff. Friedrich Gerke, "Die Wandmalereien der neugefundenen Grabkammer," 125ff.; idem, "Die Wandmalereien der Petrus-Paulus Katakombe," 174.

44. Wirth, *RW*, esp. 97ff.; Joyce, *Decoration of Walls*, 66f.

45. Michael Rostovtzeff, *Ancient Decorative Painting in South Russia*, St. Petersburg, 1913–14, 2 vols. (in Russian). Rostovtzeff presented his conclusions in summary in "Ancient Decorative Wall Painting," 144ff. Lavin, "Ceiling Frescoes," 108f.; Gerke, "Die Wandmalereien der neugefundenen Grabkammer." Even so, in a recent study Harald Mielsch lamented the fact that so little is known about wall painting in the eastern Roman Empire ("Zur stadtrömischen Malerei," 151), echoing a remark Rostovtzeff himself made in his study of 1919 (144). See also, Rudolf Pagenstecher, *Nekropolis*, 168ff.; Achille Adriani, "La nécropole de Moustafa Pacha," *Annuaire du Musée Gréco-Romain d'Alexandrie*, 1933–34/1934–35 (1936), 113ff. Among the more or less recent discoveries in this area are a second–third-century hypogeum near Massyaf (Fernard Chapouthier, "Les peintures murales d'un hypogée funéraire près de Massyaf," *Syria*, 31, 1954, 172ff.); the lower terrace of the palace at Masada (M. Avi-Yonah, N. Avigad, Y. Aharoni, I. Dunayevsky, and S. Gutman, "The Archaeological Survey of Masada, 1955–56," *IEJ*, 7, 1957, 35ff., and Y. Yadin, "The Excavation of Masada, 1963–64," ibid., 15, 1965, 10ff.); a third-century Christian tomb in Alexandria (Henry Riad, "Tomb Paintings from the Necropolis of Alexandria," *Archaeology*, 17, 1964, 169ff.); a second-century tomb near Tyre (Maurice Dunand, "Tombe peinte dans la campagne de Tyr," *BMBeyr*, 18, 1965, 5ff.); fragments of frescoes from Kurnub dated to the "Late Roman" period (A. Negev, "Oboda, Mampsis and Provincia Arabia," *IEJ*, 17, 1967, 51f., pls. 9D and E, 10A and B, 11A); a fourth-century tomb at Or ha-Ner which contains an interesting series of portraits (Y. Tsafrir, "A Painted Tomb at Or ha-Ner," *IEJ*, 18, 1968, 170ff.); the third-century tombs at Anemurium (Elisabeth Alföldi-Rosenbaum, *Anamur Nekropolü/The Necropolis of Anemurium*, Ankara, 1971, 106ff.); a non-figural wall decoration in a Roman house at Knossos (L.H. Sackett and J.E. Jones, "Knossos: A Roman House Revisited," *Archaeology*, 32/2, 1979, 18ff.); and a second/third century pagan tomb in Jerusalem (A. Kloner, "A Painted Tomb on the Mount of Olives," *Qadmoniot*, 8, 1975, 27–30).

times notoriously so, preserving forms several generations out of date, so it seems unlikely that the material we have had at our disposal has given us a truly accurate picture of all major eastern trends and developments.[46]

Hence the importance of the wall paintings recently discovered at Ephesus and published by V.M. Strocka.[47] The paintings come from two apartment buildings (Hanghäuser) each housing several smaller units that expanded or contracted over the years in ways that often necessitated the renewal of the interior decoration. The result is that we now have in Ephesus not only a significant quantity of painting from a major eastern center, but also a sequence that can be more or less firmly dated on the basis of archaeological data from the first through the seventh century. On counts of both quantity and quality the evidence of Ephesus is unique. In our context, furthermore, it reveals two startling facts.

First, the painting in Ephesus that dates between the first and the third centuries bears witness to a phenomenon similar in principle to the one that occurred in the West during the same period, namely, the development of a non-structural style.[48] To cite only two examples: the design of the Socrates room (Hanghaus 2/Wohnung IV.7) dated to A.D. 60–80 closely resembles examples of Third Style painting from Rome and Pompeii, as Strocka himself has pointed out (moreover, the ornament in this decoration duplicates motifs also found in the House of the Vettii and the House of the "Amorini dorati" in Pompeii); in addition, the design of Hanghaus 2/Wohnung III.24 (fig. 53), dated to the early third century, presents a very close parallel to the band system as it is known in Rome and Ostia (fig. 54).[49]

When we survey the East with this development in mind, we find corroborating evidence in other places that had previously been overlooked. The change that Carl Kraeling noted at Dura, a progressive reduction of the architectural framework of wall painting from the Temple of Bel (late first century) to the later building of the Dura Synagogue (mid-third century), now has a context.[50] And so does the change within the successive phases of the Synagogue itself, from the early building, dated to the Late Antonine period, outfitted with a rich decoration of fictive marble revetment and illusionistic coffers (fig. 55) to the later building, dated to the mid-third century, where, by contrast, painted architecture is present only in residual form (fig. 56).[51] The architecture of the mid-third century occupies, relatively speaking, much less space within the overall decoration than before, and it is assembled with considerably less logic. For example, the columns in the corners of the room sit atop a frieze of biblical scenes and are thus suspended above the dado upon which they should logically rest.

The various levels of decoration in the portico of the Great Colonnade in Apamea reveal a parallel development.[52] The early painting, dated to the second century, is fictive marble

46. See, for example, the remarks of Joyce on the fate of garden paintings in the second and third centuries; *Decoration of Walls,* 57. Clearly this style had fallen out of fashion in the metropolis but not in the provinces.

47. Volker M. Strocka, *Die Wandmalerei der Hanghäuser in Ephesus;* see also the study of Werner Jobst on the mosaics of the Hanghäuser, *Römische Mosaiken aus Ephesus I. Die Hanghäuser des Embolos* (=*Forschungen in Ephesus* VIII/2), Vienna, 1977. A volume on the architecture of the two buildings is expected.

48. This is one of Strocka's essential conclusions; *Die Wandmalerei,* 141.

49. Ibid., 93ff., figs. 191–97 (H2.IV.7); 115f., figs. 263–65 (H2.III.24).

50. Carl Kraeling, *The Synagogue,* 69.

51. Ibid., 33ff.

52. Louis Reekmans, "Fresques des portiques de la Grande Colonnade," *Fouilles d'Apamée de Syrie, Miscellanea,* fasc. 6, ed. Janine Balty, Brussels, 1969, 117ff., pls. 47–50.

revetment; a later level dated to the third century shows a non-architectural pattern of red and green lines on a white ground. The excavators, in fact, have argued that the later decoration was based on the linear style known in third-century Rome, although the fragmentary condition of the frescoes does not permit a clear reading of the pattern of lines and there is otherwise no indication that the linear style occurred outside of Rome and its environs.[53] Nonetheless, the transition from the early to the late phase of decoration in the portico could hardly be more dramatic: it represents the change from a structural to a non-structural style of painting. Finally, on the basis of the Ephesus series, Strocka was able to re-date several paintings often cited as evidence of the continuity of the structural style in the Greek East during the Imperial period, notably those of the Kerch tombs of 1872, thus removing them from consideration altogether.[54] In the Greek East, therefore, there is now evidence of the widespread development of a non-structural style of wall painting. This evidence not only gives a more balanced picture of the Eastern tradition than had been obtained heretofore, but also makes it less likely that a fully illusionistic architectural style would have arisen naturally in the West through influence from the eastern Mediterranean in the early fourth century.

The second revelation of Ephesus is the decoration of a large room, b, in Hanghaus 1 (fig. 57).[55] The decoration, which survives only in part on three of the walls of the room, is divided into two zones above a low socle revetted with marble. The first zone shows a row of Corinthian columns that rest on high bases in between large, multi-colored panels; the second, a row of consoles that support compartments with distinctive circular and star-shaped insets. The decoration is thus structural and even illusionistic: both the consoles and the columns appear to project from the wall. But what makes this decoration particularly noteworthy is its situation at Ephesus. Like its Western counterparts in the structural style, it had, as we have already seen, no true precedents in the tradition of its own area. But it is earlier in date than these Western examples. The room in which the decoration is situated was created in a remodeling that also involved a change in the passageway between the peristyle and *oikos* of the apartment to which it belongs, and in this location a coin of Diocletian was found embedded in plaster.[56] Both the masonry of the walls of the apartment and the style of painting support the dating ca. 300 proposed by the excavators for the remodeling and the decoration of the room. It thus appears that the structural style emerged over a decade earlier in the East than in the West, but under similar circumstances, that is, as an innovative departure not at all in keeping with the tradition of the immediate past.

It would be difficult to piece together anything more of the story were it not for the evidence of decorations related in one way or another to the painting in room b of Hanghaus 1. This evidence comes principally from three sites: Thessaloniki, Luxor, and Piazza Armerina. The fact that the wall paintings discovered in the early 1960s in the Palace of Galerius in Thessaloniki are closely similar to the decoration of room b has already been recognized by Strocka.[57] At the time of their discovery these paintings were in poor condition, and since then they seem to have disappeared. But what we can glean from the published photographs and the excavation reports bears out Strocka's claim: the walls of the palace were divided into large and small fields separated by pilasters that stood on a high socle and were stippled to give the effect of marble.

53. Ibid., 120; Wirth, *RW*, 165ff.; Mielsch, "Verlorene römische Wandmalereien," (supra n. 1), 126ff.
54. Strocka, *Die Wandmalerei*, 36 n. 7.
55. Ibid., 31ff., figs. 2–17.
56. Ibid., 31, 36ff.

57. Ibid., 36. Stylianos Pelekanides, "Die Malerei," 216f., pl. CXI, figs. 1 and 2, pl. CXII, fig. 3; on the palace, see Michael Vickers, "Observations on the Octagon at Thessaloniki," *JRS*, 63, 1973, 111ff.

The Luxor decoration was executed in the time of Diocletian in a room dedicated to the imperial cult. It is now mostly lost, but much of it can be reconstructed on the basis of a series of water color sketches made by an English traveller, J.G. Wilkinson, in the nineteenth century and presently in the collection of the Ashmolean Museum.[58] The middle zone of the walls was occupied by a large frieze that showed two flanks of over-life size figures in procession moving from the door of the room toward figures of the Tetrarchs and the deities of the imperial cult at the rear (figs. 58 and 59).[59] Below that ran a high socle painted to imitate multi-color marble revetment cut in a pattern of roundels that are, with the exception of Ephesus and Piazza Armerina, as we shall presently see, otherwise without precedent in wall painting.[60]

Finally, there is the decoration of the Roman villa at Piazza Armerina. Although this decoration is quite extensive—there are traces of it in almost every room—it has received only scant notice in the voluminous literature on the villa.[61] In our context, however, only two points are important: the occurrence of the roundel motif (here on the exterior walls of rooms 42 and 43 [I use Kähler's numeration for the sake of convenience],[62] fig. 60), and the use of an overall wall design that was largely structural—with a socle painted to imitate marble (in room 7, the room of the "Adventus" mosaic),[63] a middle zone with columns (room 41) or rectangular, oval, and diamond-shaped panels of simulated marble (rooms 6, 9, 16, 21, 23, 24, 28, 30, 31, 34, 38, and 40–42; see fig. 61), and illusionistic elements in the form of over-life size figures obviously intended to impersonate statues (rooms 7 and 8 [the peristyle court]). The wall to the right of the triple-gated entrance is also decorated with a long vertical strip placed beside the figure of a horse. The strip (a pilaster?) contains circular and square panels, the best preserved of which shows a head painted in yellow-green suggesting that it was meant to imitate a bronze appliqué.

All of these decorations are thus closely related to one another. They make use of patterned marble revetment and other architectural motifs with illusionistic devices; hence they are, like

58. Ashmolean Museum, Oxford, The Griffith Institute, Wilkinson MS I.51–62. Johannes G. Deckers, "Die Wandmalerei des tetrarchischen Lagerheiligtums im Ammon-Tempel von Luxor," RQ, 68, 1973, 1ff.; idem, "Die Wandmalerei im Kaiserkultraum von Luxor," JdI, 94, 1979, 600ff.; Ioli Kalavrezou-Maxeiner, "The Imperial Chamber at Luxor," DOP, 29, 1975, 227ff.

59. Deckers corrects Kalavrezou-Maxeiner's misapprehension of the nature of the figural frieze. The figures of the frieze did not move in a single line in one direction across the side walls of the room as Kalavrezou-Maxeiner suggests (237f.), but formed two flanks of a procession that began at the entrance and converged on the rear of the room.

60. A similar pattern of roundels appears in the painted decoration of three tombs (M5, M6, and M22) in Hermopolis West; see Günter Grimm, "Tuna el-Gebel, 1913–1973," MDIK, 31, 1975, 221ff., pls. 68–71. The majority of tombs in the complex to which these three examples belong are dated by Grimm after the mid-second century, although the author admits that the chronology here has yet to be firmly established (231ff.). Given the fact that the tomb paintings closely resemble the Diocletianic decoration of Luxor, a date for them in the late third century seems likely. See also Rostovtzeff, Ancient Decorative Painting, pls. 68–70, 72, 74, 75.4, and 78, for a similar, though not identical,

pattern. On the date of these paintings, see n. 54. The roundel design, however, is paralleled on pavements (see Paolino Mingazzini, L'insula di Giasone Magno a Cirene, Rome, 1966, pls. 20 and 21), and in metalwork, as witness a large fourth-century pewter plate, unpublished, found in a hoard in Appleford, Berkshire, and now in the Ashmolean Museum on loan from the Amey Roadstone Corporation.

61. Substantial remains of painting are found in rooms 6–9, 16–18, 20, 21, 23, 24, 28, 30–32, 34, 38, 40–42, and on the exterior walls of the triple-gated entrance and rooms 32 and 43. Although these paintings have never been published I am informed that a full treatment by Mariette de Vos will soon appear in a complete photographic survey of Piazza Armerina edited by Andrea Carandini. (The study has since appeared: Andrea Carandini, Andreina Ricci, and Mariette de Vos, Filosofiana, La villa di Piazza Armerina: Immagine di un aristocratico romano al tempo di Constantino, 2 vols., Palermo, 1982, but it is not yet available to me.) See also Heinz Kähler, Die Villa des Maxentius, pl. 35a, and R.J.A. Wilson, Piazza Armerina, New York, 1983, 32f.

62. Kähler, Die Villa des Maxentius, fig. 3 (plan).

63. On the "Adventus" mosaic, see H.P. L'Orange, "The Adventus Ceremony and the Slaying of Pentheus as represented in two Mosaics of about A.D. 300," in his Likeness and Icon, 174ff.

the Ephesus murals, structural in design. Also, as was the case at Ephesus, none of them can be derived from a local tradition. There is no precedent in wall painting for one of the motifs favored in these designs, the roundels that contain intricate patterns. Nor is there, to my knowledge, a parallel in wall painting of the third century to the arrangement of pilasters and panels of marble revetment found at Thessaloniki, Ephesus, and Piazza Armerina.[64] It is also appropriate to mention here the possibility of thematic interconnections that would complement these formal relations. The remarkable, and to my mind unprecedented, frieze of over-life-size figures in the peristyle and the entrance at Piazza Armerina evokes the spirit if not the form of the procession at Luxor.[65]

But perhaps the most compelling consideration concerns the circumstances in which these decorations were made. With two of the sites, Thessaloniki and Luxor, we are on firm ground. The paintings at Thessaloniki were executed in the Palace of Galerius, a building belonging to the years 292–305. The decoration at Luxor dates to the period 300–309, during which Diocletian transformed the Temple of Ammon into a tetrarchic camp complete with a room dedicated to the imperial cult, precisely the room where our decoration was situated. Imperial patronage of the room at Ephesus cannot be proved, although the abundance of simulated porphyry in the decoration, together with the lavishness of the painting and the grand size of the room, would place the ensemble in at least an aristocratic context. As for Piazza Armerina, the date and the patron have been the subject of a debate that cannot be properly summarized let alone fully evaluated here.[66] Nonetheless a few key points should be noted. First, Carandini's stratigraphic survey has determined that the villa, except, possibly, the triconch, was built in a single operation between the years 300 and 320.[67] Wilson's systematic investigation has affirmed the preeminent position of Piazza Armerina: it is larger and far more luxurious than any other contemporary villa, including the two recently discovered in Sicily, both probably of the fourth century.[68] And finally, Kitzinger's study of Late Antique style has set forth a plausible context for the mosaics of the villa ca. 300 on the basis of what seem to be incontrovertible comparisons.[69] Taken together, these observations strongly suggest an early-fourth-century patron of high position for the villa, though whether he was a tetrarchic emperor, as some have suggested, or a Roman aristocrat is an open question.[70]

64. See above, pp. 37–38.

65. In this respect, both decorations, in turn, are related to the painting of the so-called Domus Faustae in Rome; see below, chapter 5, p. 74, n.18. There are, however, other examples of groups of figures standing in an architectural setting, such as the early-third-century decoration discovered on the Via dei Cerchi at the foot of the Palatine Hill; see Mrs. Arthur Strong, "Forgotten Fragments of Ancient Wall-Paintings in Rome," *BSR*, 8, 1916, 91ff.; Wirth, *RW*, 126, pls. 29, 30.1; Michelangelo Cagiano de Azevedo, "Osservazioni sulle pitture di un edificio romano di via dei Cerchi," *RendPontAcc*, Serie III, 23–24, 1947–49 (1950), 253ff., whose dating ca. 220–40 is predicated, in part, upon an incorrect dating of the Hypogeum of the Aurelii; Dorigo, *Pittura tardoromana*, 72, fig. 48; Joyce, *Decoration of Walls*, 54f., fig. 54.

66. Two studies have recently attempted to summarize the vast literature on the villa: Katherine M.D. Dunbabin, *The Mosaics of Roman North Africa*, 196ff., 243ff., and Wilson, *Piazza Armerina*, passim.

67. Carmine Ampolo, Andrea Carandini, Giuseppe Pucci, and Patrizio Pensabene, "La villa del Casale a Piazza Armerina," 141ff. Dunbabin has expressed unnecessary skepticism about the use of *terra sigillata chiara*, one of the cornerstones of Carandini's chronology, for the dating of the villa. On this problem, see also Wilson, *Piazza Armerina*, 34ff.

68. Ibid., esp. 73ff. See also Salvatore Settis "Neue Forschungen und Untersuchungen zur *Villa* von Piazza Armerina," *Palast und Hütte. Beiträge zum Bauen und Wohnen im Altertum von Archäologen, Vor-und Frühgeschichtlern*, ed. Dietrich Papenfuss and V.M. Strocka, Mainz am Rhein, 1982, esp. 524ff.

69. Kitzinger, *Byzantine Art*, 9.

70. See, for example, most recently, Giacomo Manganaro, "Die Villa von Piazza Armerina, Residenz des kaiserlichen Prokurators, und ein mit ihr verbundenes Emporium von Henna," *Palast und Hütte*, 493ff.

The related decorations of Ephesus, Thessaloniki, Luxor, and Piazza Armerina thus give evidence of a style of painting that cannot be derived from any single local tradition, that appears simultaneously in diverse locations ca. 300, and that occurs everywhere in an imperial or aristocratic milieu. There seems to be only one source that could readily account for these phenomena: the tetrarchic court. Only the court had the resources to create such a style and the diversity of location, mobility, and interest—for it devoted enormous efforts towards creating new and imposing settings wherever it was situated—to spread it. But are we then to imagine this style arising independently in several different locations? Our evidence would suggest otherwise, for it points unmistakably to the East, where, in fact, Diocletian, the founder and guiding spirit of the Tetrarchy, had his capital. And although this capital, Nicomedia, has been effaced, the literary record is clear on one point: it was a prime focus of the emperor's ambitions. Testimony to this effect, though admittedly highly prejudiced, comes from Lactantius' pamphlet, "On the Deaths of the Persecutors":

> To this there were added a certain endless passion for building, and, on that account, endless exactions from the provinces for furnishing wages to labourers and artificers, and supplying carriages and whatever else was requisite to the works which he projected. Here public halls, there a circus, here a mint, and there a workshop for making implements of war; in one place an habitation for his empress, and in another for his daughter. Presently a great part of the city was quitted and all men removed with their wives and children, as from a town taken by enemies; and when those buildings were completed, to the destruction of whole provinces, he said, "They are not right, let them be done on another plan." Then they were to be pulled down, or altered, to undergo perhaps a future demolition. By such folly was he continually endeavouring to equal Nicomedia with the city of Rome in magnificence.[71]

As Diocletion's new Rome, Nicomedia, then, could properly be imagined as the source of a new style of painting invented in the tetrarchic court.

It remains now to discuss the purpose of this new style. For Lavin the main motivation behind the appearance of the structural style of painting in the West in the early fourth century was revival, and there can be little doubt that this was the case.[72] Revival was embodied above all in the decoration of the Trier room, whose closest parallels are found in the early period of Roman painting, in the First and Second Pompeian Styles. But revival was also a factor in the earlier manifestation of the structural style ca. 300. The composition employed at Ephesus, Thessaloniki, Piazza Armerina and, later, Trier—where the wall is divided into sections by pilasters and the intercolumniations are filled with large panels that show marble revetment (Ephesus, Thessaloniki, Piazza Armerina) or figures (Trier)—has a rather clear history. It is common in the period of the Second Style, as witness the exceptionally lavish example in the House of the Griffins on the Palatine dated to the late first century B.C., where columns appear to stand on projecting plinths in front of a wall covered with cut variegated marble.[73] But it

71. Lactantius, *De mortibus persecutorum*, 7.8ff. trans William Fletcher, Edinburgh, 1871, 169f. See also the commentary of J. Moreau, *De la mort des persécuteurs* (=*SC* 39), Paris, 1954, 235f. On the date of the work, see Timothy D. Barnes, "Lactantius and Constantine," *JRS*, 63, 1973, 29ff.

72. Lavin, "Ceiling Frescoes," 107, 113 n. 53.

73. Giulio Rizzo, *Le pitture della "Casa dei grifi"* (=*Monumenti della pittura antica scoperti in Italia*, Sez. 3, *La pittura ellenistico-romana*, Roma, fasc. I), Rome, 1936, 9ff., pls. A, C, I–III, V–VI. On the development of the Second Style, see H. G. Beyen, *Die pompejanische*

also occurs earlier, as a hellenistic house in Centuripe illustrates with its simpler arrangement of columns above a flat socle in between painted marble panels.[74] With the passing of the Second Style or sometime soon thereafter, however, the design must have fallen out of fashion in painting; at least examples of it are most rare, especially from the late second and third centuries, and none of them even distantly resembles the schemes employed by tetrarchic painters that are so close to Second Style designs.[75] Hence the appearance of this scheme in the group we have isolated in the late third/early fourth century implies a revivalist trend.

My hypothesis that this revivalist trend originated in the ambient of the tetrarchic court, however, raises a serious problem. That such a phenomenon would have been at home in the Constantinian period is clearly indicated by other evidence, as for instance the early portraits of Constantine, themselves strongly revivalistic, replete with obvious reminiscenes of Trajanic models (fig. 62).[76] The turning back to early sources in the arts was so widespread, in fact, that Constantine's reign is generally considered to be a period of "Classical Revival," a revival, in turn, spurred on, as some have suggested, by the emperor's politics.[77] To place such a harking back in painting ca. 300, however, is to locate the phenomenon in another period altogether. To take the example of imperial portraiture again, images of the Tetrarchs, far from being consciously "classicizing," are said to embody exactly the opposite quality, the subversion of classical values (fig. 63).[78] Their primitive aspect is most striking: individual forms are rendered as simple geometric shapes which are joined together to make figures and objects; details are abbreviated and incised rather than modeled; compositions are mathematically regular. The problem, then, is to reconcile the apparent revival aspect of wall painting with what is known about sculpture from the period ca. 300 generally.

It is interesting to note first that the primitive style of sculpture during the Tetrarchy was, like painting, an issue of the imperial court. It appeared sometime in the late third century (an exact date cannot be determined) and was used in official monuments that portrayed the emperor—coins, statues and reliefs—like the porphyry Tetrarchs in Venice dated to ca. 300

Wanddekoration vom zweiten bis zum vierten Stil, The Hague, 1938, vol. I, 37ff.; Josef Engemann, *Architekturdarstellungen des frühen zweiten Stils* (=*RM* Ergänzungsheft 12), Heidelberg, 1967; R. Winkes, "Zum Illusionismus römischer Wandmalerei der Republik," *Aufstieg und Niedergang der römischen Welt,* I.4, Berlin-New York, 1973, 927ff.; Klaus Fittschen, "Zur Herkunft und Entstehung des 2. Stils—Probleme und Argumente," *Hellenismus im Mittelitalien, Kolloquium in Göttingen vom 5. bis 9. Juni, 1974,* Göttingen, 1976, 539ff.

74. Maurizio Borda, *La pittura romana,* 20 (with illustration).

75. My findings concur with those of Strocka, *Die Wandmalerei,* 36 n. 7. The mid-second-century paintings discovered at St. Albans (Verulamium), England, in Insula XXVIII, Building 3, preserve—if the excavators' dating is correct—one of the few surviving examples of the design before the tetrarchic period; see Norman Davey and Roger Ling, *Wall Painting in Roman Britain,* Gloucester, 1982, 184ff., pl. XCII. See also at Ostia the early third-century decoration of room VIII of the Inn of the Peacock (Carlo Gasparri, *Le pitture della Caupona del Pavone,* 18ff., fig. 15, pls. IV, VI, VII), the third phase of rooms VII and VIII of the House of the Yellow Walls, dated ca. 238–51 (Bianca Maria Felletti Maj, *Le*

pitture delle case delle volte dipinte, 46ff., fig. 25, pls. XII, XIII.1–2), and the decoration of Room E of the mid-third-century Insula of the Eagle (see Joyce, *Decoration of Walls,* 56, although the decoration may be later than the building in date). These designs are discussed by Joyce under the heading "Architectural System" (50ff.), although most of them are not, properly speaking, architectural schemes in the manner of the Second Style. The design of pilasters and panels was continued in opus sectile during this period, but, apparently, only sporadically; see Otfried Deubner, "Expolitio. Inkrustation und Wandmalerei," 22ff., fig. 4, pl. 4; P. Asimakopoulou-Atzaka, *He technike* opus sectile *sten entoichia diakosmese,* Thessaloniki, 1980.

76. Maria R. Alföldi, *Die constantinische Goldprägung,* 57ff.; Evelyn B. Harrison, "The Constantinian Portrait," 79ff.; Wilhelm von Sydow, *Zur Kunstgeschichte,* 45ff.

77. Ibid., 49ff.

78. Ibid., 5ff.; H.P. L'Orange, *Studien zur Geschichte,* 28ff.; Marianne Bergmann, *Studien zum römischen Porträt des 3. Jahrhunderts n. Chr.* (=*Antiquitas* 18), Bonn, 1977, 138ff.; Kitzinger, *Byzantine Art,* 7ff.; Cornelius Vermeule, "Tetrarchs True and False. The Cubistic Style," in his *Iconographic Studies,* Boston, 1980, 59ff.

(fig. 63) or the reliefs on the Arch of Constantine, ca. 315, that tell of Constantine's victory over Maxentius and of his first activities in Rome (fig. 64).[79] In sculpture, as in painting, moreover, the emergence of this style constituted an abrupt departure from the norm. No official work before this time had appeared in the primitive style.[80] It is possible, therefore, that the style in both sculpture and painting had a rationale and a message.

Previous interpretations of primitive tetrarchic sculpture, including the reliefs made for the Arch of Constantine, have emphasized three factors; since these have been dealt with at length elsewhere only brief mention of them now need be made.[81] The first interpretation is based on the notion of widespread decline.[82] It holds that sculptors of the period lacked the skill to carve in the complex classical style and therefore opted for simpler forms and easier techniques. But ample evidence counters this hypothesis. The reliefs made for Arcus Novus of Diocletian, for example, prove that late-third-century sculptors had both the wherewithal and the opportunity to carve in the classical style, although they apparently did so in a somewhat academic manner.[83] A second interpretation has sought to clarify the primitive style by drawing attention to its roots in the art of the subantique, including works made for plebeian and provincial contexts.[84] Doubtless such subantique forms were among the sources used by tetrarchic sculptors, if indeed the sculptors themselves were not of the subantique realm.[85] But as we shall see, to accept this connection as valid does not compel us to assume that the primitive style was taken over by the emperor because of its proletarian connotations. Such an interpretation, it seems, would find little support among historians of Roman political ideology.[86] A third interpretation, espoused principally by L'Orange, holds that the tetrarchic style in sculpture, with its emphasis on stiff and symmetrical forms, embodied a tetrarchic view of the world, which also found expression in architecture—in Diocletian's Palace in Split, for example, with its symmetrical layout and blocky forms—and law, as witness Diocletian's price edict that imposed an unyielding order on the functions of society.[87] But there is one fundamental point

79. For the porphyry figures in Venice, see Bergmann, *Studien zum römischen Porträt*, 163ff.; Antonino Ragona, *I tetrarchi dei gruppi porfirei di S. Marco in Venezia*, Caltagirone, 1963. The argument of Michelangelo Cagiano de Azevedo against the identification of the figures as Tetrarchs is unconvincing; see "I cosidetti tetrarchi di Venezia," *Commentari*, 13, 1962, 160ff., and the reply of H.P. L'Orange, "Nuovo contributo allo studio del Palazzo Erculio di Piazza Armerina," *Acta ad archaeologiam et artium historiam pertinentia*, II, 1965, 84ff. For the Arch of Constantine, see H.P. L'Orange and A. von Gerkan, *Der spätantike Bildschmuck des Konstantinsbogens*. On the numismatic evidence, see Herbert A. Cahn, "Kunstgeschichtliche Bemerkungen zu Diocletians Münzreform," *Gestalt und Geschichte, Festschrift Karl Schefold*, Bern, 1967, 91ff.; Cornelius Vermeule, "Maximianus Herculeus and the Cubist Style in the Late Roman Empire, 295 to 310," *Boston Museum Bulletin*, 60/319, 1962, 9ff.; Patrick Bruun, "The Successive Monetary Reforms of Diocletian," *ANSMN*, 24, 1979, 129ff.

80. Hans von Schönebeck, "Die christliche Sarkophagplastik unter Konstantin," *RM*, 51, 1936, 256f. The style of these works, however, was the result of a profound re-orientation of classical art; see Kitzinger, *Byzantine Art*, 14ff.

81. Kitzinger, *Byzantine Art*, 8ff.

82. Bernard Berenson, *The Arch of Constantine or the Decline of Form*, London, 1954.

83. Heinz Kähler, *Zwei Sockel eines Triumphbogens im Boboligarten zu Florenz*, Berlin-Leipzig, 1936; Michelangelo Cagiano de Azevedo, *Le antichità di Villa Medici*, Rome, 1951, 44 (no. 16), 48 (no. 22), pls. XVII–XVIII. Cagiano de Azevedo argues that Diocletian's arch on the Via Lata was composed of spolia like Constantine's.

84. Ranuccio Bianchi Bandinelli, *Rome. The Late Empire*, 73ff.; Kitzinger, *Byzantine Art*, 11ff. On the subantique tradition, see Bianca Maria Felletti Maj, *La tradizione italica nell'arte romana*, Rome, 1977.

85. Hugo Brandenburg, "Stilprobleme der frühchristlichen Sarkophagkunst Roms," 447ff.; idem, "Ars Humilis. Zur Frage eines christlichen Stils in der Kunst des 4. Jahrhunderts nach Christus," *JbAChr*, 24, 1981, 73f.

86. Timothy D. Barnes, *Constantine and Eusebius*, Cambridge, MA, and London, 1981, 3ff., and the companion documentary volume, idem, *The New Empire of Diocletian and Constantine*, Cambridge, MA, and London, 1982; William Seston, *Dioclétian et la tétrarchie*, Paris, 1946.

87. H.P. L'Orange, *Art Forms and Civic Life*.

that this interpretation does not explain. If the primitive style was a direct expression of the Tetrarch's personality and beliefs, why would Constantine, the nemesis of the Tetrarchs, have taken over this style for his arch?[88] Admittedly, this was the only monumental use Constantine made of the primitive style, but it could hardly be attributed to inadvertence. Either the emperor or his advisors carefully controlled the design of the arch, as witness the sculptures it incorporates from monuments dedicated to Trajan and Hadrian. References to these earlier emperors must have been, in some sense, programmatic, since they recur on coins and in sculpture throughout the early Constantinian period.[89] In any event, none of these interpretations has taken into account both the primitive style of sculpture and the structural style of painting that we now know to be its virtual contemporary in date.

It seems to me that the single major problem with prior interpretations is that they have attempted to categorize the tetrarchic style in terms—"anti-classical," "proletarian," and "totalitarian"—that could hardly have been viable in Late Antiquity. It would be well to discard these terms and to return to the original context of the style. In my view this context yields an unambiguous answer to our question of meaning; it is an answer, moreover, that finds agreement in Kitzinger's notion of the "Roman values of a bygone age."[90] Kitzinger lamented the fact that his notion, however, was bound to remain uncorroborated.[91] No ancient source speaks about the contemporary perception of the tetrarchic style. It is to this problem specifically that the following remarks are devoted.

In attempting to understand the meaning of Late Antique style, and especially the meaning of the primitive style of the late third/early fourth century, scholars have neglected Roman writings on art as a source, perhaps because they contain no explicit explanation for tetrarchic developments. The evidence they offer is indeed less direct but worth pondering nonetheless. A case for interpretation may be predicated on the fact that these writings, which come from many different periods and contexts, hold so similar a view of art that, as J.J. Pollitt has argued, they seem to reflect a broad and coherent notion of artistic development that was a commonplace in antiquity.[92] It is a notion that involves not only the concept of artistic periods, but also of period styles, and herein lies its greatest significance in our context. The salient characteristics of the primitive style of the late third and early fourth centuries—the rude handling of form, the simplification, the hardness and the angularity—are the very qualities ascribed to ancient sculpture, either Greek, Roman, or Italic, by classical writers. Cicero, and Quintillian after him, used the traits of rudeness (*durus*) and stiffness (*rigidus*) that they saw in ancient sculpture to describe ancient Roman oratory.[93] Similarly, Lucian employed the Greek equivalent of the Latin *durus*, σκληρός, as a stylistic designation to cover the same period of antiquity.[94] Ancient art was thought to be simple—Plutarch reports that "a bronze statue of [Porsenna] used to stand near the Senate House, of simple [ἁπλοῦς] and archaic [ἀρχαϊκὸς] workmanship"—as well as compact, spare, and crude.[95] It was also known that poses of

88. See Ernst Kitzinger's review of L'Orange in *ArtB*, 49, 1967, 350f., and idem, "On the Interpretation of Stylistic Changes," 7f. (in *The Art of Byzantium*, 38f.).

89. Harrison, "The Constantinian Portrait," 99f.; Von Sydow, *Zur Kunstgeschichte*, 22ff., 44ff.; Alföldi, *Die constantinische Goldprägung*, 57ff.

90. Kitzinger, *Byzantine Art*, 12.

91. Idem, "On the Interpretation," 6.

92. J.J. Pollitt, *The Ancient View of Greek Art:* *Criticism, History and Terminology*, New Haven, 1974, esp. 66ff., 73ff. See also Pollitt's earlier study, "Professional Art Criticism in Ancient Greece," *GBA*, 64, 1964, 317ff.

93. Cicero, *Brut.* 70; Quintillian, *Inst.* 12.10.7.

94. Lucian, *Rh. Pr.* 9.

95. Plutarch, *Publicola* 19.6 (The translation cited here is from the edition of Bernadotte Perrin, New York, 1927); Demetrius, *Eloc.* 14; Pausanias, 10.38.7.

ancient figures lacked torsion and that ancient sculptors left no space between the fingers of the hand.[96] In painting, a similar situation pertains. The use of marble incrustation was known to be an ancient invention and the use of architectural motifs, an ancient style: "Hence the ancients who first used polished stucco began by imitating the variety and arrangement of marble inlay; then the varied distribution of festoons, ferns, colored strips. Then they proceeded to imitate the contours of buildings, the outstanding projections of columns and gables."[97] Both of these features, fictive architecture and revetment, were, of course, important aspects of the structural style that appeared in the tetrarchic court ca. 300.

Against the background of these concepts the existence of genuinely ancient works of art in the late third/early fourth century need not have been an issue—though it could hardly be denied that such works were available—nor would it be necessary to assume that ancient works were always recognized as such at that time. If a particular patron of the later third century was interested in creating a work of art in an "ancient style" he would only have to avail himself of what was, after all, simply common knowledge among educated men, and then choose the appropriate artist to translate into reality his understanding of antiquity based on the critical tradition.[98] Conceivably artists working in a subantique style would have been selected to recreate what was known to have been the primitive style of antiquity because of their ability to render such a style, and not because of any class associations their work carried. It is thus possible that the concept of an ancient style was drawn upon in the late third and early fourth centuries to create new and yet uniquely "ancient" forms of sculpture and painting. Or perhaps it would be more accurate to suggest that this concept gave focus to the larger ambitions of renewal that were born and flourished in the tetrarchic court.

From the standpoint of matters other than style, evidence of these ambitions is revealed at every turn. Tetrarchic propaganda is littered with references to early Rome.[99] Panegyricists consistently cite ancient Romans, such as Scipio Africanus, as precedent and model for the emperor, to the near exclusion of any figure from the imperial period.[100] The religious activities of Diocletian and Maxentius were saturated with references to ancient origins.[101] Furthermore, the Tetrarchs focused upon the area in and around the Old Forum to an extent unparalleled before or after them.[102] At their hands the venerable *centro storico* of Rome underwent an extraordinary transformation. What still remains today is considerable: the Decennalia base, the Curia, the "Temple of Romulus," the Basilica of Maxentius and Constantine, and the Temple of Venus and Rome. An obsession with archaic heroes, antique rites, and ancient sites is also manifest in other parts of the empire.[103] In this context then, the tetrarchic style of wall design

96. Pliny, *NH* 35.158 (see Pollitt, *Ancient View*, 372–73); Philostratus, *VA* 4.28.

97. Vitruvius, *De Arch.* 7.5.1–2; Pliny, *NH* 36.47ff. See also T. Dohrn, "Crustae," *RM*, 72, 1965, 126ff.

98. For the larger context of the usage argued here, see E.H. Gombrich, "The Debate on Primitivism in Ancient Rhetoric," *JWarb*, 29, 1966, 24ff.

99. Jean Gagé, "Le 'Templum Urbis' et les origines de l'idée de 'Renovatio,'" *Mélanges Franz Cumont* (=*AIPHOS* IV), Brussels, 1936, 164ff.; Peter Brown, *The Making of Late Antiquity*, 50f.

100. Édouard Galletier, *Panégyriques latins*, 3 vols., Paris, 1949–1955; François Burdeau, "L'empereur d'après les panégyriques latins," *Aspects de l'empire romain*, Paris, 1964, 1ff.; Sabine MacCormack, "Latin Prose Panegyrics: Tradition and Discontinuity in the Later Roman Empire," *Revue des études augustiennes*, 22, 1976, 29ff.

101. MacCormack, "Latin Prose Panegyrics," 52; H.P. L'Orange, "Ein tetrarchisches Ehrendenkmal auf dem Forum Romanum," *RM*, 53, 1938, 30ff.

102. Heinz Kähler, *Das Fünfsäulendenkmal für die Tetrarchen auf dem Forum Romanum* (=*Monumenta Artis Romanae* III), Cologne, 1964, 30f. Richard Krautheimer has stressed the "spirit of renewal" in tetrarchic building in Rome; *Rome; Profile of a City, 312–1308*, Princeton, 1980, 7f. And Ward Perkins has described its conservative character; Axel Boethius and J.B. Ward Perkins, *Etruscan and Roman Architecture*, Baltimore, 1970, 500.

103. Beak Brenk, "Die Datierung der Reliefs," 238ff. Brenk cites important numismatic evidence of Diocletian's concern with the past.

and the primitive style of tetrarchic sculpture may be seen as the embodiment of and setting for intellectual and political aspirations.

As a coda to this interpretation, a solution may be outlined to the problem to which I alluded earlier. Art historians have long been puzzled by the composite nature of the Arch of Constantine (fig. 65). Old sculptures taken from monuments that belonged to Trajan, Hadrian, and Marcus Aurelius were employed side by side with new reliefs executed in the primitive style of the early fourth century. Yet no attempt was made to bring the various parts into a unity.[104] I suggest that this arrangement be understood primarily in terms of the political message encoded in the reliefs, part of which scholars have already elucidated. The use of sculptures belonging to Trajan, Hadrian, and Marcus Aurelius stressed Constantine's membership in the company of noble emperors and his role as continuator of the Roman tradition.[105] In this respect, Constantine employed a theme that had roots in the third century.[106] But by representing the events of the present day—the narrative of the relief band—in the primitive style, Constantine appears to have made a new and more profound point: that *his* rule was to be the true renewal of the greatness of Rome's ancient origins.

The fourth-century structural style of painting may thus be given a meaningful place within the ambient of the tetrarchic court. That it was indeed the ultimate progenitor of the style of the second part of the catacomb is supported when we turn to the other major aspect of the decoration, figure style. While the coarse style of the decorative motifs in cubicula D–O of the Via Latina catacomb was almost certainly a creation of mid-century, the grand style of the large-scale figural scenes had its roots in the tetrarchic period. This style, moreover, appears in the cult room at Luxor and in the villa at Piazza Armerina, both of which give evidence of a tetrarchic style of wall design.

Among the surviving fragments of painting at Luxor is a group of heads whose pure oval shape and careful modeling find a parallel in Samson's enemies in F and the crowds in the Crossing of the Red Sea and the Raising of Lazarus in O (figs. 3 and 5).[107] Similar comparisons can be made with Piazza Armerina, though here the primary testimony is not wall painting but mosaic.[108] The head of a servant in the Great Hunt mosaic in the villa (fig. 66) is almost identical in shape, features, position, and hairstyle to the head of Christ in the scene of the Samaritan Woman at the Well in F (fig. 67), and very close to the head of Moses in the Crossing of the Red Sea in O (fig. 3).[109] Beside the Piazza Armerina servant stands another figure (fig. 68) which is also clearly related to the Samaritan Woman flanking Christ in F (fig. 69).[110] Finally, the foremost of Samson's enemies, shown wounded and running from the hero with his arms outstretched in a meaningless gesture, resembles a figure from the Great Hunt whose gesture makes sense, for he is shown preparing the sail on a boat.[111]

104. Certain heads on the older reliefs, however, were recarved to resemble Constantine and his father, Constantius Chlorus; see Raissa Calza, "Un problema di iconografia imperiale sull'arco di Costantino," *RendPontAcc*, Serie III, 32, 1959–60, 133ff.

105. *Age of Spirituality*, 67ff., s.v. "North Facade of the Arch of Constantine." On the significance of the location of the arch, see Heinz Kähler, "Konstantin 313," *JdI*, 67, 1952, 3.

106. Von Sydow, *Zur Kunstgeschichte*, 49ff.

107. Deckers, "Die Wandmalerei im Kaiserkultraum" (supra n. 58), figs. 22 and 23.

108. According to my observations, only a few painted figures in the villa have survived, and these in rooms 7 (remains of figures above socle), 8 (figures with shields), 17 (putti), 18 (putti), 23(?), 28(?), 31 (two figures), and 34 (traces of figures).

109. Biagio Pace, *I mosaici di Piazza Armerina*, fig. 23; Ferrua, *Le pitture*, pls. CIII, CXV. See also the study of Andrea Carandini, *Ricerche sullo stile e la cronologia dei mosaici della villa di Piazza Armerina* (= *Studi Miscellanei* 7), Rome, 1964, where other comparisons between Piazza Armerina and the Via Latina catacomb are made (27ff., 62ff., pls. V.2 and 4, VI.1 and 2, VII.1 and 2, XXI.1–4, 6).

110. Gino Gentili, *La villa erculia di Piazza Armerina*, pl. XXVI; Ferrua, *Le pitture*, pl. CIII.

111. Gentili, pl. XXV; Ferrua, *Le pitture*, pl. CV.

But above and beyond instances of specific similarity there are more general and yet deeper interconnections between these monuments. Admittedly, in apparent contrast to Luxor (where, after all, less has survived), Piazza Armerina is far from perfectly homogeneous in style.[112] This situation has been attributed to such factors as differences in workshop practice, individual personality, and iconographic model.[113] Nonetheless, the mosaics of the villa have certain overriding stylistic characteristics that are clearly relevant to the decoration of D–O. Figures, taken individually, seem firm, hard, and schematic; grouped together, they occupy a space that is fragmented into many separate planes.[114] The latter point can even be illustrated with what is known about the scanty remains of Luxor from Wilkinson's water color sketches. The densely packed procession on the left wall of the cult room seems at first as a complex grouping that occupies a deep, amorphous space.[115] But upon closer examination, it is apparent that this complex grouping is actually constructed on the basis of a simple alternation of a type of soldier with tethered horse, exemplified in the statues of the Dioscuri that once ornamented the Baths of Constantine and now stand beside the Quirinal Palace in Rome.[116] This figure type is arranged facing first left, then right, in a shallow plane. The rigid arrangement of the figures on the rear wall of the room, moreover, calls to mind the composition of the reliefs of the *Adlocutio* and the *Largitio* on the Arch of Constantine.[117]

The mention of the Arch of Constantine, however, raises an important question: Can the figure style that appears in Piazza Armerina and Luxor be considered a tetrarchic innovation, in the sense of the primitive style of tetrarchic sculpture that was also employed on the Arch of Constantine, or did it have a wider base in Late Antiquity? At first it would seem that the former alternative is ruled out by the case of Piazza Armerina, where we know that many ornamental motifs, as well as entire compositions, derived from North African precedents.[118] These imply that the figure style of the villa also came from North Africa. But, actually, there is little evidence to support this claim.

The North African component in the making of the villa was doubtless strong. Still, it seems that prior to Piazza Armerina, certain stylistic elements of the villa were common only outside of North Africa. A case in point is the mosaic of the "Great Hunt." The Great Hunt, a single, unified landscape populated by various figures and beasts, occupies the entire length of the east side of the peristyle of the villa.[119] The design concept was an important one, as Lavin has stressed, insofar as it represented a certain stage in the breakdown of the classical tradition of the emblema and the rise of the Late Antique notion of the all-over figure carpet.[120] But this concept—that is, the concept of filling one or more sides of a peristyle or portico with figures in a continuous landscape—is entirely without precedent in North Africa. It has, however, numerous antecedents in Italy: the black-and-white mosaic from the peristyle at Castel Porziano dated to the second century and now in the Museo Nazionale delle Terme in Rome; the

112. Irving Lavin, "The Hunting Mosaics of Antioch and Their Sources," 244ff.; Pace, *I mosaici,* 93ff.

113. Lavin, "Hunting Mosaics," 249f., n. 300.

114. See, for example, Pace, *I mosaici,* figs. 11, 18, 25, 27, 35.

115. Deckers, "Die Wandmalerei im Kaiserkultraum" (supra n. 58), figs. 13, 34.

116. Ernest Nash, *A Pictorial Dictionary of Ancient Rome,* vol. II, London, 1968, 444, figs. 1244–45, s.v. "Thermae constantinianae."

117. L'Orange and Gerkan, *Der spätantike Bildschmuck,* pl. 5.

118. Most recently R.J.A. Wilson has restated the case for North African influence in Sicily in "Roman Mosaics in Sicily: The African Connection," *AJA,* 86, 1982, 413ff.; see also Wilson, *Piazza Armerina* (supra n. 61), 51ff., 116.

119. On the Great Hunt see Georg Daltrop, *Die Jagdmosaiken der römischen Villa bei Piazza Armerina,* Hamburg and Berlin, 1969, 23ff.; Andrea Carandini, "Appunti sulla composizione del mosaico detto 'grande caccia' della villa del Casale a Piazza Armerina," *Dialoghi di Archeologia,* 4–5, 1970–71, 120ff.

120. Lavin, "Hunting Mosaics," 256ff.

mosaic of the gladiators from a peristyle in the Tenuta di Torre Navona near Rome, perhaps of the third century, and now in the Galleria Borghese; and a mosaic from a portico on the Esquiline dating, in all probability, to the early fourth century and now in the Antiquarium Communale.[121] Thus, there is reason to believe that the source of inspiration for the Great Hunt came from outside North Africa, and this could only mean that the villa was the result of not one but two or more influences coming together.

This conclusion is also supported by the figure style of the mosaics, for which there are likewise no true precedents in North Africa. I say precedents rather than parallels because the latter exist (from the *Maison des protomés* at Thuburbo Maius, the *Maison des chevaux* at Carthage, and a structure in the Dermech district of Carthage), but—and this is the important point—none of them is clearly and unambiguously earlier than the villa in date.[122] So it is possible—indeed, in my opinion, probable—that this figure style came to the villa and to North Africa simultaneously from somewhere else. Since the figure style, like the wall design of the villa, matches that of Luxor and, furthermore, as Kitzinger has pointed out, reveals traits also found in tetrarchic portraiture, coinage, and sculpture, it is reasonable to assume that this component was a tetrarchic one.[123] We may conclude, therefore, that an innovative figure style accompanied and complemented the new structural style of wall design that originated in the tetrarchic court ca. 300. Both elements, in turn, were the ultimate source of the style of the second part of the Via Latina catacomb.

Up to this point we have spoken of the relationship between the painting of the second part of the catacomb and its source only in formal terms. But what of the meaning the tetrarchic style originally had—was this, too, still current when the Via Latina catacomb was painted? In the absence of verbal testimony, it is impossible to give a definitive answer to this question; to judge from the visual evidence, however, it would seem highly doubtful. In the tetrarchic style of painting form and meaning were precisely and intimately related. Architectural motifs,

121. For the mosaic from the peristyle at Castel Porziano, see Marion Blake, "Roman Mosaics of the Second Century in Italy," *MAAR*, 13, 1936, 147, 156; Lavin, "Hunting Mosaics," 252, figs. 117 and 118. For the mosaic of the gladiators, see Blake, "Mosaics of the Late Empire," 113ff., pls. 30.1–4; L. Rocchetti, "Il mosaico con scene d'arena al Museo Borghese," *RIASA*, n.s. 10, 1961, 79ff., figs. 1ff.; Lavin, "Hunting Mosaics," 257, fig. 120. Contrary to Lavin's assertion that "an early fourth-century date [for the Borghese mosaic] seems beyond question," the mosaic yields no clear chronology. Blake expressed doubts about so late a date, citing Canina's claim that the building in which the mosaic was found belongs to the time of Caracalla (p. 115). The style of the mosaic is clearly distorted by later restorations; nonetheless, many forms in the mosaic are comparable to those in the mosaic of the athletes from the Baths of Caracalla, now in the Vatican, thus suggesting an early third-century date (see Blake, "Late Empire," 111f., pls. 25.1–2, 28, and 29). For the mosaic from the Esquiline, see ibid., 116f., pls. 27.2–3, 31.5; J. Aymard, "Quelques scènes de chasse sur une mosaïque de l'Antiquarium," *MélRome*, 54, 1937, 42ff., fig. 1ff.; Lavin, "Hunting Mosaics," 258, figs. 122 and 123.

122. Ibid., 247ff.; Dunbabin, *Mosaics of Roman North Africa*, 196ff., esp. 211ff.; Wilson, *Piazza Armerina*

(supra n. 61), 51ff. For the *Maison des protomés* in Thuburbo Maius, see L. Poinssot and P. Quoniam, "Mosaïques des bains des protomés à Thuburbo-Maius," *Karthago*, 4, 1953, 155ff., figs. 2ff. For the *Maison des chevaux* in Carthage, see J. W. Salomonson, *La mosaïque aux chevaux de l'antiquarium de Carthage* (=*Études d'archéologie et d'histoire ancienne publiées par l'Institut historique néerlandais de Rome* I), The Hague, 1965. For the floor from the Dermech district of Carthage, see A. Mahjoubi, "Découverte d'une nouvelle mosaïque de chasse à Carthage," *CRAI*, 1967, 264ff., fig. on 265.

123. Kitzinger, *Byzantine Art*, 9. In this context it would also be useful to raise the question as to whether all other mosaics related to Piazza Armerina are to be explained as instances of North African influence. One such case is the "villa" at Desenzano in northern Italy dated to the late third/early fourth century; see Ettore Ghislanzoni, *La villa romana in Desenzano*, Milan, 1962, passim and 152ff., on the date. Would it not be more reasonable to argue that this style was an empire-wide phenomenon—spread, as I have suggested, by the imperial court—than that it came to this small and rather obscurely located Italian "villa" with North African craftsmen or their designs as Dunbabin implies (*Mosaics of Roman North Africa*, 215)?

fictive marble revetment, and a primitive-looking figure style were employed to refer specifically to ancient art. Any change in form, therefore, would signify a change in meaning. And in the case of the painting in the second part of the catacomb, there are two important changes which suggest that the original meaning of the style employed was no longer understood.

The figures of the second part, by and large, lack what expressed so well the concept of "the ancient" under the Tetrarchy: an emphatic hardness and angularity. Perhaps farthest from this quality is the scene of the Crossing of the Red Sea in O (fig. 3), whose triumphant Israelites seem to sway in unison in a rhythmic dance that portends the refinement of the Theodosian period.[124] A softening of form is also evident in the Balaam in F, the Christ between Peter and Paul and the "Philosophical Discourse" in I, and the putto on the left entrance wall of N. Similarly, new elements entirely foreign to the meaning of the tetrarchic style have appeared in the overall design of the rooms: in D, the lunette-shaped section of the upper wall is decorated in the linear style;[125] in E, the design of the upper portion of the side walls is based on the early-third-century band system;[126] and in I and N the upper zone of the walls (fig. 70) exhibits a characteristic design element of the linear style, a rectangular field divided into "L" shaped sections by curved transverse lines, as exemplified by the decoration of an early third-century tomb discovered on the Via Ostiense or the third-century wall painting in room XIV of the Inn of the Peacock in Ostia (fig. 71).[127]

It is interesting to observe that these designs were all derived from the non-structural style of the third century where they were originally intended to cover the surfaces of a room in a continuous pattern. Here, on the other hand, they appear dismembered, for they are used only on isolated sections of the surfaces of the walls. These "design segments" are thus like spolia—for they derive from another context—and their use here is analogous to the use of spolia in architecture, also a characteristic phenomenon of the fourth century.[128] Classical architects, of course, availed themselves of spolia, though primarily for foundations of buildings or cores of walls; beginning with the Tetrarchy and continuing through Late Antiquity and the Middle Ages, however, the practice of reusing architectural elements in other contexts was widespread.[129]

124. On the Theodosian style in sculpture, see Johannes Kollwitz, *Oströmische Plastik der theodosianischen Zeit,* Berlin, 1941; Ernst Kitzinger, "A Marble Relief of the Theodosian Period," *DOP,* 14, 1960, 17ff. (in *The Art of Byzantium,* 1ff.); Hans-Georg Severin, "Oströmische Plastik unter Valens und Theodosius I," *JbBerlMus,* 1969, 211ff.; Kitzinger, *Byzantine Art,* 31ff.

125. But the linear style is here rendered in a form typical of the late third and early fourth centuries: the framing lines have been thickened and made rigidly symmetrical, and the decorative elements have been enlarged so that they no longer appear to float but to be held firmly within their frames.

126. The upper portion of the side walls in E is also related in design to the decorations of the Lateran domus cited earlier (above, n. 1). Further parallels are found at Ephesus: H2.SR 19 and 20 (Strocka, *Die Wandmalerei der Hanghäuser,* 74ff., figs. 131, 139–41, 144), H2.SR 25 (83f., figs. 161–66), H2.SR 27 (85ff., figs. 170–78), H2.SR 29 (87ff., figs. 180–84), H2.18 (140, figs. 280–90), H2.16a (123ff., figs. 297–305), H2.17 (126, figs. 307–11), H2.14b (102ff., figs. 224–35), H2.22 (111f., figs. 244–55). The design employed in these paintings is also identical to one used in a

Roman house of undetermined date discovered in the Athenian Agora; see Homer A. Thompson, "Excavations in the Athenian Agora, 1948," *Hesperia,* 18/3, 1949, pl. 40.2; see also Walter Drack, "Neu entdeckte römische Wandmalereien in der Schweiz," *Antike Welt,* 11/4, 1980, 17ff., figs. 3–5 (dated to the early second century).

127. G. Lugli, "Via Ostiense. Scavo di un sepolcreto romano presso la basilica di S. Paolo," *NS,* 1919, 333, fig. 25; Gasparri, *Le pitture della Caupona del Pavone,* 26, fig. 9.

128. F.W. Deichmann, *Die Spolien in der spätantiken Architektur* (=*Bayerische Akademie der Wissenschaften, Phil.-hist. Klasse, Sitzungsberichte* 6), Munich, 1975.

129. Ibid., 5ff.; idem, "Säule und Ordnung in der frühchristlichen Architektur," *RM,* 55, 1940, 114ff.; Arnold Esch, "Spolien. Zur Wiederverwendung antiker Baustücke und Skulpturen im mittelalterlichen Italien," *Archiv für Kulturgeschichte,* 51, 1969, 1ff. Spolia, for example, were used to build the core of Hadrian's Triumphal Arch erected 129–30 in Gerasa; see Carl H. Kraeling, *Gerasa, City of the Decapolis,* New Haven, 1938, 80.

Diocletian's Arcus Novus represents an early instance of the use of spolia and it was soon followed by the so-called Temple of Romulus on the Via Sacra, the Arch of Constantine, and the great Christian basilicas of the Lateran and St. Peter's.[130] It has often been debated, in fact, whether the spolia used in these buildings had mainly an economic or an artistic rationale.[131] The fact that so similar a phenomenon appears in painting where the rationale could only have been artistic suggests that the latter was indeed the case, at least for the fourth century. In this context, however, the appearance of non-structural elements of design could only indicate that the structural style had lost its original meaning, for the non-structural could hardly evoke the form or the spirit of ancient painting.

We might observe in conclusion that the larger process our analysis implies is quite different from the one we saw when studying the first group of paintings from the catacomb. The early paintings exhibit, to a large extent, continuity within a single geographic and functional context. Here, on the other hand, the process must have involved the diffusion through certain intermediary points of a style created and consciously framed in a distant milieu—for how else can we account for the fact that the tetrarchic style entered a realm in the Via Latina catacomb so foreign to the one for which it was originally created? Thus, it is not only in form but also in the larger artistic development to which the style bears witness that the second group of paintings from the catacomb differs from the first. The issues this observation raises, however, must be a matter for our final chapter.[132] To pursue them here would take us far beyond our intended scope: to recognize the stylistic sources clearly.

130. Deichmann, *Die Spolien,* 5ff. On later developments in Rome that bore upon the use of spolia, see Richard Krautheimer, "The Architecture of Sixtus III: A Fifth-Century Renascence?" *De Artibus Opuscula XL. Essays in Honor of Erwin Panofsky,* ed. Millard Meiss, New York, 1961, vol. I, 291ff.

131. Deichmann, "Säule und Ordnung," 114; idem, *Die Spolien,* 94ff.
132. See below, pp. 72–76.

IV

Subjects and Uses of Imagery

IN order to understand the differences between cubicula C and O in plan and style of painting we have had to take, at times, a rather broad view, to speak in terms of general trends, of indigenous practices and foreign traditions rather than of specific patrons and their intentions. Quite clearly this was determined by the nature of our evidence. But with the imagery of the catacomb we have an opportunity to make more concrete our understanding of the situation. Imagery is directly expressive of ideas, tied to an intellectual tradition, and thus gives more immediate access to the thought world of the patron or designer. In this instance imagery is all the more interesting because, though superficially similar as we have seen, it was actually used for vastly different purposes in the two cubicula. Our aim now is to define these purposes closely.

CUBICULUM C—A PROGRAM OF SALVATION

The goal of the first part of our discussion will be the proof of one point: that the imagery in C that relates directly to cubiculum O, namely the two lunette paintings, forms part of a programmatic ensemble involving other elements of the decoration. To begin, we should note that our ensemble can be defined as a more or less self-contained entity in both architectural and iconographic terms.

The lunette paintings in C decorate two niches that form the sides of the cubiculum proper and a spatial unit distinct from the arcosolium that occupies the rear wall. In antiquity, this distinction would most likely have been even more emphatic. The arcosolium and the cubicu-

lum proper were once separated by an object of which only traces now remain: two holes in the tufa of the walls, one on either side of the springing of the vault of the framing arch of the arcosolium (see fig. 34). To judge from the width of the holes, the fact that they align horizontally, and the impression left in the plaster, we can assume that the object once inserted there was a beam of some sort that ran across the arcosolium opening. This interpretation is supported by the fact that such a beam, in marble and in almost the same position—though with a slight but significant difference—survives in cubiculum O, which otherwise reproduces in all essentials the architectural form of cubiculum C (fig. 72). The only clue as to the function of this object also comes from O: the beam there preserves on its underside the traces of four metal pins. These may be the remains of hooks, perhaps to hold curtains or lamps, a usage that would, in effect, have closed the arcosolium off from the cubiculum proper, although it is not one known elsewhere in the Roman catacombs.

If the beam in C, like the one in O, performed this function it would have divided the room into two parts. And here the difference we have just alluded to in the positions of the two beams becomes an important issue. In O, the beam runs straight across the arcosolium opening, thus neatly dividing the arcosolium from the cubiculum proper. In C, on the other hand, the beam would have been set at a slight angle, running from the front edge of the framing arch of the arcosolium on the left to the back edge of the framing arch on the right (fig. 73). It is this position, slightly askew vis-à-vis the arcosolium and the cubiculum proper, that, in turn, appears to be reflected in the iconography of the room.

All the imagery in the arcosolium is of one type: the Adam and Eve and the female orant on the rear wall (fig. 34), the shepherd flanked by two scenes from the story of Jonah—Jonah spewed from the whale on the left and Jonah resting under the gourd on the right of the vault— and the Trial of Job on the left side wall of the framing arch of the arcosolium behind the hole that held the beam are signitive images of the most laconic sort. They all derive from third-century Christian art and were all commonplace by the early fourth century when cubiculum C was decorated.[1] Presumably, too, they would have been hidden from the viewer in the room by the objects(s) suspended from the beam of the arcosolium.

The imagery of the cubiculum proper, however, is for the most part neither laconic nor traditional. We shall begin our description in the right rear corner and move clockwise around the room, since this order will prove significant in the discussion that is to follow (fig. 73). In the right rear, opposite Job but in front of the beam hole, we find Moses at the Burning Bush (fig. 74, position 1). This is followed by the Crossing of the Red Sea (fig. 2, positions 2–4), displayed on three walls of the right niche of the room, and Moses striking the rock, painted on the face of the pier in the right front corner (fig. 75, position 5). Across from the Striking of the Rock, painted on the face of the left front pier, there is a youthful male figure with a scroll (fig. 76, position 6). Then follows the scene in the left lunette showing a multitude gathered behind a large figure who points with a staff to a small building on the right below two sketchily painted, monochrome vignettes of Moses receiving the Law (right) and the Column of Fire from Exodus (left) (fig. 4, positions 7 and 8). This scene actually begins on the left side wall of the room's left niche. On the right side wall occurs the Sacrifice of Abraham (fig. 77, position 9). Finally, the vault of the cubiculum shows Christ seated, en face, flanked by an open codex and a capsa filled with scrolls (fig. 78).

1. The motifs in the arcosolium of C often occur together on third-century sarcophagi; see Friedrich Gerke, *Die christlichen Sarkophage*, pls. 2.1, 6.2, 51, 52, and 53.1. See also Jakob Speigl, "Das Bildprogramm des Jonasmotivs in den Malereien der römischen Katakomben," *RQ*, 73, 1978, 1ff.

It is thus possible to define, in architectural and iconographic terms, a context for the two lunette paintings in C in an ensemble that will be the subject of the following discussion. The only element in this group that has attracted any considerable scholarly attention is the scene in the lunette of the left niche of the room. This scene cannot readily be identified with an event described in any literary source that has come down to us from antiquity. Moreover, it appears to concern two separate and unrelated subjects, so that opinion as to its meaning has divided along essentially two lines.

Enrico Josi, followed by Ferrua in his publication of the catacomb, proposed that the scene was the Raising of Lazarus.[2] This conclusion was based not only on obvious similarities between the scene and the Lazarus event as it was commonly shown in the early fourth century—the large figure who gestures with a staff resembles the miracle-working Christ and the small temple-like structure, Lazarus's tomb (fig. 79)—but also on the fact that the corresponding scene in O, closely related to, indeed copied from the one in C, shows the Raising of Lazarus. But this interpretation cannot stand. Perhaps the most serious objection to it is the absence of the body of Lazarus—typically a small, mummy-like form as in O—from the building on the right that is interpreted as Lazarus' tomb.[3] Given the popularity of the Lazarus theme in Early Christian art, it is unlikely that this element would have been omitted by an early fourth-century artist. Furthermore, there is no parallel in any extant Early Christian representation of Lazarus to the multitude behind the large gesturing figure. One might argue that the artist simply followed the text on this point—John 11:38ff. implies that a large group went with Jesus to the tomb—but if he was as literal in his rendition as this interpretation suggests, why did he omit Mary and Martha who John tells us were also present at the tomb? Finally, no source has yet come to light which would explain the connection between the vignettes at the top of the lunette and Lazarus, a combination of elements which is indeed odd.[4]

Other scholars, however, have taken a cue precisely from these vignettes and argued that the entire scene has to do with Moses and the Israelites' journey to the Promised Land. This possibility has one thing to commend it: a rationale for the juxtaposition of the scene with the Crossing of the Red Sea in the facing lunette. But there are great difficulties in determining exactly what event in the Exodus is illustrated here. André Grabar, for example, proposed that the scene represented a combination of Moses in prayer before the cloud that hid the Lord on Mount Sinai (above) and the crowd of Israelites before the sanctuary they were to build according to the Lord's commandment as described in Exodus 35 (below).[5] But his interpretation neglects two important questions concerning, first, the identity of the large gesturing figure in the lower portion of the scene, and second, the rationale for the inclusion of the Column of Fire, which would have had no place at this point in the story.

A similar line is followed by Ursula Schubert with equally unsatisfactory results. Schubert identifies the scene—but only in the most general terms—as the "Sinai Theophanie."[6] But what

2. *CRAI*, 1956, 275ff.; Ferrua, *Le pitture*, 55.

3. For comparison, see Giuseppe Bovini and Hugo Brandenburg, *Repertorium der christlich-antiken Sarkophage* nos. 26 (23, pl. 8), 241 (139ff., pl. 54), 364 (173, pl. 66), 625 (252f., pl. 94), 674 (271f., pl. 102), 770 (316f., pl. 121), 771 (317ff., pl. 122), 772 (319f., pl. 122), 807 (337f., pl. 129). Erland Billig cites many examples where Lazarus' tomb is represented in a form analogous to the building in the left lunette of cubiculum C; see *Spätantike Architek-turdarstellungen* 1, Stockholm, 1977, figs. 48, 51–54, 56.

4. Ferrua believed that the vignettes were intended to be put over the Crossing of the Red Sea, "e solo per isbaglio di qualche garzone di bottega che non capì gli ordini furono messe qui"; see Ferrua's review of Kötzsche-Breitenbruch, *Die neue Katakombe*, in *BZ*, 71, 1978, 119.

5. *CRAI*, 1956, 276f.

6. Ursula Schubert. *Spätantikes Judentum*, 30f.

precise event the main activity shown here represents remains a mystery. The evidence Schubert offers has mainly to do with the temple-like structure on the right. This structure, Schubert claims, can be understood as a reference to Sinai by concepts that were familiar in the rabbinical tradition of Biblical commentary. The point is well taken—but only in part. What is most interesting for us is the connection Schubert makes between the building and the rabbinical notion that identified Sinai with the Temple Mount. Schubert uses this identification to explain the form of the building at the top of the steps—an important observation and one to which we shall return. Schubert's further argument, that the identification of Mount Sinai with Jacob's Ladder in rabbinical commentaries accounts for the flight of steps leading up to the building, however, is quite unconvincing.

The problems of the biblical narrative are altogether ignored by Cagiano de Azevedo, who has suggested that the scene represents Moses leading the Israelites into the Promised Land, symbolized by Jerusalem in the form of the Sepulchre of Christ.[7] The identification, of course, is impossible because Moses never entered the Promised Land. The point was explicitly stated in the Biblical text and, to my knowledge, never disputed. Nor is there substantiation for Cagiano de Azevedo's claim that the building in the painting represents the Sepulchre of Christ. The supporting evidence he cites, to which we shall also return—a painted frieze showing scenes from Exodus in the cupola of a mausoleum in El Bagawat, dating, in all likelihood, to the fifth century—contains a building (fig. 83) that almost surely represents the Temple, not Christ's tomb.

If previous explanations have been unable to account for all of the elements in the scene of the left niche of cubiculum C, it is perhaps because they have not examined the subject within a wide enough frame of reference—like the one we have recognized in the ensemble of cubiculum C proper. Without this context, the scene indeed makes little sense, though the context alone is not enough. As everyone who has treated this problem has discovered, there are no true parallels to this scene among extant works. To understand its meaning, therefore, we must eventually refer to concepts found in Christian writings of the third and fourth centuries. These prove that the decoration of C did not stand alone; in fact, it represented the pictorial expression of a theme well known in its own day.

The most striking aspect of the decoration in cubiculum C proper is the arrangement of the two side niches, yet the significance of this arrangement has never been fully recognized. The large paintings in the two lunettes face each other across the room. At the same time, elements of the subjects in each of the paintings (the Egyptian army and the victorious Israelites on the right and the multitude on the left) are portrayed on the narrow portions of the walls adjacent to the lunette. It is apparent that this stereoscopic arrangement has nothing to do with the narrative content of the two scenes; the side walls do not constitute, in any sense, a foreword or postscript to the main action. But they extend the compositions of the lunettes and as such create the impression of a sequential movement that serves to bond the two sides of the room. Continuity is further stressed in several ways. If panels 2–4 and 7–8 were put together in the order in which they now stand—following the movement of the figures, the groundlines, and the direction of light and shadow—they would form a continuous and unified frieze. Where the two sides of the room would be bonded in this hypothetical frieze the join would be seamless because the crowd of triumphant Israelites in the small right panel of the right niche is identical

7. Cagiano de Azevedo, "Una singolare iconografia," 111ff.

to the multitude in the small left panel of the left niche. And, indeed, it is as if a continuous frieze had been cut up and placed on different but consecutive portions of the walls. All of this is not as far-fetched as it would seem because the same arrangement, though interestingly enough turned inside out occurs in a Roman monument precisely contemporary to cubiculum C in date, namely, the Arch of Constantine. Each of the reliefs on the small sides of the Arch is literally wrapped around the corner to form a configuration much like the one found in the side niches of C (fig. 80).[8] These relief panels, moreover, contain segments of a continuous narrative that encircles the entire arch in a band; in this respect, too, they will prove analogous to the paintings in C.

One additional piece of the puzzle needs consideration: the representations beside each of the large paintings in the two niches, our "segmented frieze." On the right side of the room, these panels, in positions 1 and 5, show Moses first at the Burning Bush and then striking the rock (figs. 74 and 75). There are several significant points about the panels: first, they, together with the Crossing of the Red Sea in the right niche, all have to do with Moses; second, if the scenes are read in a sequence from left to right, that is, in the direction of the movement shown in the lunette painting, all of the events they illustrate appear in chronological order; and third, this chronological development is further stressed by the vivid differentiation of Moses' age in the two smaller panels, where he is portrayed first as a youth at the Burning Bush, and then as an aged patriarch at the rock. All of these features complement and enhance the sequential aspect of the decoration observed in the arrangement of the two lunette paintings.

But the scenes in the two smaller panels also bear another, more direct and meaningful relationship to the lunette. Just as they bracket the central composition, the events they illustrate gloss the main action. It was at the Burning Bush that Moses first received the Lord's commission—represented here as a scroll in the upper left corner of the panel—to bring the Israelites out of Egypt and into the land "flowing with milk and honey" (Exodus 3:1ff.), a journey which began most dramatically with the Crossing of the Red Sea. It was precisely this commission that the Lord then took away when Moses struck the rock as narrated in Numbers 20:2ff.[9] In this episode Moses angered the Lord because he did not follow the Lord's express command: "You did not trust me so far as to uphold my holiness in the sight of the Israelites; therefore you shall not lead this assembly into the Land which I promised to give them." We may see in the events that decorate the right wall of cubiculum C, then, an epitome of Moses' role in the salvation of the Israelites: its beginning, when Moses was given the commission at the Burning Bush; its climax, the Crossing of the Red Sea; and its end, when the Lord's commission was taken away at the rock.[10]

So far we have reconstructed two principles that seem to apply to the cubiculum: first, that the decoration can be fitted together like the segmented frieze on the Arch of Constantine; and second, that the events shown are represented in a meaningful way in chronological order. Assuming that a principle of sequential chronological narrative applied throughout, one thing is immediately clear when we turn to the left side of the room: Moses cannot be the subject of the events represented here. The next element in the sequence following the scene of the aged patriarch striking the rock is the representation of a young man holding a scroll (fig. 76). To

8. L'Orange and Gerkan, *Der spätantike Bildschmuck,* 51f., 59f., 72, 78ff., pl. 18a–d.

9. On the iconographic tradition of the scene, see Paul van Moorsel, "Il miracolo della roccia nella letteratura e nell'arte paleocristiane," *RACr,* 40, 1964, 221ff.

10. Groups of scenes from the life of Moses appear in other contexts in Early Christian art, but apparently without programmatic meaning; see Gisela Jeremias, *Die Holztür der Basilika S. Sabina,* 36ff.

judge from the relationship established on the right side of the room between the small panels and the lunette, the young man, furthermore, should be identified with the large figure in the lunette gesturing with the staff. If the right side of the room shows Moses' mission, then there is one conspicuous and logical subject for the left: the mission of Joshua. For Joshua not only became the leader of the Israelites after Moses, he actually brought the people into the Promised Land, completing the task Moses began at the Red Sea. It is this commission, moreover, that the youthful figure on the left side of the room now has in his possession in the form of a scroll that recalls the Lord's presentation to Moses at the Burning Bush.

The fact that the painting in the left lunette represents Joshua's mission to bring the Israelites into the Promised Land, however, is not immediately apparent. Two features in the painting—the building on the right and the vignettes at the top—require further elucidation. First, the building. It is interesting to note that the painting in the left lunette does not continue onto the right side wall of the niche as is the case on the right side of the room. In place of an extension of the lunette painting there occurs a representation of the Sacrifice of Abraham, situated so that the scene abuts the right edge of the building (fig. 77). The significance of this juxtaposition was recognized by Schubert. She noted that Jewish writers often identified the site of the Sacrifice of Abraham with that of the Temple.[11] The identification was rooted in the Biblical text, Genesis 22:2 and 2 Chronicles 3:1: the Sacrifice took place in the land of Moriah and Solomon's Temple was subsequently built on Mount Moriah.[12] Moreover, this connection was given visual expression in the pre-eminent Jewish monument to have survived from antiquity, the Dura Synagogue (fig. 81). The face of the arch above the Torah niche on the rear wall of the synagogue shows, undoubtedly in reference to the Biblical connection, the Temple with its appurtenances beside the Sacrifice of Abraham.[13] A suggestive echo of this usage occurs in the sixth-century mosaic floor of the Synagogue of Beth Alpha, where a pedimented facade, identified as the Temple by the utensils of the Jewish rite and the birds, plants, and lions that surround it, and the Sacrifice of Abraham are represented in two separate registers, one above and one below a central panel depicting the zodiac (fig. 82).[14]

The building in the lunette exhibits one other feature that establishes its identity as the Temple, namely, the long flight of steps. The steps occupy so prominent a position in the building that one would assume that they either denoted an architectural feature meaningful to the viewer or served to visualize some well-known quality. In the case of the Temple, the significance of the motif is not far to seek—as Psalm 78 tells us, "He built His sanctuary as high as the heavens"—and this fact was well known to Jews, pagans, and Christians.[15]

11. Schubert, *Spätantikes Judentum,* 31; see also Rachel Wischnitzer, *The Messianic Theme in the Paintings of the Dura Synagogue,* Chicago, 1948, 88f.

12. Carl Kraeling, *The Synagogue,* 57f.; Dimitri Ainalov, *The Hellenistic Origins of Byzantine Art,* trans. Elizabeth and Serge Sobolevitch and ed. Cyril Mango, New Brunswick, NJ, 1961, 98 and n. 115; Kurt Schubert, "Die Bedeutung des Bildes für die Ausstattung spätantiker Synagogen-dargestellt am Beispiel der Toraschreinnische der Synagoge von Dura Europos," *Kairos,* 17, 1975, 12ff. It is interesting to observe that the altar upon which Isaac is to be sacrificed is often shown in Early Christian art with a long flight of steps; see Ainalov, 94ff.; Isabel Speyart van Woerden, "The Iconography of the Sacrifice of Abraham," *VChr,* 15, 1961, 229ff.; Archer St. Clair, "The Iconography of the Great Berlin Pyxis," *JbBerlMus,* 20, 1978, 23ff.

13. Kraeling, *The Synagogue,* 54ff., pl. XVI.

14. E.L. Sukenik, *The Ancient Synagogue of Beth Alpha,* London, 1932, 21ff., pls. VIII, XIX.

15. See, for example, Tacitus, *Hist.* 5.11–12. L.-Hugues Vincent and M.A. Steve, *Jérusalem de*

For example, Aristeas, in his famous "letter" written in the late second or early third century B.C., describes the situation in these terms: "When we reached the district, we beheld the city [i.e., Jerusalem] set in the center of the whole of Judaea upon a mountain which rose to a great height. Upon its crest stood the temple in splendour, with its three enclosing walls, more than 70 cubits high and of a breadth and length matching the structure of the edifice."[16]

The great height of the Temple's situation, however, was not visualized in art until a much later period.[17] Perhaps the earliest extant instance is at El Bagawat in the Mausoleum of Exodus (fig. 83).[18] Some scholars, like Cagiano de Azevedo, have claimed that the structure here represents the Sepulchre of Christ because it appears to have a dome.[19] But the building's central form, with its rectangular base and arched top, is closer to the shape of the Ark of the Covenant as it was commonly shown in Late Antiquity—as witness, for example, the Dura Synagogue paintings (fig. 84)—than to representations of domed buildings.[20] The presence of the Ark would identify the building as the Temple, the Ark's resting place. And an identification of the building as the Temple, perhaps as a symbol of Jerusalem, as Ahmed Fakhry has suggested, would be more consistent with the Old Testament scenes to which it belongs in the painting at El Bagawat.[21]

This interpretation is also supported by the fact that the Temple appears in an almost identical form in an even later representation in the ninth-century Utrecht Psalter (fig. 85). The artist of the psalter has illustrated Psalm 134 with a structure that represents the *Domus Dei* of verse 2, that is, the Temple, also identified as Sion.[22] The structure is in all respects similar to the building shown at El Bagawat, though here the long flight of steps is located under the central portion of the building rather than to one side. Similarly, in the Chludov Psalter, a Byzantine work also of the ninth century, Sion is represented four times in the form of a

l'Ancien Testament, Paris, 1956, vol. 2, 373ff.; T.A. Busink, *Der Tempel von Jerusalem von Salomo bis Herodes,* Leiden, 1970, vol. 1, 1ff.

16. H. St. J. Thackeray, *The Letter of Aristeas,* London, 1917, 40; André Pelletier, *Lettre d'Aristée à Philocrate* (=SC 89), Paris, 1962, 142f. and 57f. on the date.

17. On the representation of the Temple, see Carol Krinsky, "Representations of the Temple of Jerusalem before 1500," *JWarb,* 33, 1970, 1ff.

18. Ahmed Fakhry, *The Necropolis of El-Bagawat,* 44ff.; and, following Fakhry, J. Schwartz, "Nouvelles études sur des fresques d'El Bagawat," *CahArch,* 13, 1962, 1ff.

19. Cagiano de Azevedo, "Una singolare iconografia," 111ff., following André Grabar, *Martyrium. Recherches sur le culte des reliques et l'art chrétien antique,* Paris, 1946, vol. 2, 20, n. 3, and Henri Stern, "Les peintures du mausolée 'de l'Exode' à El–Bagaouat," *CahArch,* 11, 1960, 93ff. See also Noël Duval, "La représentation du palais dans l'art du bas-empire et du haut moyen age d'après le psautier d'Utrecht," *ibid.,* 15, 1965, 247f.; M.L. Thérel, "La composition et le symbolisme de

l'iconographie du mausolée de l'Exode à El Bagawat," *RACr,* 45, 1969, 232.

20. Kraeling, *The Synagogue,* pls. LIV, LVI; Helen Rosenau, "Some Aspects of the Pictorial Influence of the Jewish Temple," *PEFQ,* 1936, 157ff., fig. 6; idem, *Vision of the Temple,* London, 1979, figs. 13, 14; Sukenik, *Ancient Synagogue of Beth Alpha,* figs. 26, 34, 38. This form continues in Byzantine art; see T. Ouspensky, *L'octateuque de la bibliothèque de Sérail à Constantinople,* Munich, 1907, figs. 137 (fol. 234v) and 161 (fol. 333r); Wanda Wolska, *La topographie chrétienne de Cosmas Indicopleustès,* Paris, 1962, 122ff., fig. 6. Interestingly enough, structures similar to the Ark also appear in later medieval representations of the Temple, as in Chapel 16 at Göreme, of the mid-eleventh century; see Marcell Restle, *Die byzantinische Wandmalerei in Kleinasien,* Recklinghausen, 1967, vol. 2, pl. 155.

21. Fakhry, *Necropolis of El-Bagawat,* 56.

22. E.T. De Wald, *The Illustrations of the Utrecht Psalter,* Princeton, n.d., pl. CXVI; Duval, "La représentation du palais," fig. 1.

basilica and twice this basilica surmounts a long flight of steps (fig. 86).[23] This evidence leads me to believe that the flight of steps functioned as a kind of shorthand sign to denote the Temple as a symbol of Sion or Jerusalem.[24]

An important aspect of the second feature of the lunette painting, the vignettes, is their style. They are painted in monochrome in a sketchy style entirely dissimilar to the chromatically richer style of the scene below. There are, it seems to me, two possible explanations for this distinction. On the one hand, the painter of the lunette may have wanted to suggest a physical distance between Moses on the Mount and the Column of Fire and the main action of the scene by employing a technique familiar to classical and late antique painters. In the early-fifth-century *Itala* fragment in Quedlinburg, for instance, distant views of landscape and architecture—typically elements of a non-narrative nature—are rendered in a sketchy style.[25] In no example known to me, however, was this style employed in the interest of narrative as in the Via Latina catacomb. On the other hand, the painter of C may have intended the stylistic differentiation in the lunette to suggest that Moses and the Column occupied a realm of existence different from that of the action represented below. That such a manipulation of styles, or modes, was possible in Late Antiquity has been demonstrated by Kitzinger, who cites examples as early as the third century in sculpture.[26] But perhaps the most striking instance is in painting, in the seventh-century icon of the Virgin and Child with Saints from Mount Sinai where individual figures are given different meaning by the style used to portray them.[27] It is this phenomenon, moreover, that allows us best to explain the place of the vignettes in the overall scheme of the painting in the left lunette.

Diverse as they are, all of the strands we have touched on—Joshua, the Temple, Moses on the Mount and the Column of Fire—are tied together, and the place of the lunette in the sequence of cubiculum C accounted for by reference to one Biblical passage: Joshua 1:1–9. The passage describes the Lord's presentation of Joshua's mission. The Lord makes three statements: first, that Joshua will fulfill the promise given to Moses: "My servant Moses is dead; now it is for you to cross the Jordan, you and this whole people of Israel, to the land which I am giving them. Every place where you set foot is yours: I have given it to you, as I promised Moses" (vv. 2–4); second, that the Lord will accompany Joshua forever: "No one will ever be able to stand against you: as I was with Moses, so I will be with you: I will not fail you or forsake you" (vv. 5–6); and third, that the Law will accompany Joshua as it accompanied Moses: "Only be strong and resolute; observe diligently all the law which my servant Moses has given you. You must not turn from it to the right or left, if you would prosper wherever you go. This book of the law must ever be on your lips; you must keep it in mind day and night so that you may diligently observe all that is written in it" (vv. 7–9).

23. M. V. Shchepkina, *Miniatiury Khludovskoi Psaltyri,* Moscow, 1977, fols. 51r, 79r, 86v, 100v. The basilica of Sion on fols. 51v and 86v is placed above steps. See also André Grabar, "Quelques notes sur les psautiers illustrés byzantins du IXᵉ siècle," *CahArch,* 15, 1965, 61ff., figs. 1–4, where he argues that the images of Sion in the Psalter were derived from pre-iconoclastic models.

24. In Ezekiel's vision of the Temple, the southern gate is reached by seven steps (Ez. 40:26). This feature is illustrated in Richard of St. Victor's commentary on the Vision of Ezekiel, dated ca. 1160–75 (Oxford, Bodleian Library, MS Bodley 494); see C.M. Kauffmann, *A Survey of Manuscripts Illuminated in the British Isles, III, Romanesque Manuscripts, 1066–1190,* London, 1975, 113f., figs. 242 and 243. But the Temple was also represented without steps; see G.B. de Rossi, "Insigne vetro rappresentante il Tempio di Gerusalemme," *BACr,* 1882, 137ff. Another explanation for the building shown on the glass is given by Erwin R. Goodenough, *Jewish Symbols in the Greco-Roman Period,* vol. 2, 113ff.

25. H. Degering and A. Boeckler, *Die Quedlinburger Italafragmente,* Berlin, 1932, pl. IV.

26. Kitzinger, *Byzantine Art,* 18f.

27. Ibid., 117f., figs. 210–12.

Each statement in this passage is visualized in the lunette. The Lord's presence promised to Joshua is represented by the Column of Fire, the form in which the Lord accompanied the Israelites through the desert.[28] The Law of the Lord is shown in emblematic form, in the vignette of Moses on the Mount, which represents the moment in which the Law was given to the people of Israel. Finally, Joshua appears below at the head of the Israelite multitude revealing to them the Promised Land in the form of the Temple. In this context, too, the style of the vignettes at the top of the lunette is clarified. The Column of Fire and Moses on the Mount are to be understood as images of concepts, not as entities that exist in the realm of the action represented below. Thus Moses' mission in the deliverance of the Israelites, represented on the right side of the room, is completed with Joshua's mission, shown on the left. The figure of the young man in the panel to the left of the left lunette is then identified as Joshua, who has taken up the commission of the Lord in the form of the scroll that was presented to Moses at the Burning Bush.[29]

As I noted earlier, the scene in the left lunette has proven difficult to interpret largely because no iconographic parallel to it has yet come to light. The problem is particularly serious in light of the explanation offered here because the Medieval and Byzantine tradition of Joshua illustration is so rich and varied,[30] and yet, to my knowledge, there is not a single analogy to the painting in the left lunette in later illustrations of Joshua. Even more significantly, Joshua is shown, without exception, in military garb, befitting his essential role as warrior general, beginning with the mid-fifth-century mosaic cycle in Santa Maria Maggiore.[31] The artist of C, however, has not shown Joshua in his military aspect and it remains to account for this exception.

By the fourth century, Joshua was commonly recognized by Christians as a type of Christ, and his entry into the Promised Land as a prefiguration of salvation.[32] The association, of course, was an obvious one given the fact that Joshua and Jesus are the same name in Hebrew, Greek, and Latin. And given Joshua's role in sacred history it should come as no surprise that this notion found expression in explicitly military terms.[33] But Joshua's deeds also had significance in a context in which the hero's military aspect was not given a prominent role. In a discourse on Moses' doubt in Sermon 352, Augustine states:

> Because it was said to Moses that he would not lead the people into the Promised Land, another was elected, Joshua the son of Nun. But this man was not called by that name. He was called Hoshea. When Moses recommended him to lead the people into the Promised Land, Moses summoned him and changed his name. He called him Joshua (=Jesus) so that not by Moses but by Joshua, that is, not by law but by grace would the people of God enter. However, he was not the true Joshua but a type, as

28. *RAC*, VII, 786ff., s.v. "Feuersäule."

29. It is interesting to observe that three of the events in our sequence—Moses at the Burning Bush, the Crossing of the Red Sea and Moses Receiving the Law—also appear in sequence in the distychs of Prudentius; see Günter Bernt, *Das lateinische Epigramm im Übergang von der Spätantike zum frühen Mittelalter* (=*Münchener Beiträge zur Mediävistik und Renaissance-Forschung* 2), Munich, 1968, 68ff.; Renate Pillinger, *Die Tituli Historiarum oder das sogenannte Dittochaeon des Prudentius*, Vienna, 1980, 34ff.

30. Kurt Weitzmann, *The Joshua Roll* (=*Studies in Manuscript Illumination* 3), Princeton, 1948, 30ff., 73ff.; Meyer Schapiro, "The Place of the Joshua Roll in Byzantine History," *GBA*, 35, 1949, 161ff.

31. Johannes Kollwitz, "Der Josuazyklus von S. Maria Maggiore," *RQ*, 61, 1966, 105ff.; *Die frühchristlichen und mittelalterlichen Mosaiken in Santa Maria Maggiore zu Rom*, ed. H. Karpp, Baden-Baden, 1966, pls. 128ff.; Beat Brenk, *Die frühchristlichen Mosaiken in S. Maria Maggiore zu Rom*, Wiesbaden, 1975, 122ff.

32. Ibid., 122ff.

33. Ibid., 123.

indeed the Promised Land was not the true one but a type of it. That one was, for the first people, temporal; the one promised to us will be eternal.[34]

Augustine drew here upon a notion that had roots deep in the Christian past. Two passages from Origen, which I quote in full because of their relevance to the sequence in C, demonstrate this point:

> When one is led from the darkness of ignorance into the light of knowledge, when one is converted from earthly concerns to spiritual precepts, one leaves Egypt and comes into the desert, that is, a way of life in which, in silence and peace, one occupies oneself with divine laws and fills oneself with heavenly declarations; and having prepared and arranged oneself through these things—having crossed the Jordan—one hastens to the Promised Land, that is, through the grace of baptism one attains the precepts of the gospels.[35]

> Think not that these things that happened in the past—about which you now hear—do not concern you, for everything will be fulfilled in you according to a mystical plan. You, who having abandoned the darkness of idolatry, first begin to leave Egypt when you desire to attain the knowledge of divine law. When you have been numbered in the company of catechumens and have begun to obey the precepts of the church, you have crossed the Red Sea. In the resting places of the desert you are absorbed in listening to the laws of God and in contemplating the face of Moses in which the glory of God is revealed. When you arrive at the spiritual source of baptism, in the presence of the priestly and levitical order, you will be initiated into the venerable and glorious mysteries which only those who have a right to know, know, and at this moment, having crossed the Jordan with the help of the priests, you will enter the Promised Land, where Joshua, after Moses, takes charge of you and becomes the guide of your new route.[36]

34. Aug., *sermo* 352.4, *PL* XXXIX, 1553f.: "Quoniam dictum est Moysi. . . quod ipse in terram promissionis non introduceret populum, eligitur alius Jesus Nave; et iste homo non hoc nomine vocabatur, vocabatur Auses. Et cum ei introducendum populum Moyses commendaret, vocavit eum, et mutavit ei nomen, et appellavit eum Jesum: ut non per Moysen, sed per Jesum, id est non per legem, sed per gratiam populus Dei in terram promissionis intraret. Sicut autem Jesus ille non verus, sed figuratus; ita etiam terra promissionis illa non vera, sed figurata. Illa enim populo primo temporalis fuit: nobis quae promissa est, aeterna erit."

35. Origen, *hom. in num.* 26.4, *PG* XII, 776: "Nam et cum quis de errorum tenebris ad agnitionis lumen adducitur, et de terrena conversatione ad spiritualia instituta convertitur, de Aegypto videtur exisse et venisse ad solitudinem: ad illum videlicet vitae statum, in quo per silentium et quietem exerceatur divinis legibus, et eloquiis coelestibus imbuatur: per quae institutus et directus, cum Jordanem transierit, properet usque ad terram repromissionis, id est per gratiam baptismi, usque ad evangelica instituta perveniat." For the text history of the homily quoted here and the one in

n. 36, see W.A. Baehrens, *Überlieferung und Textgeschichte der lateinisch erhaltenen Origeneshomilien zum Alten Testament,* Leipzig, 1916, 81ff., 104ff.

36. Origen, *hom. in Jesu Nav.* 4.1, ed. Annie Jaubert (= *SC* 71), Paris, 1960, 148: "Et ne aestimes quod haec in prioribus gesta sunt, in te vero, qui nunc auditor horum es, nihil tale geratur: omnia complentur in te secundum mysticam rationem. Etenim tu, qui cupis nuper idolatriae tenebris derelictis ad audientiam divinae legis accedere, nunc primum Aegyptum derelinquis. Cum catechumenorum aggregatus es numero et praeceptis ecclesiasticis parere coepisti, digressus es mare rubrum et in deserti stationibis positus ad audiendam legem Dei et intuendum Moysei vultum per gloriam Domini revelatum cotidie vacas. Si vero etiam ad mysticum baptismi veneris fontem et consistente sacerdotali et Levitico ordine initiatus fueris venerandis illis magnificisque sacramentis, quae norunt illi, quos nosse fas est, tunc etiam sacerdotum ministeriis Iordane digresso terram repromissionis intrabis, in qua te post Moysen suscipit Jesus et ipse tibi efficitur novi itineris dux."

The parallel is accurate and complete, and it indicates that this is the context in which the sequence shown in C should be viewed. As I argued earlier, the scene in the left lunette represents Joshua's entry into the Promised Land as presented in the Lord's commission. What is shown here is not a narrative moment from the story of Joshua, but the concept of Joshua's mission. Likewise, the right side of the room does not represent the narrative of Exodus as such, but the concept of Moses' mission. The juxtaposition of the two signified for Christians the transfer of authority from what I would call the *dux itineris antiqui*, Moses, to the *dux itineris novi*, Joshua, that is, Jesus, a passage from law to grace.

Origen's text, finally, throws light on a feature of cubiculum C proper which we have not yet had an opportunity to consider, the decoration of the vault (fig. 78). The vault shows the seated figure of Christ in the aspect of teacher, flanked on the left by a capsa containing scrolls and on the right by an open codex. In the context of Origen's homilies cited above, the essential meaning of the figure is clear. Christ presents the viewer with the ultimate goal in his spiritual Exodus, the "instituta evangelica," the precepts of the gospels which were, for Origen, the true meaning of the Promised Land.

The close correspondence we have just observed between text and image might, then, lead us to believe that the ideas of Origen specifically were the direct source of the program in cubiculum C proper. But the possibility seems unlikely. For instance, both John Chrysostom and Ambrose speak of the Crossing of the Red Sea as a type of baptism; the Crossing of the Jordan was widely held to have similar connotations.[37] And even if Origen gave these themes their fullest and finest expression, we need not assume that the designer of the cubiculum or its model knew him first hand. Origen was widely influential in the West, as Hilary of Poitiers, Augustine, and Ambrose attest;[38] his works, moreover, were translated into Latin as early as the late third/early fourth century by Victorinus of Pettau, who died a martyr in 304.[39] Thus there is no need to connect our painter to Origen directly; indeed there is ample reason to assume that the painter's familiarity with the notions so well expressed by Origen stemmed from the fact that these notions were generally known in the period in which both the theologian and our painter lived.

Nor does it seem to have been the case that the sequence found in C was first developed for the Via Latina catacomb. In the catacomb of Calixtus we find two images juxtaposed on the vault of an arcosolium painted in the second quarter of the fourth century: the Multiplication of the Loaves on the left (fig. 87) and on the right Moses both at the Burning Bush and striking the rock (fig. 88).[40] Doubtless this juxtaposition had to do with the fundamental Christian

37. F. Dölger, "Der Durchzug durch das Rote Meer als Sinnbild der christlichen Taufe," *Antike und Christentum*, 2, 1930, 63ff.; idem, "Der Durchzug durch den Jordan als Sinnbild der christlichen Taufe," ibid., 70ff.; Per Lundberg, *La typologie baptismale dans l'ancienne église* (=*Acta Seminarii neotestamentici upsaliensis* 10), Leipzig-Uppsala, 1942, 116ff.; Jean Daniélou, "Traversée de la mer rouge et baptême aux premiers siècles," *Recherches de science religieuse*, 33, 1946, 402ff. See also *RAC*, IV, 370ff., for a selection of relevant texts.

38. Berthold Altaner, "Augustinus und Origenes. Eine quellenkritische Untersuchung," *HJ*, 70, 1951, 15ff.; Karl Baus, "Das Nachwirken des Origenes in der Christusfrömmigkeit des heiligen Ambrosius," *RQ*, 49, 1954, 21ff.; Hugh T. Kerr, *The First Systematic Theologian. Origen of Alexandria*, Princeton, 1958, 3ff.; Émile Goffinet, *L'utilisation d'Origéne dans le commentaire des*

Psaumes de saint Hilaire de Poitiers (=*Studia Hellenistica* 14), Louvain, 1965; Max Schär, *Das Nachleben des Origenes im Zeitalter der Humanismus* (=*Basler Beiträge zur Geschichtswissenschaft* 140), Basel-Stuttgart, 1979, 23ff.

39. Ibid., 30; Ernst Benz, *Marius Victorinus und die Entwicklung der abendländischen Willensmetaphysik*, Stuttgart, 1932, 23ff.

40. Wilpert, *Le pitture*, pl. 237; Erich Becker, *Das Quellwunder des Moses in der altchristlichen Kunst*, Strassburg, 1909, 13, pl. IV.3. An alternative interpretation is made by Van Moorsel, "Il miracolo della roccia" (supra n. 9), 244, figs. 9 and 11 (Van Moorsel's claim that the Two Brothers sarcophagus [fig. 11] shows Moses present at the water miracle of Peter, and hence constitutes support for a similar reading of the scene in Calixtus, is unconvincing); Umberto M. Fasola, *Pietro e Paolo a Roma*, 49ff.

concepts of Law (Moses) and Grace (Christ). But the painter of the arcosolium made use here of a motif also found in the sequence of C. He combined in one panel two figures of Moses, first as a youth at the Burning Bush and then as an aged patriarch at the rock, a combination that evokes the concept of the Law with a synopsis of the career of the giver of Law, Moses. The panel, therefore, is comparable to the right wall of cubiculum C, so closely, in fact, that the two may ultimately go back to a common source.

It is possible, indeed probable, that this source was another catacomb painting, but it may also have come from another context altogether. Here an important consideration is the architectural form of the cubiculum. This form is unusual in one respect: the side niches in C that are so prominent a feature of the room and so lavishly decorated apparently served no funerary function. But they form a kind of cruciform configuration (fig. 73) that is analogous to the interior plans of several early baptisteries: at Corinth (fig. 89), Aigosthenos, and Cos, for example, or Pirdop, Varna, Thessaloniki, Pola, Mariana, and Sabratha.[41] Moreover, in the baptisteries of Sabratha and Varna an apse or rounded niche, like the arcosolium of C, is located at the rear of the room. The problem of the relationship between the baptistery and the tomb in the Early Christian period has been much discussed, although to my knowledge only in terms of the influence of tombs upon baptisteries.[42] But if meaningful relationships between the two types of structures existed—and this is still an open question—it is conceivable that influence may, at times, have gone the other way around and resulted in the construction of a tomb in the image of a baptistery. Iconographically, this would make much sense, since it was in the baptistery that the promise of eternal life was given to Christians, the promise redeemed at the tomb.[43] And this derivation would certainly seem to have a bearing on the decoration of cubiculum C in both a formal and a thematic sense. Unlike the painting in most contemporary catacombs, where an image could be shifted from one wall to another without seriously altering the meaning of the ensemble, each scene in C derives meaning from its place in the overall sequence, and the perception of the sequence as a unified whole is guided and underlined by the architectural framework within which it is situated. Thus the combination of architecture and decoration found in C would presumably have come from the same source, if it did not stem from the builder of the Via Latina catacomb. And if our readings from Origen have any relevance, the source could easily have been associated with baptism: one gained the "instituta evangelica"—that is, the Promised Land—"per gratiam baptismi."[44]

But there are problems with this relationship, not the least of which is chronology. There is

41. For Corinth, see A.C. Orlandos, "Les monuments paléochrétiens découverts ou étudiés en Grèce de 1938 à 1954," *Actes du V^e Congrès International d'Archéologie Chrétienne*, Aix-en-Provence, 1954 (=*Studi di Antichità Cristianà* 22), Vatican City-Paris, 1957, 111f.; for Cos, see idem, "Les baptistères du dodécanèse," ibid., 205, figs. 4, 13; for Aigosthenos, see idem, *Ergon*, 1954 (1955), 12ff., fig. 16ff.; for Varna and Pirdop, see V. Ivanova, *Annuaire Musée Sofia*, 1922–25, 446f., 460f., 563, figs. 291 and 301; for Thessaloniki, see S. Pelekanides, *Palaiochristianika Mnemeia Thessalonikes*, Thessaloniki, 1949, 24, fig. 1; for Sabratha, see John Ward Perkins and R.G. Goodchild, "Christian Antiquities of Tripolitania," 7ff., fig. 4, pl. IIb; for Pola, see A. Khatchatrian, *Les baptistères paléochrétiens*, 1962, 145; and for Mariana, see G.

Moracchini, "Le pavement en mosaïque de la basilique paléochrétienne et du baptistère de Mariana (Corse)," *CahArch*, 13, 1962, fig. 14. See also Khatchatrian, *Origine et typologie des baptistères paléochrétiens*, Mulhouse, 1982, 27.

42. F. Dölger, "Zur Symbolik des altchristlichen Taufhauses," *Antike und Christentum*, 4, 1934, 153ff.; F.W. Deichmann, *Ravenna. Hauptstadt des spätantiken Abendlandes, Kommentar I*, Wiesbaden, 1974, 25ff.

43. Walter M. Bedard, *The Symbolism of the Baptismal Font in Early Christian Thought* (=*Catholic University of America Studies in Sacred Theology*, Second Series, 45), Washington, 1951, 4ff.; Paul A. Underwood, "The Fountain of Life in Manuscripts of the Gospels," *DOP*, 5, 1950, 43ff.; Khatchatrian, *Origine et typologie*, 13f.

44. Above, n. 35.

no evidence that a cruciform plan was employed for baptisteries before the fifth century.[45] Furthermore, if C was derived from a baptistery, we could reasonably expect its decoration to have some bearing on later baptismal iconography, since the other early baptistery that we know, the one at Dura, clearly connects with subsequent developments.[46] But there is not the slightest trace of the influence of cubiculum C or its model anywhere. Finally, to attribute the architecture of C to an early baptistery would be to isolate the cubiculum even more in the context of the Roman catacombs, for no other chamber resembles C in form or suggests such a source. This relationship, however, touches on the broader issue of the influence of architecture built above ground on the design of the catacombs. The phenomenon is by no means limited to the Via Latina catacomb, yet crucial evidence that may one day elucidate it is only now being systematically collected and analyzed. The numerous small tombs and ancillary structures built for Christians above the catacombs are especially relevant here; the tombs that ringed the basilicas in Rome, such as San Sebastiano and St. Peter's, may have a bearing on this problem as well.[47] Doubtless a study that would expound the typology of, establish a chronology for and distinguish morphological changes in the small-scale Christian tomb built above ground in the fourth century would throw much light on the problem of cubiculum C and other rooms in the catacombs. Therefore, although the architectural peculiarities of the cubiculum make it conceivable that a structure with a non-funerary purpose, like a baptistery, served as a model for the form and hence for the decoration of C, the foregoing considerations compel us to leave the question of source open.

It is interesting to observe, finally, how often we have had to turn to the Jewish realm in interpreting the meaning of the elements in C. The significance of the juxtaposition of the Temple and the Sacrifice of Abraham is, insofar as I have been able to determine, otherwise documented only in purely Jewish contexts. And even though the steps of the Temple seem never to have been represented in Jewish art, the motif may have had a precedent in the high stepped podium upon which the early Torah shrine was set.[48] The form of the shrine at Dura (fig. 90), for example, suggests that it was built to imitate the Ark within the Temple, for it is composed of an arched niche set atop steps and enframed by columns much like the representations at El Bagawat and in the Utrecht Psalter.[49] Furthermore, the symbolic use of the Temple was deeply rooted in Jewish art and thought, particularly in the diaspora, where the Temple was conceived of as the spiritual locus of Jewish aspiration.[50] Nowhere is this message communicated more succinctly than on the coins of the Bar Kokba Revolt with their images of the Temple of messianic promise.[51]

45. Khatchatrian, *Les baptistères paléochrétiens,* xif.; idem, *Origine et typologie,* 27.

46. Carl H. Kraeling, *The Christian Building,* 206ff.; see also, for example, Jean–Louis Maier, *Le baptistère de Naples et ses mosaïques* (=*Paradosis* 19), Fribourg, 1964, 75, 86, 96, 107f., where similarities between the baptisteries of Dura and Naples are noted.

47. Antonio Ferrua, "Il cimitero sopra la catacomba di Domitilla," *RACr,* 36, 1960, 173ff.; Francesco Tolotti, *Il cimitero di Priscilla* (supra chap. 2, n. 25), 107ff.; Philippe Pergola, "Il *Praedium Domitillae* sulla via Ardeatina: Analisi storico-topografico delle testemonianze pagane fino alla metà del III secolo d.C.," *RACr,* 55, 1979, 313ff.

48. Carl Wendel, *Der Thoraschrein im Altertum* (=*Hallische Monographien* 15), Halle, 1950, 17ff.

49. Kraeling, *The Synagogue,* 54ff., pl. XXV. 1.

50. Goodenough, *Jewish Symbols,* vol. 10, 23; Jean Daniélou, "La symbolique du temple de Jérusalem chez Philon et Josephe," *Le symbolisme cosmique des monuments réligieux, série orientale,* Rome, 14, 1957, 83ff.; F.W. Deichmann, "Von Tempel zur Kirche," 54ff. For an alternative view, see *The Synagogue: Studies in Origins, Archaeology and Architecture,* ed. Joseph Gutmann, New York, 1975, xviiff.

51. G.F. Hill, *British Museum Catalogue of the Greek Coins of Palestine,* London, 1914, CIV–CVIII, pls. 32 and 33. See also Goodenough, *Jewish Symbols,* vol. 1, 276f., vol. 4, 114ff.; Kraeling, *The Synagogue,* 60; Alice Muehsam, *Coin and Temple. A Study of the Architectural Representation on Ancient Jewish Coins* (=*Near Eastern Researches* 1), Leeds, 1966, 1ff.; A. Reifenberg, *Ancient Jewish Coins,* Jerusalem, 1965, 33ff., 60f., pl. XII.

Admittedly, these motifs are only a small part of the decoration of the cubiculum, so it would be imprudent to place too much emphasis on them. And, indeed, if they originated in a Jewish context it is possible that they entered the Christian realm through any number of channels.[52] But it would also be prudent to entertain the possibility that the decoration of C was born in a context where Jewish and Christian art coexisted. It is tempting to imagine the situation in terms of Dura for two reasons: first, because the Christian building there was a baptistery and hence of a type that may have been important in the making of C; and second, because the Jewish decoration there was more elaborate and more sophisticated than the Christian and hence more likely to have been influential on Christian developments.[53] But the fact is that this influence never materialized at Dura, where, in spite of their physical proximity, Christian and Jewish phenomena were quite separate.[54] Thus we have arrived at a point reached once before, with no clear cut explanation for the few connections we have made. Nonetheless, it is worth noting that, though ill-defined, it is essentially the same point.

It is appropriate to conclude by stressing once again what is indeed most striking about the decoration of C: its programmatic character. To judge from extant remains, the type of monumental decoration so familiar from later Medieval art—wherein a variety of figures and scenes are employed in the service of a complex overriding theme—is otherwise utterly unknown in Christian Rome of the third and early fourth centuries.[55] What distinguishes the decoration of C is not so much the various elements that make it up, but the fact that they appear to form a meaningful sequence. It is the idea of a sequence of images, of a decoration complex in theme and subject, in a word, a program, that is new in Christian art with cubiculum C. In this respect the decoration of C does not really have a sequel until the fifth century, and at that time in a wholly different context: at the great basilicas of St. Peters, St. Pauls, and Santa Maria Maggiore.[56] In fact, the paintings of the cubiculum appear to anticipate basilical decoration as we can reconstruct it in two areas, in arrangement and in form. Like the walls of the nave of a basilica, the cubiculum shows scenes of a narrative order to be read consecutively beginning on the right wall at the far (east) end as one faces the arcosolium (or apse). Both cubiculum and basilica reach a climax in a different kind of image—a non-narrative, hieratic one—here put on the vault of the chamber itself (Christ flanked by roll and codex), while in the basilica, on the vault of the apse. If these connections have any validity, they suggest that the basilical program of the fifth century was adumbrated in an embryonic form in the early Constantinian period. Nevertheless, I do not want to press the point. The theme of the paintings of the cubiculum

52. C.-O. Nordström, "Rabbinic Features in Byzantine and Catalan Art," *CahArch,* 15, 1965, 179f.; Heinrich Strauss, "Jüdische Quellen frühchristlicher Kunst: Optische oder literarische Anregung?" *ZNW,* 57, 1966, 114ff.

53. See above, chapter 3, pp. 30–31. The likelihood that other synagogues were decorated with frescoes is discussed by Joseph M. Baumgarten, "Art in the Synagogue. Some Talmudic Views," *Judaism,* 19, 1970, 196ff. Interestingly, the Dura Baptistery is decorated, like C, with a scene that occupies more than one wall; see Kraeling, *The Christian Building,* 71ff.

54. Kraeling, *The Christian Building,* 216f.

55. Cf. Josef Fink, "Hermeneutische Probleme in der Katakombe der Via Latina in Rom," *Kairos,* 18, 1976, 186ff. I would like to thank Irving Lavin for

drawing my attention to the importance of this aspect of the decoration.

56. Joseph Garber, *Wirkungen der frühchristlichen Gemäldezyklen der alten Peters-und Pauls-Basiliken in Rom,* Berlin-Vienna, 1918; John White, "Cavallini and the Lost Frescoes in S. Paolo," *JWarb,* 19, 1959, 84ff.; Stephen Waetzoldt, *Die Kopien des 17. Jahrhunderts nach Mosaiken und Wandmalereien in Rom,* Vienna-Munich, 1964; Brenk, *Die frühchristlichen Mosaiken* (supra n. 31). See also André Grabar, *Christian Iconography. A Study of Its Origins* (=*Bollingen Series* 35), Princeton, 1968, 128ff.; Herbert L. Kessler, "Narrative Representations," in *Age of Spirituality, Catalogue,* 449ff. G. Wilpert's hypothesis that a typological decoration was put up in the Lateran in the time of Constantine is unconvincing; see "La decorazione constantiniana della basilica lateranense," *RACr,* 6, 1929, 53ff.

was very much at home in an early Constantinian tomb; in a monumental public building it would have been quite out of place.

But finally there remains something familiar about the decoration of cubiculum C proper, and this is its thematic congruence with the signitive imagery of the arcosolium of the room. The concept of personal salvation was, as we have already observed, the most important message the signitive art of the catacombs had to communicate.[57] And in C too, though through an ensemble rather than through an individual image, we hear a familiar voice making the intimate activity of personal salvation continue the work of sacred history: "Think not that these things that happened in the past—about which you now hear—do not concern you, for everything will be fulfilled in you according to a mystical plan."[58] Thus, while remarkably new in many respects, the decoration of cubiculum C was also in its time age-old.

CUBICULUM O—A DECORATION FOR NEW CHRISTIANS

What will concern us in the following discussion of the two paintings in O that were copied from C is not so much what stayed the same as what changed. For this reveals most clearly the new function of imagery, now nonprogrammatic in nature and no longer in touch with the wellspring of religious sentiment that gave rise to the imagey in C. Larger changes, however, strike us immediately upon entering the room. Partly by widening the arcosolium opening and partly by raising the marble beam across it, the designer of O has made it appear that the cubiculum and the arcosolium were no longer separated from one another (fig. 35). The unity of the room is enhanced by the decoration whose relevant portion, which we shall now review, is concentrated in, though not entirely confined to, a middle zone that encircles the entire room.

Two female figures flank the entrance to the cubiculum. They have been identified as Ceres, on the right, with torch, crown, and altar, and Persephone, on the left, with sheaves of wheat (fig. 91).[59] The area of the two niches then follows, with the Crossing of the Red Sea in the lunette on the right (fig. 3) flanked by single figures, an Egyptian soldier on the left (fig. 92) and a triumphant Israelite on the right (fig. 93); and on the left, with the Raising of Lazarus in the lunette (fig. 5) flanked by Balaam (fig. 94) and Daniel (fig. 95). The sides of the framing arch of the rear arcosolium show Noah on the left (fig. 96) and a female orant on the right, and the arcosolium itself, the Multiplication of the Loaves and the Three Hebrews on either side of a pair of genii and putti flanking a peacock. In the vault of the arcosolium there is a female bust (fig. 47), presumably a representation of the deceased, enframed by garlands, and on the vault of the cubiculum proper, Ceres and Persephone reappear, now enthroned and holding grapes and sheaves of wheat (fig. 97).[60]

As we approach the decoration, we notice first that the painter of O has eliminated the sequential ordering of parts that was essential to the meaning of the imagery of C. This he has replaced with a more or less symmetrical arrangement of static and self-contained units. The

57. Wladimir Weidlé, *The Baptism of Art,* 10f.; Ernst Kitzinger, "Christian Imagery: Growth and Impact," in *Age of Spirituality: A Symposium,* 142ff.

58. See above, n. 36.

59. W.N. Schumacher, "Reparatio vitae," 137ff.; idem, "Die katakombe," 342ff.

60. Schumacher, "Reparatio vitae," 139, leaves open the question of the identification of the vault figures, although there hardly seems to be any doubt.

two lunette paintings in O lack the overlaps characteristic of C and hence are no longer tangibly connected to one another. The overlaps have been replaced by single standing figures—the Egyptian soldier and the triumphant Israelite on the right, Balaam and Daniel on the left— elements that bracket the lunettes and stress their isolation. These forms echo in the remaining panels of the middle zone of the room: in the Ceres and Persephone at the entrance, and in the Noah, Christ, Three Hebrews, and female orant in the room—nearly all single, standing figures with arms raised in prayer, surrounded by an expanse of blank space. As they face each other across the room, like rudimentary icons, a palpable symmetry is created that reaches a climax on the rear wall of the arcosolium with its balanced grouping of genii and putti.

Moving closer, we observe that the painter of O has also made changes in the images he copied directly. In the case of the Crossing of the Red Sea, these were slight enough: the enlargement of the figure of Moses and the addition of a star above his staff and a swastika-shaped gammadion to his garment; they hardly alter the meaning of the scene the painter strove to reproduce.[61] The changes made in the opposite lunette, on the other hand, were more serious because they transformed the model upon which the painting was based. These changes were essentially three: the body of Lazarus was added to the building that symbolized the Promised Land in Joshua's mission in C; the structure was shifted nearer to the center of the composition and a wing added onto it so that it was isolated from the adjoining panel of the right side wall of the niche;[62] and the vignettes were rendered in the same style as the scene below rather than in a constrasting and sketchy style. Thus the painter of O turned what was a depiction of Joshua's mission to lead the Israelites into the Promised Land, replete with symbolic representations of the Promised Land, the Lord, and the Law of Moses, into a scene of the Raising of Lazarus wherein the miracle occurs below the Column of Fire and Moses on the Mount.

The case of Lazarus, in particular, raises most pointedly the question of whether the painter of O, in copying imagery from C, truly understood the meaning of his model. And it is this case that gives us the clearest answer. The situation seems to admit of only two explanations: the painter of O either purposefully transformed his model into the Raising of Lazarus, or he misread it as such. If we pursue the first possibility, we would have to account for the presence of the vignettes of Moses and the Column in the Lazarus scene—for this combination of images would have had to make sense to the executant artist or the designer of the cubiculum. But none of the exegesis undertaken in the service of interpreting the scene in C as the Raising of Lazarus has yet uncovered evidence that would explain this connection.[63] It is, of course, possible that these motifs were related in a sense that has been lost to us today, but this seems unlikely. It is much more probable that the painter of O actually thought that the scene he copied from C represented Lazarus. And indeed—pace Professor Josi—this would have been an easy mistake to make. As I noted earlier, the scene of Joshua's mission bears a distinct resemblance to the Raising as it was represented at this time. From this one would have to conclude, then, first, that the painter of O did not comprehend the meaning of the sequence in C, and second, that he copied the painting even though he could not explain the significance of the relationship between the vignettes and the scene he thought to be the Raising of Lazarus.

61. Kötzsche-Breitenbruch, *Die neue Katakombe*, 81f. The star in the Crossing seems to be without parallel. Kötzsche-Breitenbruch cites for comparison only the star in the scene of the miracle of the quails on the right small side of a sarcophagus in Aix-en-Provence whose front shows the Crossing of the Red Sea.

62. A similar depiction of Lazarus' tomb with a wing added onto it occurs on the wall of the vestibule of the basilica of St. Thecla; see Umberto M. Fasola, "La basilica" (supra ch. 2, n. 49), 257, fig. 41.

63. Above, p. 53.

But if the painter of O did not really understand the imagery of C, why did he copy it? It is possible that he stumbled upon some fortuitous meaning in misreading Joshua's mission as the Raising of Lazarus. The juxtaposition of the Raising of Lazarus and the Crossing of the Red Sea—that is, what the painter of O might have thought was depicted in cubiculum C—is precisely what appears on a sarcophagus in Brescia.[64] Such juxtapositions on sarcophagi are often intended to remind the viewer of some larger theme, though it is difficult to imagine what the precise point here would have been. But quite apart from these considerations, this explanation has another, more serious failing: it does not account for the fact that the painter of O turned specifically to models in C, models that must have been rather arcane to him, rather than to other versions of the two scenes with which he was surely more familiar. Another explanation, however, is possible. The painter of O may have simply copied the scenes in C because they were works of the past, specifically, of the Christian past. The following remarks may help to clarify this interpretation.

Two other characteristics of the scenes in O are of interest in our context. First, imagery in O is presented in a way that can only be described as artful. The quality of isolation mentioned earlier is not simply an iconographic phenomenon in O; it is also an artistic one. Each image is enframed, often by multiple frames, like a precious panel painting in a museum. And the prominence of framing devices has apparently also enforced a certain attitude towards composition. Unlike their counterparts in C, the images in O are composed to a great extent according to principles of symmetry and balance, qualities that have their correlative in the overall arrangement of the decoration. I would call this aspect the "enhancement" of the image. Second, the Christian images in O occur in a setting that is decidedly pagan in character. We shall have more to say about this setting presently; for now, one point will suffice. Although the figures of Ceres and Persephone at the doorway and on the ceiling of the room derive from pagan tomb decoration of a conventional sort, the theme of rebirth they embody segues flawlessly into the Christian message; there may also have been an implicit Christian message in the grapes and sheaves of wheat held by the enthroned figures on the ceiling.

The ornate framework employed to enhance the image and the pagan themes and motifs, together with the use of older Christian imagery and the apparent mistakes and misunderstandings, are precisely the characteristics of two other Roman monuments nearly contemporary to O in date, namely, the sarcophagus of Junius Bassus dated to 359 and the Mausoleum of Constantia, or Sta. Costanza, dated to ca. 350 (figs. 98–101).[65] It is interesting to observe first that the predominant imagery in both monuments is of an older Christian type. The scenes of Adam and Eve, Abraham, Daniel, and Job on the sarcophagus, or of Moses and Susanna discernible in the drawings made of the decoration of the dome of Sta. Costanza (now lost), all derive from the signitive imagery of the third century; by the mid-fourth century they must have had a distinctly old-fashioned air. Furthermore, they are arranged much like the images in O, in isolated and self-contained units.

Unlike their true signitive forebears of the third century, however, these images are not simply displayed. They are presented as monumental, elaborately enframed, and somewhat pompous works of art. On sarcophagi of the third and early fourth centuries it was often the point to pack in as much imagery, and hence as much meaning, as possible so that the individual subjects blended together as if in a monotonous litany. On the sarcophagus of Junius

64. Schumacher, "Reparatio vitae," 141, pl. 21a; idem, "Die Katakombe," 339.

65. Bovini and Brandenburg, *Repertorium der christlich-antiken Sarkophage*, 279–83, pls. 104 and 105, no.

680. Henri Stern, "Les mosaïques de l'église de Sainte Costance à Rome," *DOP*, 12, 1958, 159ff., and 166ff., where the accuracy of the drawings recording the dome decoration is discussed.

Bassus, however, the scenes are set out in an ornate, aedicular structure so that each claims attention as a work unto itself, as Kitzinger has so aptly noted.[66] This, and the fact that the figures in the scenes are now more artfully portrayed than before—with pose and physique reminiscent of classical statuary—sets Junius Bassus apart from all prior double-zone sarcophagi. Similarly, it is hard to imagine a more artful frame for the image than the one in the dome of Sta. Costanza. Here the small panels with Christian scenes are arranged in a lush framework of floral candelabra and caryatids that rest on little islands in a sea filled with sporting putti (fig. 100). In both monuments, too, the setting of the Christian scenes is elaborated with pagan motifs. The two center columns on both front registers of the sarcophagus (fig. 98) are covered with reliefs of vintaging putti, and on its small sides (fig. 99) putti, densely packed in two superimposed friezes, harvest grapes and wheat, precisely the theme found in the pagan element of the decoration of cubiculum O. The grape harvest is also represented at Sta. Costanza in the vault mosaics of the ambulatory, where it occurs in conjunction with busts that have been convincingly identified as Dionysus and Ariadne (fig. 101), an apparent allusion to the long pagan association of death and Dionysiac bliss.[67]

Finally, there is evidence that the two monuments contain iconographic mistakes. No satisfactory explanation has yet been offered for the apparent transposition of two scenes on the sarcophagus of Junius Bassus: the upper left panel showing the Sacrifice of Abraham which appears in a register that otherwise contains only scenes having to do with the arrest of Christ and Peter located on either side of a representation of Christ between Peter and Paul, and the lower right panel showing the arrest of Paul which appears in a register with Old Testament scenes placed flanking Christ's Entry into Jerusalem.[68] From a logical and programmatic point of view, the two scenes, of Abraham and Paul, should have been reversed. Thus the present order may be a mistake made by an artist or patron perhaps insufficiently familiar with or mindful of the imagery he was using. In Sta. Costanza, there is evidence, albeit indirect, of a mistake of another sort. In the scene identified by Stern, mistakenly in my opinion, as Lot receiving the Angels before Sodom (see fig. 100, second scene from the left) a figure seated beside a building is engaged in conversation with two standing figures.[69] The scene is so close to Early Christian and Medieval representations of the Vision of Abraham at Mambre that it would seem difficult to identify it as anything else.[70] Yet if this was the case, the artist has erred in failing to show a third visitor explicitly called for by the text.[71]

There is, it seems to me, one clear and unambiguous explanation for these qualities; it lies in the realm of patronage. The sarcophagus, commissioned by the *Praefectus Urbis* and a member of one of the most prominent aristocratic families of Rome, and the mausoleum, built for the

66. Kitzinger, *Byzantine Art*, 26.

67. Werner Jobst, "Die Büsten im Weingartenmosaik von Santa Costanza," *RM*, 83, 1976, 431–37, and idem, *Römische Mosaiken aus Ephesus I. Die Hanghäuser des Embolos* (=*Forschungen in Ephesos* VIII/2), Vienna, 1977, 74. See also Martin P. Nilsson, *The Dionysiac Mysteries of the Hellenistic and Roman Age*, Lund, 1957, 116ff.; Robert Turcan, *Les sarcophages romains à représentations dionysiaques*, Paris, 1966; Friedrich Matz, *Die dionysischen Sarkophage*, Berlin, 1968–75, vols. 1–4. The floor mosaic that presumably once adorned the mausoleum, showing Silenus and a companion in the midst of a vine scroll, lends support to this hypothesis; see Stern, "Les mosaïques," fig. 58; Karl Lehmann, "Sta. Costanza," *ArtB*, 37, 1955, 193ff., fig. 3.

68. Cf. the remarks of Friedrich Gerke, *Der Sarkophag des Junius Bassus*, Berlin, 1936, 16; George M. A. Hanfmann, *Season Sarcophagus*, 184f.; no. 540 (on confusions in the season imagery); Marion Lawrence, "Columnar Sarcophagi in the Latin West," *ArtB*, 14, 1932, 131f. (on certain decorative peculiarities). See also the convoluted interpretation offered by J. A. Gaertner, "Zur Deutung des Junius–Bassus–Sarkophages," *JdI*, 83, 1968, 240ff.

69. Stern, "Les mosaïques de Sainte Costance," 176f.

70. Kötzsche-Breitenbruch, *Die neue Katakombe*, 56ff., pls. 6–8.

71. Gen. 18:2.

daughter of the emperor, represent the highest level of patronage. They issued from a circle in which Christianity was not a deep-seated tradition but a relatively recent innovation, and this circumstance may explain the character of the Christian imagery found here.[72] The images used in both monuments were born as humble signs of a fervent religiosity; here they have become signs of a different sort. Because of their age-old character they proclaim the patron's adherence to the Christian tradition in its most venerable manifestation. They explicitly associate the new aristocratic Christian with ancient Christianity, thus giving him a kind of pedigree he would not otherwise have had. Hence the artfulness with which these images are displayed. They are set out proudly as visible tokens of a time–honored faith in the context of the conventions of aristocratic Roman funerary decoration. And hence, too, the apparent mistakes made in transcribing them. What mattered here above all was not the original message of deliverance and redemption but the fact that the images were venerable Christian representations.[73] That the images had been used and revered by Christians in the past was sufficient justification for employing them. Because the original message was no longer of foremost concern, a door was opened to a variety of mistakes and misunderstandings.

This interpretation may also offer us insight into different and yet related problems of the period. For example, around mid-century there appeared for the first time the scene of Christ the lawgiver flanked by Peter and Paul—the *traditio legis*.[74] The scene is found primarily on sarcophagi, as, for example, the sarcophagus of Junius Bassus (fig. 98), but it also occurs in other monuments, including Sta. Costanza.[75] It has often and persuasively been argued that the scene was originally created for the apse of a church; because of the prominence of the apostle Peter, it is assumed that this church was the Vatican basilica.[76] The courtly and ceremonial aspect of the image clearly befitted this monumental setting. But what purpose did the image serve in the altogether different context of the private tomb? In light of the usage of ancient Christian imagery by the Roman aristocracy outlined here it may be argued that the *traditio legis* also served as a kind of token of association with the Christian tradition, not, however, in its ancient manifestation, but as embodied in that religion's primary locus in Rome.

I would argue, therefore, that the use of imagery in cubiculum O was also of this superficial sort. The patron or painter of the room, a member of what I have suggested was a class of "new" Christians, wished to create a Christian pedigree for himself. So motivated, he took what he believed were representations of a traditional, perhaps even archaic, Christianity—the Crossing of the Red Sea and the scene opposite it in cubiculum C—and copied them or had them copied in O. The only problem was that the older imagery was no longer properly understood—thus Joshua's mission became the Raising of Lazarus, and a system of signs was made out of what had before been essentially expressive of deeply felt spiritual aspirations.

The remaining Christian images in O also seem to fit this pattern in two respects. First, they all come from the signitive tradition of the third century; Daniel, Noah, the Three Hebrews

72. See Peter Brown's illuminating study, "Aspects of the Christianization of the Roman Aristocracy," 1ff. (in *Religion and Society*, 161ff.), and idem, "Dalla 'Plebs Romana' alla 'Plebs Dei': Aspetti della cristianizzazione di Roma," in *Governanti e intellettuali popolo di Roma e popolo di Dio (I–VI secolo) (=Passatopresente 2)*, Turin, 1982, 123–45. Raban von Haehling, *Die Religionszugehörigkeit der hohen Amtsträger des römischen Reiches seit Constantins I. Alleinherrschaft bis zum Ende der theodosianischen Dynastie (324–450 bzw. 455 n. Chr.)*, Bonn, 1978.

73. Thus a typological program, as implied by

Lehmann, "Sta. Costanza," 93, and Beat Brenk, *Spätantike und frühes Christentum*, 50, seems to me out of the question. The larger context for the usage argued here is described by Kitzinger, "Christian Imagery" (supra n. 57), 141ff.

74. The most extensive recent treatment of the problem is by Cäcilia Davis-Weyer, "Das Traditio-Legis-Bild und seine Nachfolge," 7ff.

75. Ibid., figs. 1–7 (sarcophagi) and 8 (Sta. Costanza).

76. Ibid., 10ff.; Kitzinger, "Christian Imagery," 144f.

and the Orant are among the earliest Christian subjects known. Three of them, in fact, are also represented in the first part of the catacomb—Daniel, the Orant, and Balaam—and these, though different from the later representations, may have served as a source of inspiration for the artist of O. Second, in both the Multiplication of the Loaves and Noah (fig. 96), the heads of the figures have been repainted. Though we cannot be sure of the purpose of these changes, or indeed of the appearance of the original forms, we can be reasonably certain that the new heads were added soon after the old ones were finished because the colors in both parts of the paintings match so closely. This, in turn, implies but does not of course prove that some sort of miscalculation was made.

We cannot conclude without some mention of the pagan decoration of the room. Though this in itself could easily be the subject of a lengthy study,[77] for now, one point will suffice: that the pagan motifs in O also seem cut off from the religious sentiment to which they originally owed their existence. Because imagery like the Ceres and Persephone in O was employed in Roman tombs throughout antiquity and without interruption we cannot really speak of a harking back to an earlier time in this case. But the presence of these motifs in a Christian context surely implies a desire to preserve a part of the Roman past.[78] But what part? In this regard it is interesting to observe that pagan themes are used here in a particular way. In the case of cubiculum O and related monuments, the pagan motifs chosen seem to be those that either made a passive reference to Christianity—in the wheat and grapes—or embodied themes like personal salvation, eternal life, and the blissful afterlife that corroborated Christian notions.[79] It is as if something external to the images were the determining force behind the selection, a standard to be applied to traditional forms and concepts. And herein lies the difference between the pagan image in O and its prototypes. The images in O do not spring from an internally coherent, pagan system of values; they are generated in response to Christianity itself.[80] Thus they represent an essentially Christian usage in the manner of the Virgilian centos of Faltonia Betitia Proba or the Calendar of 354.[81] For the Christian, this very act made the past coherent with the present. But for the true pagan, it must have been tantamount to denying the past validity.[82] Hence, for instance, the emperor Julian's insistence that Christians not teach about paganism.[83] If cubiculum O, the sarcophagus of Junius Bassus, and the mosaics of Sta. Costanza tell at least part of the story accurately, it was the Christian usurpation of the pagan past that was one of the true pagan's most justified fears.

77. For instance, see most recently Josef Engemann, "Altes und Neues zu Beispielen heidnischer und christlicher Katakombenbilder im spätantiken Rom," *JbAChr*, 26, 1983, 128ff.

78. Our analysis of the imagery of O need not have any bearing on the motifs in the cubicula that are entirely pagan, namely E and N, for it would seem that these were the tombs of pagans (contra E.R. Goodenough, "Catacomb Art," 133, and Josef Fink, "Lazarus an der Via Latina," 209ff.). Ferrua has explained this situation in terms of a split family; *Le pitture*, 93f. In light of the commercial hypothesis outlined in chapter 2, however, we need not assume that the owners of the tombs in the second part of the catacomb were related to one another. See also, Marcel Simon, "Remarques sur la Catacombe," 327ff., esp. 333.

79. Schumacher, "Die Katakombe," 338.

80. Cf. Simon's remarks on the pagan imagery in the catacomb ("Remarques," 330f.), although aspects of his interpretation—the scene of Lazarus in O, the influence of the pagan imagery—seem forced.

81. *Cento Probae*, ed. Carl Schenkl (=*CSEL* xvi), Vienna, 1888. Henri Stern, *Le calendrier de 354*, 111ff.

82. R.A. Markus, "Paganism, Christianity and the Latin Classics in the Fourth Century," *Latin Literature of the Fourth Century*, ed. J.W. Binns, London, 1974, 1ff.; A.H.M. Jones, "The Social Background of the Struggle between Paganism and Christianity," *The Conflict between Paganism and Christianity in the Fourth Century*, ed. Arnaldo Momigliano, Oxford, 1963, 17ff.

83. Julian, Letter 36, "Rescript on Christian Teachers," in *The Works of the Emperor Julian*, trans. W.C. Wright, New York, 1923, 117ff. See Johannes Geffcken, *The Last Days of Greco-Roman Paganism*, trans. Sabine MacCormack, Oxford, 1978, 141ff.; Polymnia Athanassiadi-Fowden, *Julian and Hellenism*, Oxford, 1981, 121ff.

V

A Wider View: Implications and Causes

I
T would transcend the limits of our present task to discuss the implications of all the
developments we have touched on in the foregoing analysis. Yet we might well ask
how the discontinuities we have observed in the Via Latina catacomb fit into the larger
scheme of things. In this, the concluding chapter, I would like to take up the issue of the
larger context partly to answer this question and partly for another reason: because it will
help to establish the milieu and hence the underlying cause of the act of imitation recorded
in cubiculum O.

Regarding the architectural plan, we can be brief. What we saw in the catacomb was the
replacement of a traditional Roman form in Phase I/II by a new plan in Phase III/IV that was
derived, in my hypothesis, from the East and was meant to serve, if not entirely at least in part,
as a commercial endeavour. This change cannot be documented in any other catacomb, or at
least not to such an extent. In the catacomb of Domitilla, for instance, we find groups of
polygonal cubicula planned as a whole in the mid-fourth century and set into, as it were, an
otherwise traditional Roman plan going back to the third century.[1] But if this were evidence of
Eastern influence, it would be on a small scale. The explanation for the anomalous position of
the Via Latina catacomb in this regard may lie in the fact that it was one of the few catacombs
ever developed as a private enterprise.[2] Most of the other Roman catacombs, and all of those
that are now well known, were large undertakings administered by the church.

1. Nestori, *Repertorio,* fig. 28, cubicula 39–40 and
68–69. See also chapter 2, n. 60.

2. Among the other tombs that were also presuma-
bly private are an anonymous Christian hypogeum

With the style of the painting of the catacomb, however, the situation is quite different. For what we have observed here, the displacement of a traditional Late Antonine/Severan style that had persisted through the third and into the early fourth century by a new style created ca. 300 in the ambient of the tetrarchic court, seems to have been a widespread phenomenon.

The essential continuity we noted in cubicula A–C is corroborated by studies of third-century painting in general, by Borda and Joyce, for example, and in particular by studies of the Ostian material, perhaps the richest sequence of Late Antique wall painting in the Roman ambient, by Felletti Maj, Moreno, Gasparri, and Van Essen.[3] What they do not recognize, however, is a shift in emphasis like the one we discerned in the relationship between cubicula A–C and their sources, though this too seems to have been a broader pattern of the period. Within this time span we may thus distinguish two phases: one of the late second-early third centuries on the one hand, and the other of the later third and early fourth centuries on the other.

The principal event of the first phase, which we may call "dynamic," was the emergence in the second quarter of the third century of the linear style; this betokened a fundamental change in the form and, more significantly, in the structure of Roman wall design.[4] Ever since the appearance of the Third Style in the late first century B.C., non-structural tendencies had held sway in Roman, specifically city-Roman, painting, but never to this extreme: here, in the linear style (fig. 102), the design, though vaguely reminiscent of the architectural schemes of the past, as Bianchi Bandinelli and others have observed, is now wholly abstract: it is composed of lines, dots, and dashes in red and green, boldly and asymmetrically arranged, with no clear division of zones on the walls and with minimal differentiation in pattern between wall and ceiling.[5] The most interesting questions are why this style was created—for it presumes a high degree of understanding of abstraction on the part of its audience—and where, though these are questions we cannot hope to answer with the evidence now available to us.

We can say, however, that the basic principles that this design type embodies seem to have been adhered to in other formats of the period. The band system, as we observed in the Lateran examples, is one of these; another is the design exemplified by the Severan decoration of the Inn of the Peacock in Ostia.[6] The scheme in rooms 6 and 9 of the inn, for example, derives from a type of decoration known as the "panel system," as illustrated in rooms 11 and 15 of the House of the Muses in Ostia or room β beneath San Sebastiano, both dated to the mid-second century.[7] In the earlier paintings the wall is given a comprehensible structure with clearly

discovered on the Via Prenestina (see *NBACr*, 20/1-2, 1914, 33), the hypogeum discovered under the "Casale dei Pupazzi" on the Via Appia (see Antonio Ferrua, "Un piccolo ipogeo sull'Appia antica," *RACr*, 39, 1963, 175ff., esp. 185), the catacomb of Vibia (see Ferrua, "La catacomba di Vibia," *RACr*, 47, 1971, 7ff.), and a small catacomb discovered in 1903 on the Via Latina (see Margherita Guarducci, "Valentiniani a Roma: ricerche epigrafiche ed archeologiche," *RM*, 80, 1973, 187f.; Wilpert, *Le pitture*, pls. 265–67). See also Pasquale Testini, *Le catacombe*, 141ff.

3. Maurizio Borda, *La pittura romana*, 112ff.; Joyce, *Decoration of Walls*, 64ff.; Felletti Maj, *Le pitture delle case delle volte dipinte*, 36ff., 52ff.; idem and Paolo Moreno, *Le pitture della casa delle Muse*, 61ff.; Carlo Gasparri, *Le*

pitture della Caupona del Pavone, 27ff.; C.C. van Essen, "Studio cronologico," 165ff. A corresponding development in the East is affirmed by V.M. Strocka, *Die Wandmalerei der Hanghäuser in Ephesos*, 141ff.

4. Wirth, *RW*, 165ff.; Harald Mielsch, "Verlorene römische Wandmalereien," *RM*, 1975, 126ff.; Kitzinger, *Byzantine Art*, 20.

5. Ranuccio Bianchi Bandinelli, *Rome. The Late Empire*, 86ff.; Irving Lavin, "Ceiling Frescoes in Trier," 107.

6. Gasparri, *Le pitture*, 15ff., 22ff., pls. I, II, VII.1, VIII, X.

7. Felletti Maj and Moreno, *Casa delle Muse*, 43ff., pls. XV.2, XVII.1; Paul Styger, *Il monumento apostolico*

defined zones of panels. In the Inn of the Peacock, however, though the basic element, the panel, is the same, this structure has vanished: the wall is seen as if through a kaleidescope; a coherent pattern is never stabilized.

This quality of agitation soon disappears from painting. The period of the later third and early fourth centuries, which we may call the "static" phase, witnessed, largely within the context of the dynamic designs of the early third century, the re-integration of the wall as a two-dimensional surface. The phenomenon is one with which we are already familiar from cubicula A–C, hence we may be brief. The same flattening that took place in the band system also occurred in the vastly more popular linear style. To take only one example, the early-fourth-century ceiling in cubiculum N69 of the catacomb of Petrus and Marcellinus (fig. 103):[8] the ceiling is based on a design similar to the one found in the Tomb of the Statilii and Alii dated to the early third century (fig. 104).[9] Whereas in the earlier painting the design seems to fluctuate between flat surface and airy spaciousness, in the later one this quality of spatial ambivalence is wholly lacking. All of the elements, the figural and decorative motifs and the linear framework, have the same substance so that the entire decoration appears flat. Similarly, in a fresco decoration in Bolsena dating, in all probability, to the late third century, the design employed is essentially two-dimensional in character: above a red socle are set large yellow panels separated by red and white vertical divisions.[10] This style lasted until the second quarter of the fourth century; after that there is no evidence of it in Rome.[11]

It was from this context at the end of a tradition that the style of A–C emerged. Concurrently, the new tetrarchic style first appeared in Rome. Traces of it occur at the very end of the third and the beginning of the fourth centuries—more precise dates are lacking—in the fictive marble designs of the baths under the Lateran Baptistery, in room VIII (wall c) of the House of the Yellow Walls, and in room X (the triclinium) of the House of the Muses at Ostia.[12] Tangible proof of connections with tetrarchic painting is provided by an example of the early Constantinian period, in the room of an insula beneath the church of Ss. Giovanni e Paolo.[13]

della via Appia (=DissPontAcc, Serie II, 13), Rome, 1918, 106f., figs. 53–55; F. Tolotti, Memorie degli Apostoli in catacumbas (=Collezione "Amici delle Catacombe" 19), Vatican City, 1953, 142ff.; Joyce, Decoration of Walls, 35, fig. 26.

8. Wilpert, Le pitture, pl. 61.

9. Ernest Nash, A Pictorial Dictionary of Ancient Rome, London, 1968, vol. II, 366, fig. 1149, s.v. "Sepulchrum Statiliorum et Aliorum"; see also Maurizio Borda, "Il fregio pittorico delle origini di Roma," Capitolium, 34/5, 1959, 3ff.

10. Jean Andreau, Alix Barbet, and Jean-Marie Pailler, "Bolsena (Poggio Moscini): bilan provisoire des trois dernières campagnes (1967, 1968, 1969)," MélRome, 82, 1970, 227, 230f.

11. Among the last examples of this style are the paintings discovered under the Farnesina ai Baullari and now in the Museo Barracco (Affreschi romani dalle raccolte dell'Antiquarium Communale, Rome, 1976, 49ff., no. 8), and the wall paintings in the so-called hypogeum of Diana (see Luisanna Usai, "L'ipogeo di via Livenza in Roma," Dialoghi di Archeologia, 6, 1972, 363ff.). Both decorations have been dated plausibly to mid-century.

12. Giovanni Pelliccioni, "Le nuove scoperte sulle origini del battistero lateranense," MemPontAcc, Serie III, 12/1, 1973, figs. 101, 114, 125, pl. VIII.1; Felletti Maj, Le pitture, 49, 54, pl. XIII.3; Felletti Maj and Moreno, Casa delle Muse, 38ff., pl. XIII. See also Van Essen, "Studio cronologico," 180, fig. 3 (Caupona detto Termopolio); Friedrich Gerke, "Die Wandmalereien der neugefundenen Grabkammer in Pécs," 126f.; Joyce, Decoration of Walls, 66f.

13. Harald Mielsch, "Zur stadtrömischen Malerei," 158ff., pls. 81ff. Mielsch also takes note of the fact that the "incrustation style" exemplified by the walls of the room of the orant is a late third-early fourth century innovation in Rome (164). M. Trinci Cecchelli claims that the fictive revetment was painted over a previous design dated by the author to the mid-third century; see "Osservazioni sul complesso della 'Domus' celimontana dei Ss. Giovanni e Paolo," Atti del IX Congresso Internazionale di Archeologia Cristiana, Rome, 1975 (=Studi di Antichità Cristiana 32), Vatican City, 1978, vol. I, 558ff. I have not been able to verify this claim. The building to which the room belongs underwent several phases of renovation; see Richard Krautheimer, Corpus Basilicarum Christianarum Romae, Vatican City, 1937, vol. I, 276ff.

Here there occurs the roundel motif with interlocking squares (fig. 105, at the far right side) also found at Luxor and Piazza Armerina.[14]

Instances of the use of this style increase steadily through the first half of the fourth century in the Roman catacombs; decorations at Aquileia, Stobi, and York demonstrate that this usage was a widespread phenomenon.[15] The persistence of this style into the later fourth century, often in quite modest contexts, is clear evidence of the popularity of the tetrarchic innovation. In a private tomb unearthed in Bulgaria, at Silistra, probably of the third quarter of the fourth century or later, the figure of the deceased in the central panel on the rear wall of the chamber (fig. 106) bears a distinct resemblance to the older official in the Great Hunt at Piazza Armerina (fig. 107), while the band of simulated projecting consoles above recalls the same motif at Ephesus.[16] And the wall design of the peristyle court of Piazza Armerina and of the Trier room was Christianized in a villa from the second half of the fourth century at Lullingstone, Kent, by the addition of figures of orants.[17]

The reason for the longevity of the tetrarchic style seems to have been its continued influence at court and in an aristocratic context. Though the evidence of court painting in Rome in the late third and early fourth centuries is scattered and fragmentary, two monuments bear witness to tetrarchic innovations, the villa of Maxentius on the Via Appia, ca. 306–12, and the so-called Domus Faustae, discovered near the Lateran and dating between 315 and 337, where the decoration was presumably sponsored by a member of the court. In the first example the innovations are visible in the structural design of a painted coffered vault in the entrance to the circus, and in the second in the style of figures whose emphatic contours and firm modeling recall the paintings of Luxor and the mosaics and paintings of Piazza Armerina.[18]

14. Above, chapter 3, pp. 38–39. The motif also occurs in an early-fourth-century decoration in Marsala; see G. Agnello, *La pittura paleocristiana della Sicilia* (=*Collezione "Amici delle Catacombe"* 17), Vatican City, 1952, fig. 29.

15. Wilpert, *Le pitture,* pls. 13 (Priscilla N37), 31.1 (Domitilla N49), 54.1 and 2 (Domitilla N31), 143.1 (Calixtus N46), 194 and 195 (Domitilla N74), 229 (Domitilla N45), and 248 (Domitilla N50); Enrico Josi, "Le pitture rinvenute nel cimitero dei Giordani," *RACr,* 5, 1928, figs. 2, 11, 13–15, 37; Antonio Ferrua, "Un nuovo cubicolo dipinto della via Latina," *RendPontAcc,* Serie III, 45, 1972–73 (1974), 171ff. (socle zone); Nestori, *Repertorio,* 202, s.v. "marmo." See also *AA,* 88, 1973, 527 (Mithreum under S. Stefano Rotondo). For Aquileia, see Carlo Cecchelli in *La basilica di Aquileia,* Bologna, 1933, figs. 9, 11, pl. XXIII; Josef Fink, *Der Ursprung der ältesten Kirchen am Domplatz von Aquileja,* Cologne, 1954, 52ff., fig. 9; Heinz Kähler, *Die spätantiken Bauten unter dem Dom von Aquileia,* Saarbrücken, 1957, 30f., pl. 6. The painting from Stobi, revealed in a recent excavation underneath the episcopal basilica, was brought to my attention by Dr. Blaga Aleksova, to whom I am most grateful. It shows a row of columns separated by panels of marble revetment with designs similar to those at Ephesus and Luxor. According to Dr. Aleksova, the painting dates to the second quarter of the fourth century. For York, see Norman Davey and Roger Ling, *Wall Painting in Roman Britain,* Glou-

cester, 1982, 201ff., pl. CI; clearly related are decorations at Collingham, 102ff., pl. XXXVI (third-fourth century), and Water Newton, 217, pl. CIX (date uncertain).

16. A. Frova, *Pittura romana,* fig. 1; D. Dimitrov, "Le système décoratif et la date des peintures murales du tombeau antique de Silistra," *CahArch,* 12, 1962, 35ff.

17. Davey and Ling, *Wall Painting in Roman Britain,* 138ff., pl. LVI.

18. The vault painting in the villa of Maxentius was recorded by Bianconi and discussed by Harald Mielsch, "Zur stadtrömischen Malerei," 152, fig. 1. Bianconi noted that the painting decorated the "Porta Triumphalis" of the circus; unbeknownst to Mielsch, portions of the decoration still survive. On the villa and circus, see A. Frazer, "The Iconography of the Emperor Maxentius' Buildings on the Via Appia," *ArtB,* 48, 1966, 385ff. Recent excavations have uncovered some wall painting from the villa, but mostly from building phases that pre-date Maxentius. For the early fourth century only negligible remains have been found on the site; see Giuseppina Pisani Sartorio and Raissa Calza, *La villa di Massenzio sulla via Appia: Il palazzo, le opere d'arte,* Rome, 1976, 49ff., 91, 128. The third component of the Maxentian complex, the tomb, has not been thoroughly investigated. None of its decoration, however, has survived; see Pisani Sartorio and Romana de Angelis Bertolotti, "Tomba di Romolo sulla via Appia," *Archeologia Laziale,* 2, 1979, 107ff.; A. Frazer, "From

For the Constantinian period, the Trier decoration is a case in point. Even though this decoration has been cited as an instance of Constantinian classicism, it clearly relates to tetrarchic precedent in figure style and design—with its simulated pilasters separated by panels of marble revetment and life-size figures that echo the paintings of Piazza Armerina and Ephesus.[19] For example, the figure of a woman holding a jewelry box at Trier (fig. 108), though softer and more unified overall, closely resembles the Ambrosia of Piazza Armerina (fig. 109) particularly in the tilt of the head and the prominence of the eyes.[20] Doubtless the style of Trier and hence of Constantinian court painting in general was built on a tetrarchic base. So too was the style of the mosaics at Centcelles, near Tarragona, which are even later in date. The mosaics decorate the dome of a mausoleum dated to ca. 350 and built, as some have suggested, for a son of Constantine—though the evidence on this point is not compelling—or an official of the realm.[21] The three concentric bands around the central medallion contain a series of small Christian scenes together with representations of the seasons and appropriate labors that are populated with figures that, with their blocky proportions and sharp-edged features, perpetuate the style of Piazza Armerina (figs. 110, 111).[22] Moreover, the architectural division of the lowermost zone evokes tetrarchic schemes whose columns, like the ones at Centcelles, are shaded to suggest the third dimension.[23]

Yet, in time, the changes in this style became more extreme. We can sketch briefly the

Column to Wall: The Peribolos of the Mausoleum of Maxentius," *In Memoriam Otto Brendel,* ed. L. Bonfante and H. von Heintze, Mainz, 1976, 185ff.

On the development of the coffered ceiling, see Doro Levi, *Antioch Mosaic Pavements,* vol. 1, 381ff.; F.W. Deichmann "Kassettendecken," 83ff. It is interesting to observe that painted coffered ceilings become widespread in the catacombs only in the fourth century, and many of these find parallels in the East: the ceiling of cubiculum N7 of Marcus and Marcellianus (Wilpert, *Le pitture,* pl. 177.2) and of arcosolium N2 of Hippolytus (Foto Ipp. A17) resemble a third-century stone ceiling from Palmyra (Robert Wood, *The Ruins of Palmyra,* London, 1753, pl. XLId); also close are the vaults of the right arcosolium in cubiculum N2 of the "Four Orants" (Wilpert, pl. 211.2) and another ceiling from the same Palmyrene tomb (Wood, pl. XLIc). As for the Via Latina catacomb, many of the coffered designs of the second part also find parallels in the East: compare the vault of the left arcosolium in F (Ferrua, *Le pitture,* pl. XLVII) and a third-century stone ceiling from Palmyra (Wood, pl. XIXa); the soffit in D (partly discernible in Ferrua, pl. XLII) and a stone soffit in Miletus (Herbert Knachfuss, *Der Südmarkt und die benachbarten Bauanlagen* (=*Milet,* ed. Theodor Wiegand, I.7) Berlin, 1924, fig. 106); the vault of the right arcosolium in F (Ferrua, pl. LI, incorrectly labeled "sinistra") and the ceiling of Tomb B of the Anfushi complex in Alexandria (Rudolf Pagenstecher, *Nekropolis,* 116ff., 180ff., figs. 77, 111; Blanche R. Brown, *Ptolemaic Paintings and Mosaics,* 53f., fig. 2).

For the "Domus Faustae," see Valnea Santa Maria Scrinari, "Per la storia e la topografia del Laterano," *BA,* 50, 1965, 38ff.; idem, "Nuove testimonianze per la 'Domus Faustae,' " *RendPontAcc,* Serie III, 43, 1970–71,

207ff.; Ernest Nash, "Convenerunt in domum Faustae in Laterano, S. Optati Milevitani I, 23," *RQ,* 71, 1976, 1ff.; Mielsch, "Zur stadtrömischen Malerei," 175ff. See also the related painting of the "Dea Barberini"; Michelangelo Cagiano de Azevedo, "La Dea Barberini," *RIASA,* n.s. 3, 1954, 108ff.

19. Lavin, "Ceiling Frescoes in Trier," 97ff. In recent years, more of the ceiling has been recovered; see Theodor Konrad Kempf, "Die konstantinischen Deckenmalereien aus dem Trierer Dom," *Archäologisches Korrespondenzblatt,* 7, 1977, 147ff.; and most recently, Winfried Weber, *Constantinische Deckengemälde aus dem römischen Palast unter dem Trierer Dom,* Trier, 1984 (I am grateful to Anna Gonosová for this reference).

20. Lavin, "Ceiling Frescoes in Trier," fig. 6; Bernard Andreae, *The Art of Rome,* pl. 156. Gino V. Gentili, *La villa erculia di Piazza Armerina,* pl. LVI.

21. F. Camprubi, "I mosaici della cupola di Centcelles nella Spagna," *RACr,* 19, 1942, 87ff.; H. Schlunk, "Untersuchungen im frühchristlichen Mausoleum von Centcelles," *Neue deutsche Ausgrabungen im Mittelmeergebiet und im Vorderen Orient,* Berlin, 1959, 344ff.; T. Hauschild and H. Schlunk, "Vorbericht über die Arbeiten," 119ff., and 175ff. on the date of ca. 350 proposed by the authors for the mausoleum; T. Hauschild, "Untersuchungen im Monument von Centcelles (Tarragona)," *Actas del VIII Congreso Internacional de Arqueologia Cristiana,* Barcelona, 1969 (=*Studi di Antichità Cristiana* 30), Vatican City-Barcelona, 1972, 333ff., pls. CXLVff.; H. Schlunk, "Bericht über die Arbeiten in der Mosaikkuppel von Centcelles," ibid., 459ff., pls. CCff.

22. Hauschild and Schlunk, "Vorbericht über die Arbeiten," pls. 23–26.

23. Ibid., pl. 29.

development subsequent to the Via Latina catacomb with two examples of the projecting console motif. This motif, employed at Ephesus with an architectural logic, has become, in a tomb in Nicaea dated to the second half of the fourth century, an ornamental device (fig. 112).[24] The consoles still decorate the upper part of the wall, but they are now arranged within a frame that deprives them of clear architectural meaning. In the late fourth or perhaps even the fifth century, at Stobi, the motif has migrated to the ceiling where, severed from architectural reality altogether, individual consoles are now enframed in square panels like coffers (fig. 113).[25] Thus, the motif was no longer perceived as a three-dimensional architectural structure but rather as a two-dimensional surface cover. The transformation of architectural motifs into two-dimensional schemata is, in a sense, the true achievement of the wall design of the later fourth and early fifth centuries, since it set a pattern of usage for much of medieval painting in the West.[26] But a predilection for the two-dimensional matrix presumes some continuity with earlier developments, for it surely had roots in the painting of the static phase of the later third and early fourth centuries.

Turning, finally, to the use of imagery, we discover that the phenomena we observed in the Via Latina catacomb were in part unusual and in part common in their time. What was unusual was the programmatic aspect of the decoration of cubiculum C. To judge from the surviving evidence, programmatic decorations were virtually unknown in a Christian context until a much later period.[27] There is, in fact, only one precedent for C in this respect: it is a monument we have referred to often regarding the sources of the style, choice, and arrangement of the scenes in cubicula A–C, as well as the sources of certain motifs in C. It is the Dura Synagogue. Almost every aspect of the decoration of the synagogue has been the subject of a scholarly dispute whose outcome is still uncertain, but there is little doubt today about one point: that the ensemble formed a programmatic whole.[28] The fact that it did so, uniquely among extant monuments in the third century, raises again the question of Jewish influence on Early Christian art, a question that we still cannot answer. Only archaeology now holds any hope of uncovering a tangible link between the two realms in this respect. And it is interesting to contemplate the Dura situation again, which would seem to contain all of the ingredients one assumes were necessary: the physical proximity of Jewish and Christian communities together with their arts respectively complex and simple, sophisticated and rudimentary. Had such conditions persisted into the second half of the third century, actual influence might have occurred at Dura (had the town survived), or anywhere else, for that matter, where these circumstances were reproduced.

What was apparently more common was the copying of early imagery noted in cubiculum O. There is evidence that such copying began much earlier in the fourth century. Among the

24. Nezih Firatli, "An Early Byzantine Hypogeum Discovered at Iznik," *Mélanges Mansel*, Ankara, 1974, vol. 2, 919ff.

25. James Wiseman, "Stobi in Yugoslavian Macedonia: Archaeological Excavations and Research, 1977–78," *Journal of Field Archaeology*, 5, 1978, 398, 405f., fig. 9.

26. See, for example, Otto Demus, *Romanesque Mural Painting*, trans. Mary Whittall, New York, 1968, pls. 27 (Sant'Angelo in Formis), 208 (San Clemente de Tahull), 242 (Niederzell auf der Reichenau, Sankt Peter und Paul), 260 (Perschen bei Nabburg, Friedhofkapelle); C.R. Dodwell, *Painting in Europe. 800 to 1200*, Baltimore, 1971, fig. 9 (Trier, wall painting from St. Maximin). Lavin, "Ceiling Frescoes in Trier," 112f.

27. M.L. Thompson, "The Monumental and Literary Evidence for Programmatic Painting in Antiquity," *Marsyas*, 9, 1960/1, 36ff. See above, chapter 4, pp. 64–65.

28. Much of the debate, at least up to 1956, was summarized by Carl Kraeling in *The Synagogue*, 340ff. For the discussion since then, see Joseph Gutmann, "Programmatic Painting in the Dura Synagogue," in *The Dura-Europos Synagogue, a Re-evaluation (1932–1972)*, ed. Gutmann, Missoula, MT, 1973, 137ff.

few scraps of decoration still visible in the Renaissance on the walls of the Mausoleum of Helena (actually the intended Mausoleum of Constantine, about which we have already spoken) were, to quote Antonio Bosio's description of 1594: ". . . alcune figure di santi, con le diademe rotonde, di mosaico; se bene per l'antichità, molto consumate e guaste; tra i quali santi avvertimmo, che uno haveva il fuoco a i piedi. . . ."[29] Doubtless these figures represented the Three Hebrews in the Fiery Furnace, as A. Recio has suggested.[30] But it is unlikely that this then-ancient Christian image stood alone; other scenes of a similar sort must have accompanied it. Given the type of decoration this identification suggests and the architectural context, it is possible that the overall scheme resembled that of Sta. Costanza, and hence that the imagery had substantially the same meaning here as it did in cubiculum O.

Furthermore, the phenomenon found in O was not limited to Rome. The mausoleum of Centcelles, after all, was decorated much like Sta. Costanza, with signitive imagery arranged in elaborately enframed panels in superimposed registers, and it is located in Spain.[31] Nor, finally, was this a phenomenon of monumental art alone. The interpretation we have given here would also seem to explain the imagery on the Brescia casket, made probably in the third quarter of the fourth century, which shows an array of scenes, many of an ancient signitive sort—the Jonah story, Daniel in the Lion's Den, the Three Hebrews in the Fiery Furnace, the Raising of Lazarus, and the Healing of the Blind Man—that have defied all attempts at interpretation in programmatic terms (fig. 114).[32] The question these scenes raise, moreover, are manifold: What is the significance of the scene on the casket's right side, which shows seven figures in a fire (The Three Hebrews? The Seven Maccabees?)? Why, in the scene to the right of this, are (presumably) the tablets of the law on the ground? Who is the figure beside the altar on the upper register of the casket's left side? These questions suggest that the imagery was, in part, misunderstood and here misrepresented.[33] Thus it seems that, for the reasons we have suggested, the phenomenon of copying was relatively widespread in the period from the time of Constantine through the third quarter of the fourth century.

All of this brings us, finally, to the issue of causes. If we are correct in our interpretation, the salient factor we have identified is a shift of interest in Christianity itself brought about by the new conditions of the fourth century. These conditions involved the transformation of the

29. A. Recio, "Una posible escena musiva paleocristiana vista por Bosio en el mausoleo de Sta. Helena," RACr, 53, 1977, 146.

30. Ibid., 150ff.

31. Hauschild and Schlunk, "Vorbericht über die Arbeiten," 146ff., fig. 3. All of the Christian scenes represented in the dome were signitive in nature: Adam and Eve, Daniel in the Lion's Den, the Jonah story, the Good Shepherd, the Refusal of the Three Hebrews to worship the Golden Idol, the Three Hebrews in the Fiery Furnace, and the Raising of Lazarus.

32. A case in point is the recent study where vague and general correlations between concepts and images are used to support a most unlikely interpretation of the casket as anti-Arian propaganda sponsored by Ambrose in Milan in 386; see Carolyn Joslin Watson, "The Program of the Brescia Casket," Gesta, xx, 1981, 283ff. For the casket, see W.F. Volbach, Elfenbeinarbeiten der Spätantike und des frühen Mittelalters, Mainz, 1976, 77f., no. 107, pl. 57 (with bibliography).

33. See, for example, Robert L. McGrath, "The Martyrdom of the Maccabees on the Brescia Casket," ArtB, 47, 1965, 257ff., where the problem of the 7 figures in the fire is discussed. While the author interprets the scene as the Martyrdom of the Maccabees, he cannot explain why the Mother and the Tutor— "two seemingly essential components" (260)—are missing from the casket. A similar case of the superficial use of imagery, kindly suggested to me by Herbert Kessler, may be made for the late-fourth-century silver reliquary in San Nazaro Maggiore, Milan; see Helmut Buschhausen, Die spätrömischen Metallscrinia und frühchristlichen Reliquiare. 1. Teil: Katalog (=Wiener Byzantinistische Studien 9), Vienna, 1971, 223ff., pls. B38ff. The sole signitive episode is the scene of the Three Hebrews, who are here oddly represented without fire and accompanied by a fourth figure (an angel?). Other details are also difficult to explain: the costume of the Magi (only two) in the Adoration, the youthful "elder" in the Judgment of Daniel, and the debate over the dead child in the Judgment of Solomon.

small and relatively stable pre-Constantinian Christian society into the large and diverse oecu-mene of the post-Constantine era; they created a circumstance in which a new constituency, of converts, would seek to define itself in terms of the past.[34] Would this not then also explain why the impulse to make complex and thematically unified decorations that came to the fore ca. 320 was submerged, only to reappear much later and in a different context? For to copy on such a scale must have exerted an essentially disruptive influence on the development of Christian imagery and a retarding effect on the growth of programmatic decoration. And finally, is not this change ultimately to be held responsible for the relationship between cubicula C and O, not to mention the form of the Via Latina catacomb itself? For what we have discovered in C is the reflection of pre-Constantinian Christian Rome in a room built and decorated as part of the modest nucleus of the catacomb, and in O, the picture of the new Christian Rome of the mid-fourth century in a room built on a grander scale and with a decoration steeped in foreign practices and less deeply motivated than before. Is it not possible, then, to read cubicula C and O as a graphic metaphor for the change that took place within fourth-century Christianity? To this extent, they would also show us in terms more concrete than we might otherwise know how the past was preserved in the present of the fourth century, how imitation, in effect, redressed discontinuity.

34. Above, chapter 4, nn. 72 and 82.

Bibliography

Achelis, Hans. *Die Katakomben von Neapel*. Leipzig, 1936.

Age of Spirituality: A Symposium, ed. Kurt Weitzmann. New York, 1980.

Age of Spirituality, Catalogue of the Exhibition at the Metropolitan Museum of Art, ed. Kurt Weitzmann. New York, 1979.

Agnello, Giuseppe. *La pittura paleocristiana della Sicilia* (= *Collezione "Amici delle catacombe"* 17). Vatican City, 1952.

Alföldi, Maria R. *Die constantinische Goldprägung*. Mainz, 1963.

Ampolo, Carmine, Andrea Carandini, Giuseppe Pucci, and Patrizio Pensabene. "La villa del Casale a Piazza Armerina: Problemi, saggi stratigrafici ed altre ricerche," *MélRome, Antiquité*, 83, 1971, 141–281.

Andreae, Bernard. *The Art of Rome*, trans. R.E. Wolf. New York, 1977.

——. *Studien zur römischen Grabkunst* (=*RM*, Ergänzungsband 9). Heidelberg, 1963.

Becatti, Giovanni. "Case ostiensi del tardo impero, I–II," *BA*, 33, 1948, 102–28, 197–224.

Benoit, Fernand. *Sarcophages paléochrétiens d'Arles et de Marseille*. Paris, 1954.

Beyer, Hermann Wolfgang, and Hans Lietzmann. *Die jüdische Katakombe der Villa Torlonia in Rome*. Berlin-Leipzig, 1930.

Bianchi Bandinelli, Ranuccio. "Continuità ellenistica nella pittura di età medio- e tardo-romana," *RIASA*, N.S. 2, 1953, 77–161.

——. *Rome. The Late Empire*, trans. Peter Green. New York, 1971.

Blake, Marion. "Mosaics of the Late Empire in Rome and Vicinity," *MAAR*, 17, 1940, 81–130.

Bloch, H. "A New Document of the Last Pagan Revival in the West, 393–394 A.D.," *Harvard Theological Review*, 38, 1945, 199–244.

Borda, Maurizio. *La pittura romana*. Milan, 1958.

Bovini, Giuseppe, and Hugo Brandenburg. *Repertorium der christlich-antiken Sarkophage*. Vol. 1, *Rom und Ostia*, ed. F. W. Deichmann. Wiesbaden, 1967.

Boyancé, Pierre. "Aristote sur une peinture de la Via Latina," *Mélanges Eugène Tisserant* 4, *ST* 234, 1964, 107–24.

Brandenburg, Hugo. *Roms frühchristliche Basiliken des 4. Jahrhunderts*. Munich, 1979.

——. "Stilprobleme der frühchristlichen Sarkophagkunst Roms im 4. Jahrhundert. Volkskunst, Klassizismus, spätantiker Stil," *RM*, 86, 1979, 439–71.

Brenk, Beat. "Die Datierung der Reliefs am Hadrianstempel in Ephesos und das Problem der tetrarchischen Skulptur des Ostens," *IstMitt*, 18, 1968, 238–58.

——. *Spätantike und frühes Christentum*, (=*Propyläen-Kunstgeschichte*, Supplementband 1). Berlin, 1977.

Brown, Blanche. *Ptolemaic Paintings and Mosaics and the*

Alexandrian Style (=*Monographs on Archaeology and Fine Arts* VI). Cambridge, MA, 1957.

Brown, Peter. "Aspects of the Christianization of the Roman Aristocracy," *JRS*, 51, 1961, 1–11. Reprinted in idem, *Religion and Society in the Age of St. Augustine*, London, 1972, 161–82.

———. *The Making of Late Antiquity*. Cambridge, MA, 1978.

Brusin, Dina Dalla Barba. "Proposta per un'iconografia nell'ipogeo di via Latina," *RACr*, 47, 1971, 91–98.

Buschhausen, Helmut. "Die Katakombe an der Via Latina zu Rom," *JÖB*, 29, 1980, 293–301.

Cagiano de Azevedo, Michelangelo. "Appunti e ipotesi sull'ipogeo 'Ferrua,' " *RACr*, 45, 1969, 31–48.

———. "Iconografie bibliche nella opzione di Giudeo-Cristiani," *Vetera Christianorum*, 9, 1972, 133–42.

———. "Una singolare iconografia vetero-testamentaria nell'ipogeo della via Latina," *RendPontAcc*, Serie III, 34, 1961–62, 111–18.

Calza, Guido. *La Necropoli del porto di Roma nell'Isola Sacra*. Rome, 1940.

Cecchelli, Carlo. *Monumento cristiano-eretici di Roma*. Roma, 1944.

Colini, Antonio. *Storia e topografia del Celio nell'antichità* (=*MemPontAcc*, Serie III, 7). Rome, 1944.

Davis-Weyer, Cäcilia. "Das Traditio-Legis-Bild und seine Nachfolge," *MünchJb*, 12, 1961, 7–45.

De Bruyne, L. "Aristote ou Socrate? A propos d'une peinture de la Via Latina," *RendPontAcc*, 42, 1969–70, 173–93.

———. "L'importanza degli scavi lateranensi per la cronologia delle prime pitture catacombali," *RACr*, 44, 1968, 81–113.

———. "La peinture cémétériale constantinienne," *Akten des VII. Kongresses für christliche Archäologie, Trier, 1965* (=*Studi di Antichità Cristiana* 27), Vatican City-Berlin, 1969, 159–214.

Deichmann, F.W. *Frühchristliche Kirchen in Rom*. Basel, 1948.

———. "Kassettendecken," *JÖB*, 21, 1972, 83–107.

———. "Il materiale di spoglio nell'architettura tardo-antica," *Corsi di cultura sull'arte ravennate e bizantina*, 23, 1976, 131–46.

———. "Vom Tempel zur Kirche," *Mullus: Festschrift Klauser* (=*JbAChr*, Ergänzungsband I), Münster Westfalen, 1964, 52–59.

Delbrueck, R. *Spätantike Kaiserporträts* (=*Studien zur spätantiken Kunstgeschichte* 7). Berlin-Leipzig, 1933.

De Rossi, G.B. *Roma sotterranea cristiana*, 3 vols. Rome, 1864–77.

Deubner, Otfried. "Expolitio. Inkrustation und Wandmalerei," *RM*, 54, 1939, 14–41.

Dorigo, Wladimiro. *Pittura tardoromana*. Milan, 1966.

Dunbabin, Katherine M.D. *The Mosaics of Roman North Africa. Studies in Iconography and Patronage*. Oxford, 1978.

Engemann, Josef. "Altes und Neues zu Beispielen heidnischer und christlicher Katakombenbilder im spätantiken Rom," *JbAChr*, 26, 1983, 128–51.

———. "Tellus. Miszelle zu einer Miszelle," *JbAChr*, 17, 1974, 147–48.

Essen, C.C. van. "Studio cronologico sulle pitture parietali di Ostia," *BullComm*, 76, 1956–58 (1959), 55–81.

Fakhry, Ahmed. *The Necropolis of El-Bagawat in the Kharga Oasis*. Cairo, 1951.

Fasola, Umberto M. *Le catacombe di S. Gennaro a Capodimonte*. Rome, 1975.

———. *Pietro e Paolo a Roma*. Rome, 1980.

Felletti Maj, Bianca Maria. "Ostia—La casa delle volte dipinte: contributo all'edilizia privata imperiale," *BA*, 45, 1960, 45–65.

———. *Le pitture delle case delle volte dipinte e delle pareti gialle* (=*Monumenti della pittura antica scoperti in Italia, Sez. 3, La pittura ellenistico-romana, Ostia*, fasc. I–II). Rome, 1961.

———. "Problemi cronologici e stilistici della pittura ostiense," *Colloqui del Sodalizio*, Seconda Serie, I, Rome, 1966–68, 27–41.

———, and Paolo Moreno. *Le pitture della casa delle Muse* (=*Monumenti della pittura antica scoperti in Italia, Sez. 3, La pittura ellenistico-romana, Ostia*, fasc. III). Rome 1967.

Ferrua, Antonio. "Una nuova catacomba cristiana sulla Via Latina," *La Civiltà Cattolica*, 107, 1956, 118–31.

———. "Una nuova regione della catacomba dei Ss. Marcellino e Pietro," *RACr*, 44, 1968, 29–78; 46, 1970, 7–83.

———. *Le pitture della nuova catacomba di via Latina* (=*Monumenti di Antichità Cristiana* 8). Vatican City, 1960.

Février, P.A. "Etudes sur les catacombes romaines," *CahArch*, 10, 1959, 1–26; 11, 1960, 1–14.

———. "L'Evolution du décor figuré et ornamental en Afrique à la fin de l'antiquité," *Corsi di cultura sull'arte ravennate e bizantina*, 19, 1972, 159–86.

Fink, Josef. *Bildfrömmigkeit und Bekenntnis*. Cologne, 1978.

———. "Herakles als Christusbild an der Via Latina," *RACr*, 56, 1980, 133–46.

———. "Hermeneutische Probleme in der Katakombe der Via Latina in Rom," *Kairos*, 18, 1976, 178–190.

———. "Ikonographische Miszellen zur römischen Grabkunst," *RACr*, 49, 1973, 163–69.

———. "Lazarus an der Via Latina," *RQ*, 64, 1969, 209–17.

———. "Die römische Katakombe an der Via Latina," *Antike Welt*, 7/1, 1976, 2–14.

———. "Werk, Wirklichkeit und der wundersame Welt der römischen Katakomben," *Antike Welt*, 8/3, 1977, 2–14.

Firatli, Nezih. "An Early Byzantine Hypogeum Discovered at Iznik," *Mélanges Mansel*, Ankara, 1974, vol. 2, 919–932.

———. "Notes sur quelques hypogées paléo-chrétiens de Constantinople," *Tortulae* (=*RQ*, Supplementheft 30), Rome, 1966, 131–39.

Frova, A. *Pittura romana in Bulgaria*. Rome, 1943.

Gasparri, C. *Le pitture della Caupona del Pavone (=Monumenti della pittura antica scoperti in Italia, Sez. 3, La pittura ellenistico-romana, Ostia, fasc. IV)*. Rome, 1970.

Gentili, Gino V. *La villa erculia di Piazza Armerina. I mosaici figurati*. Rome, 1959.

Gerke, Friedrich. *Die christlichen Sarkophage der vorkonstantinischen Zeit*. Berlin, 1940.

———. "Die Wandmalereien der neugefundenen Grabkammer in Pécs (Fünfkirchen)," *Spätantike und Byzanz, Forschungen zur Kunstgeschichte und christlichen Archäologie,* erster Halbband, Baden-Baden, 1952, 115–37.

———. "Die Wandmalereien der Petrus-Paulus-Katakombe in Pécs (Südungarn)," *Frühmittelalterliche Kunst, Forschungen zur Kunstgeschichte und christlichen Archäologie,* zweiter Halbband, Baden-Baden, 1954, 147–99.

Goodenough, Erwin R. "Catacomb Art," *Journal of Biblical Literature,* 81, 1962, 113–42.

———. *Jewish Symbols in the Greco-Roman Period,* 13 vols. New York, 1953–68.

Grabar, André. *The Beginnings of Christian Art, 200–395,* trans. Stuart Gilbert and James Emmons. London, 1967.

———. "Plotin et les origines de l'esthétique médiévale," *CahArch,* 1, 1945, 15–34.

———. "Recherches sur les sources juives de l'art paléochrétien," *CahArch,* 11, 1960, 41–71; 12, 1962, 115–52; 14, 1964, 49–57.

Guyon, Jean. "La vente des tombes à travers l'épigraphie de la Rome chrétienne (IIIe–VIIe siècles): le rôle des *fossores, mansionarii, praepositi* et prêtres," *MélRome, Antiquité,* 86, 1974, 549–96.

Guarducci, Margherita. "La 'Morte di Cleopatra' nella catacomba della Via Latina," *RendPontAcc,* 38, 1966, 259–81.

Guerri, Elena Conde. *Los "fossores" de Roma paleocristiana (Estudio iconografico, epigrafico y social) (=Studi di Antichità Cristiana 33)*. Vatican City, 1979.

Gutmann, Joseph. "The Illustrated Jewish Manuscript in Antiquity: The Present State of the Question," *Gesta,* 5, 1966, 39–44.

Gütschow, Margarete. *Das Museum der Prätextat-Katakombe (=MemPontAcc, Serie III, 4/2)*. Vatican City, 1938.

Hanfmann, George M.A. *The Season Sarcophagus in Dumbarton Oaks (=Dumbarton Oaks Studies 2)*. Cambridge, MA, 1952.

Harrison, E.B. "The Constantinian Portrait," *DOP,* 21, 1967, 79–96.

Hauschild, T., and H. Schlunk. "Vorbericht über die Arbeiten in Centcelles," *MM,* 2, 1961, 119–82.

Hempel, Heinz-Ludwig. "Zum Problem der Anfänge der AT-Illustration," *Zeitschrift für die alttestamentliche Wissenschaft,* 69 (N.F.28), 1957, 103–31.

Himmelmann, Nikolaus. *Typologische Untersuchungen an römischen Sarkophagreliefs des 3. und 4. Jh. n. Chr.* Mainz, 1973.

Jeremias, Gisela. *Die Holztür der Basilika S. Sabina in Rom (=Bilderhefte des Deutschen Archäologischen Instituts Rom 7)*. Tübingen, 1980.

Josi, Enrico. "Découverte d'une série de peintures dans un hypogée de la voie Latine," *CRAI,* 1956, 275–79.

Joyce, Hetty. *The Decoration of Walls, Ceilings and Floors in Italy in the Second and Third Centuries A.D.* Rome, 1981.

Kähler, Heinz. *Die Villa des Maxentius bei Piazza Armerina (=Monumenta Artis Romanae XII)*. Berlin, 1973.

Khatchatrian, A. *Les baptistères paléochrétiens*. Paris, 1962.

Kitzinger, Ernst. *Byzantine Art in the Making*. London, 1977.

———. "On the Interpretation of Stylistic Changes in Late Antique Art," *Bucknell Review,* 15/3, 1967, 1–10. Reprinted in Ernst Kitzinger, *The Art of Byzantium and the Medieval West,* ed. W. Eugene Kleinbauer, Bloomington, 1976, 32–41.

———. "Stylistic Developments in Pavement Mosaics in the Greek East from the Age of Constantine to the Age of Justinian," *La Mosaïque gréco-romaine, Colloques Internationaux du Centre National de la Recherche Scientifique* (Paris, 1963), Paris, 1965, 341–52. Reprinted in Ernst Kitzinger, *The Art of Byzantium and the Medieval West,* ed. W. Eugene Kleinbauer, Bloomington, 1976, 64–74.

Kollwitz, Johannes. "Die Malerei der konstantinischen Zeit," *Akten des VII. Internationalen Kongresses für christliche Archäologie,* Trier, 1965 (=*Studi di Antichità Cristiana* 27), Vatican City—Berlin, 1969, 29–158.

Kötzsche-Breitenbruch, Lieselotte. *Die neue Katakombe an der Via Latina in Rom (=JbAChr, Ergänzungsband 4)*. Münster Westfalen, 1976.

Kraeling, Carl H. *The Christian Building (=The Excavations at Dura Europos, Final Report VIII, II)*. New Haven, 1967.

———. *The Synagogue (=The Excavations at Dura Europos, Final Report VIII, I)*. New Haven, 1956.

Kretschmar, Georg. "Ein Beitrag zur Frage nach dem Verhältnis zwischen jüdischer und christlicher Kunst in der Antike," *Abraham unser Vater, Festschrift Otto Michel,* Leiden, 1963, 295–319.

Lavin, Irving. "The Ceiling Frescoes in Trier and Illusionism in Constantinian Painting," *DOP,* 21, 1967, 97–113.

———. "The Hunting Mosaics of Antioch and Their Sources," *DOP,* 17, 1963, 181–286.

Levi, Doro. *Antioch Mosaic Pavements,* 2 vols. Princeton, 1947.

L'Orange, H.P. *Art Forms and Civic Life in the Late Roman Empire*. Princeton, 1965.

———. *Likeness and Icon*. Odense, 1973.

———. *Studien zur Geschichte des spätantiken Porträts*. Oslo, 1933.

L'Orange, H.P., and A. von Gerkan. *Der spätantike Bildschmuck des Konstantinsbogens,* 2 vols. Berlin, 1939.

Markthaler, Paul. "Die dekorativen Konstruktionen der Katakombendecken Roms," *RQ*, 35, 1927, 53–111.

Marrou, Henri. "Une catacombe pagano-chrétienne récemment découverte à Rome," *Bulletin de la Société Nationale des Antiquaires de France*, 1956, 77–81.

———. "Sur une peinture de la nouvelle catacombe de la *Via Latina*," *CRAI*, 1969, 250–56.

Marucchi, Orazio. *Le catacombe romane*. Rome, 1932.

Mazar, Benjamin. *Beth She'arim I. Report on the Excavations During 1936–40. Catacombs 1–4*. Jerusalem, 1973.

Meiggs, Russell. *Roman Ostia*, 2nd ed. Oxford, 1973.

Mielsch, Harald. "Zur stadtrömischen Malerei des 4. Jahrhunderts n. Chr.," *RM*, 85, 1978, 151–207.

Murray, Sister Charles. "Art and the Early Church," *Journal of Theological Studies*, N.S. 28, 1977, 303–45.

———. *Rebirth and Afterlife: A Study of the Transmutation of Some Pagan Imagery in Early Christian Funerary Art* (=*British Archaeological Reports* 100). Oxford, 1981.

Nestori, Aldo. *Repertorio topografico delle pitture delle catacombe romane* (=*Roma Sotterranea Cristiana* 5). Vatican City, 1975.

Nordström, Carl-Otto. "Rabbinica in frühchristlichen und byzantinischen Illustrationen zum 4. Buch Mose," *Figura*, N.S. 1, 1959, 24–47.

———. "Some Jewish Legends in Byzantine Art," *Byzantion*, 25/27, 1955–57, 487–508.

Pace, Biagio. *I mosaici di Piazza Armerina*. Rome, 1955.

Pagenstecher, Rudolf. *Nekropolis. Untersuchungen über Gestalt und Entwicklung der alexandrinischen Grabanlagen und ihrer Malereien*. Leipzig, 1919.

Pelekanides, Stylianos. "Die Malerei der konstantinischen Zeit," *Akten des VII. Internationalen Kongresses für christliche Archäologie*, Trier, 1965 (=*Studi di Antichità Cristiana* 27), Vatican City–Berlin, 1969, 215–35.

Perkins, Ann. *The Art of Dura-Europos*. Oxford, 1973.

Reekmans, Louis. "La cronologie de la peinture paléochrétienne, notes et réflexions," *RACr*, 49, 1973, 271–91.

Rodenwaldt, Gerhard. "Eine spätantike Kunstströmung in Rom," *RM*, 36–37, 1921–22, 58–110.

———. "Zur Kunstgeschichte der Jahre 220 bis 270," *JdI*, 51, 1936, 82–113.

Rostovtzeff, M. *Ancient Decorative Painting in South Russia* (in Russian), 2 vols. St. Petersburg, 1913–14.

———. "Ancient Decorative Wall Painting," *JHS*, 39, 1919, 144–63.

Schefold, K. "Altchristliche Bilderzyklen: Bassussarkophag und Santa Maria Maggiore," *RACr*, 16, 1939, 289–314.

Schönebeck, Hans von. *Beiträge zur Religionspolitik des Maxentius und Constantin* (=*Klio*, Beiheft 43). Leipzig, 1939.

———. "Die christliche Sarkophagplastik unter Konstantin," *RM*, 51, 1936, 238–336.

Schubert, Kurt. "Sündenfall und Vertreibung aus dem Paradies in der Katakombe der Via Latina im Lichte der jüdischen Tradition," *Kairos*, 16, 1974, 14–18.

Schubert, Kurt, and Ursula Schubert. "Die Vertreibung aus dem Paradies in der Katakombe der Via Latina," *Christianity, Judaism and Other Greco-Roman Cults, Studies for Morton Smith at Sixty*, Part II, *Early Christianity*, ed. J. Neusner, Leiden, 1975, 173–80.

Schubert, Ursula. *Spätantikes Judentum und frühchristliche Kunst* (=*Studia Judaica Austriaca* II). Vienna, 1974.

Schumacher, W.N. "Die Katakombe an der Via Dino Compagni und römische Grabkammern," *RACr*, 50, 1974, 331–72.

———. "Reparatio vitae: Zum Programm der neuen Katakombe an der Via Latina zu Rom," *RQ*, 66, 1971, 125–53.

Simon, Marcel. "Remarques sur la Catacombe de la Via Latina," *Mullus. Festschrift Klauser* (=*JbAChr*, Ergänzungsband 1), Münster Westfalen, 1964, 327–35.

Stemberger, Günter. "Die Patriarchenbilder der Katakombe in der Via Latina im Lichte der jüdischen Tradition," *Kairos*, 16, 1974, 19–78.

Stern, Henri. *Le Calendrier de 354*. Paris, 1953.

———. "Quelques problèmes d'iconographie paléochrétienne et juive," *CahArch*, 12, 1962, 99–113.

Strocka, Volker Michael. *Die Wandmalerei der Hanghäuser in Ephesus* (=*Forschungen in Ephesus* VIII/1). Vienna, 1977.

Strong, Mrs. Arthur. "Forgotten Fragments of Ancient Wall Paintings in Rome," *BSR*, 7, 1914, 114–23; 8, 1916, 91–103.

Styger, Paul. "Heidnische und christliche Katakomben," *Pisciculi. Festschrift Dölger*, Münster Westfalen, 1939, 266–75.

———. *Römische Märtyrergrüfte*, 2 vols. Berlin, 1935.

———. *Die römischen Katakomben*. Berlin, 1933.

Sydow, Wilhelm von. *Zur Kunstgeschichte des spätantiken Porträts im 4. Jahrhundert n. Chr.* (=*Antiquitas* 8). Bonn, 1969.

Testini, Pasquale. *Le catacombe e gli antichi cimiteri cristiani in Roma*. Bologna, 1966.

Toynbee, Jocelyn. *Death and Burial in the Roman World*. London, 1971.

———, and John Ward Perkins. *The Shrine of St. Peter and the Vatican Excavations*. London, 1956.

Vermaseren, M.J., and C.C. van Essen. *The Excavations in the Mithraeum of the Church of Sta. Prisca in Rome*. Leiden, 1965.

Voelkel, Ludwig. "Archäologische Funde und Forschungen: Hypogaeum an der Via Dino Compagni (Via Latina)," *RQ*, 56, 1961, 89–95.

Ward Perkins, John, and R.G. Goodchild. "The Christian Antiquities of Tripolitania," *Archaeologia*, 95, 1953, 1–82.

Weidlé, Wladimir. *The Baptism of Art*. London, n.d.

Weitzmann, Kurt, "Book Illustration of the Fourth Century: Tradition and Innovation," *Akten des VII. Internationalen Kongresses für christliche*

Archäologie, Trier, 1965 (=*Studi di Antichità Cristiana* 27), Rome-Berlin, 1969, 257–81. Reprinted in idem, *Studies in Classical and Byzantine Manuscript Illumination,* ed. Herbert L. Kessler, Chicago, 1971, 96–125.

———. "Observations on the Cotton Genesis Fragments," *Late Classical and Mediaeval Studies in Honor of A.M. Friend, Jr.,* Princeton, 1955, 112–31.

———. "The Question of the Influence of Jewish Pictorial Sources on Old Testament Illustration," *Mullus. Festschrift Klauser* (=*JbAChr,* Ergänzungsband 1), Münster Westfalen, 1964, 401–415. Reprinted in idem, *Studies in Classical and Byzantine Manuscript Illumination,* ed. Herbert L. Kessler, Chicago, 1971, 76–95.

Weitzmann, Kurt, William C. Loerke, Ernst Kitzinger, and Hugo Buchthal. *The Place of Book Illumination in Byzantine Art.* Princeton, 1975.

Wilpert, G. *Le pitture delle catacombe romane,* 2 vols. Rome, 1903.

———. *Die römischen Mosaiken und Malereien der kirchlichen Bauten vom IV. bis XIII. Jahrhundert,* 4 vols. Freiberg im Breisgau, 1917.

———. *I sarcofagi cristiani antichi,* 3 vols. Rome, 1929–36.

Wirth, Fritz. *Römische Wandmalerei vom Untergang Pompejis bis ans Ende des dritten Jahrhunderts.* Berlin, 1934.

Wit, Johannes de. *Spätrömische Bildnismalerei.* Berlin, 1938.

Index

Illustrations

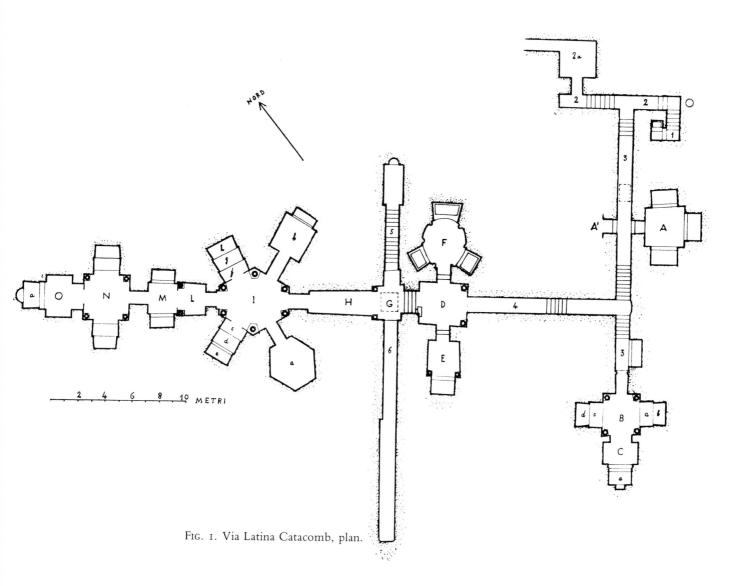

NORD

2 4 6 8 10 METRI

FIG. 1. Via Latina Catacomb, plan.

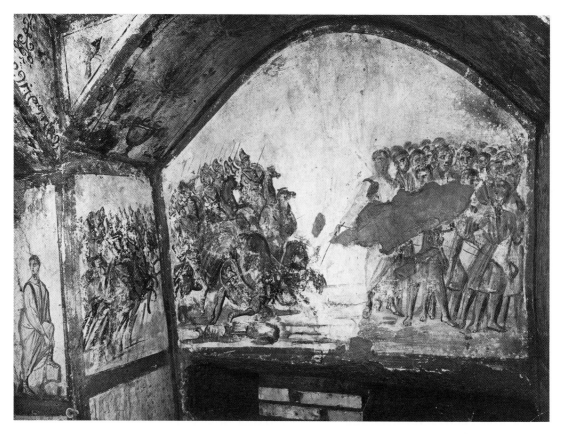

FIG. 2. Via Latina Catacomb, cubiculum C, Crossing of the Red Sea.

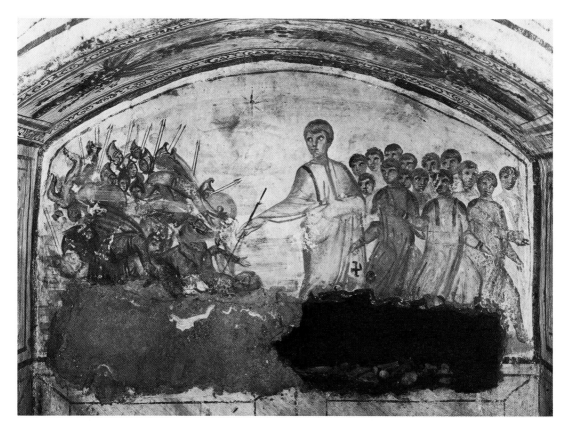

FIG. 3. Via Latina Catacomb, cubiculum O, Crossing of the Red Sea.

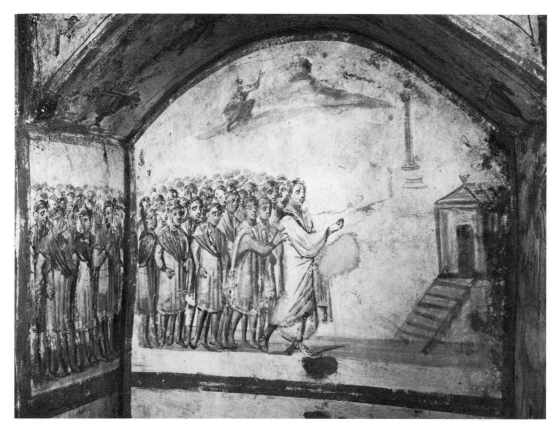

FIG. 4. Via Latina Catacomb, cubiculum C, scene here identified as Joshua leading the Israelites into the Promised Land.

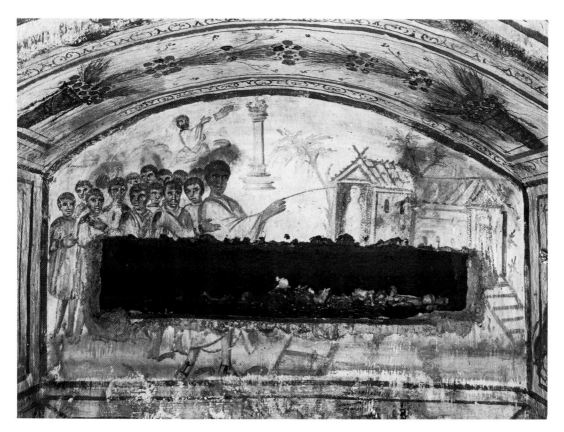

FIG. 5. Via Latina Catacomb, cubiculum O, Raising of Lazarus.

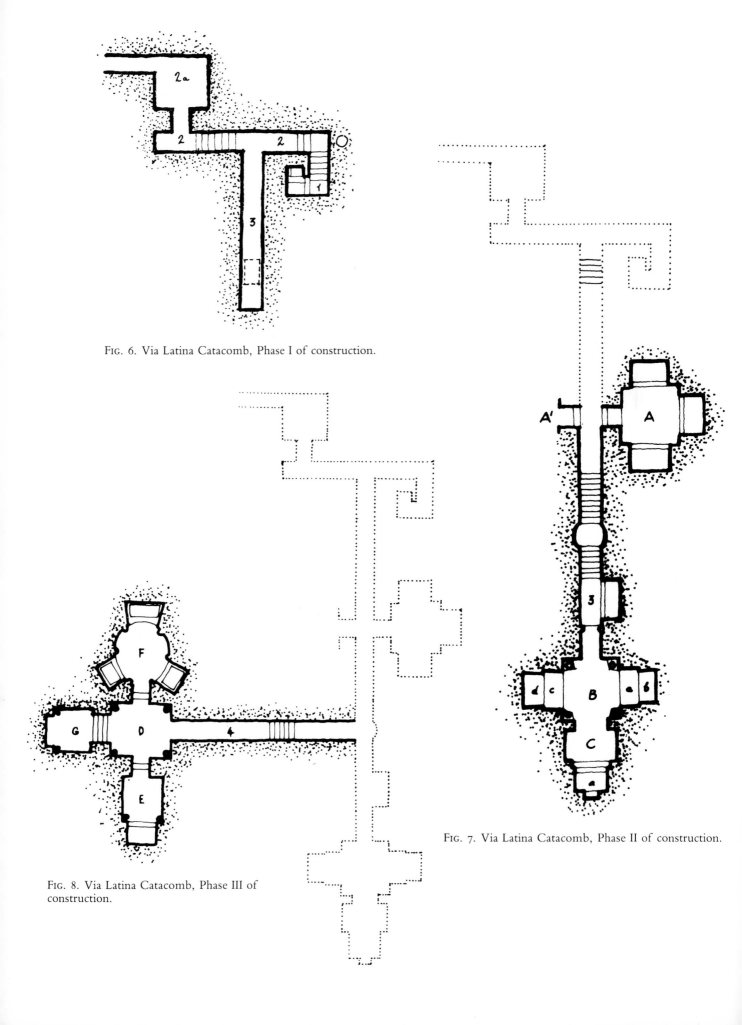

FIG. 6. Via Latina Catacomb, Phase I of construction.

FIG. 7. Via Latina Catacomb, Phase II of construction.

FIG. 8. Via Latina Catacomb, Phase III of
construction.

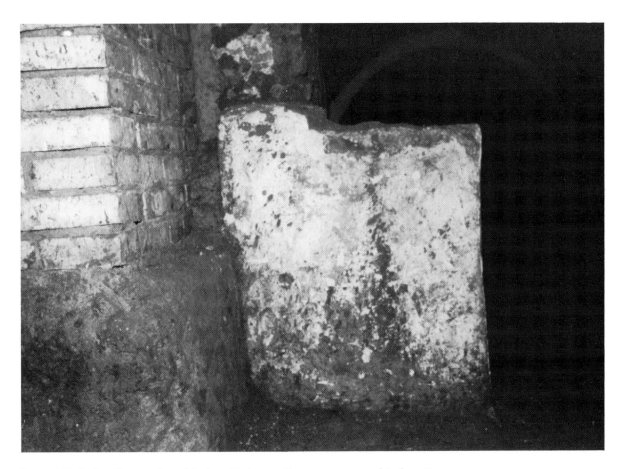

FIG. 9. Via Latina Catacomb, cubiculum D, low wall at entrance to cubiculum G.

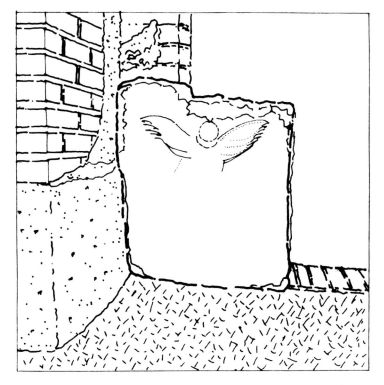

FIG. 10. Via Latina Catacomb, cubiculum D, drawing of painted
figure on face of low wall at entrance to cubiculum G.

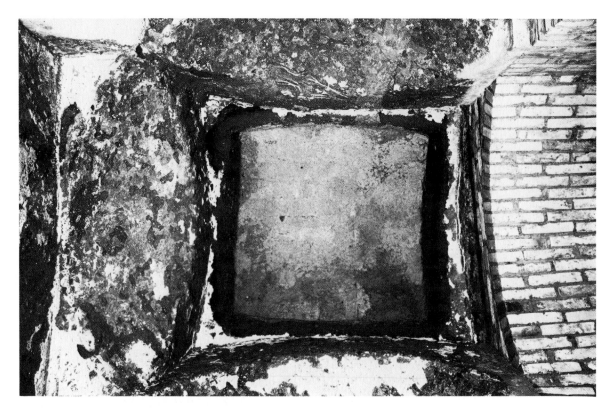

Fig. 11. Via Latina Catacomb, cubiculum G, vault.

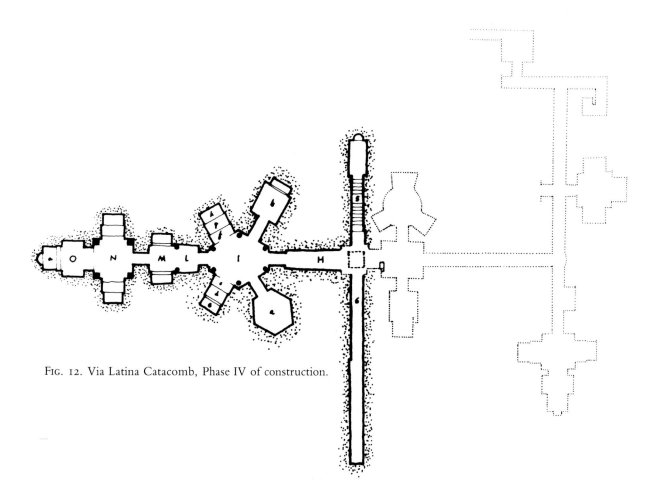

Fig. 12. Via Latina Catacomb, Phase IV of construction.

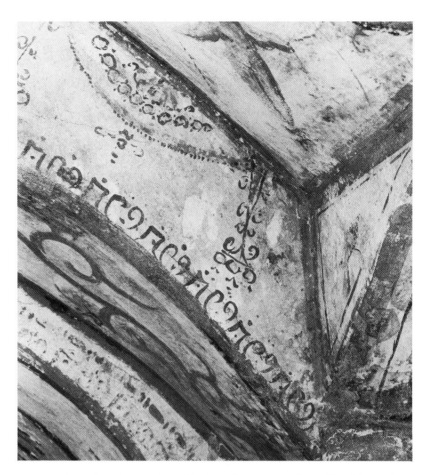

FIG. 13. Via Latina Catacomb, cubiculum C, ornamental motif and kymation pattern.

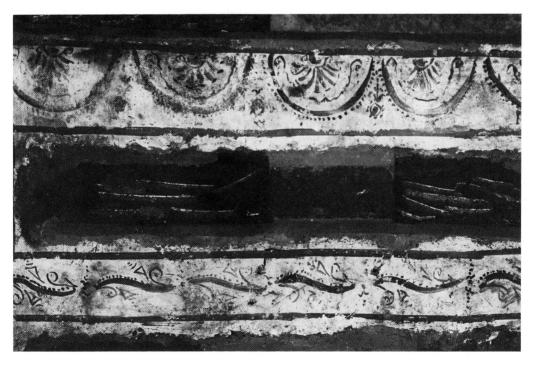

FIG. 14. Catacomb of Petrus and Marcellinus, cubiculum N66, ornamental motifs.

FIG. 15. Via Latina Catacomb, cubiculum B, Cain and Abel with Adam and Eve (detail).

FIG. 16. Catacomb of Petrus and Marcellinus, cubiculum N57, Moses striking the rock (detail).

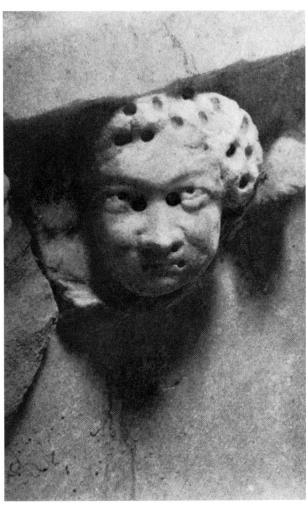

FIG. 17. Loculus plaque of Elia Afanasia (detail).

Fig. 18. Catacomb of Petrus and Marcellinus, cubiculum N64, ornamental motifs.

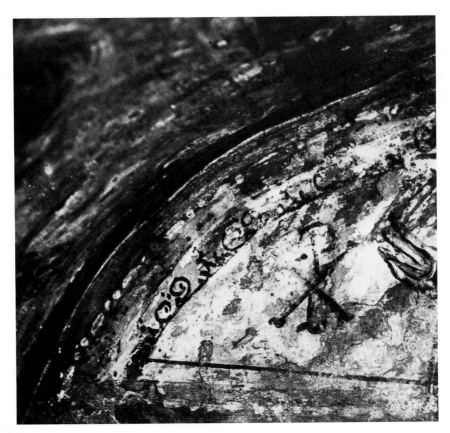

FIG. 19. *Coemeterium Maius,* arcosolium of the "Madonna orans," kymation border.

FIG. 20. Catacomb of Calixtus, cubiculum N2, kymation border.

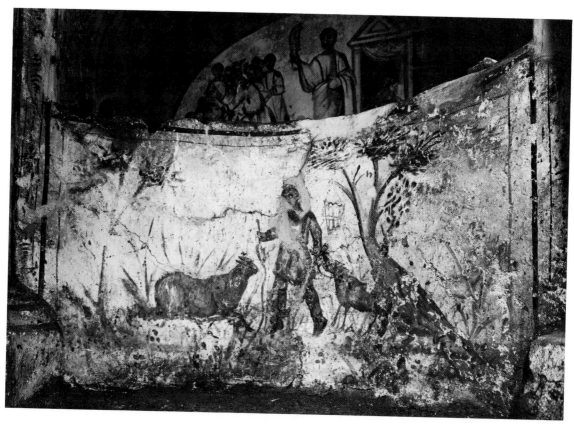

Fig. 21. Via Latina Catacomb, cubiculum F, Good Shepherd.

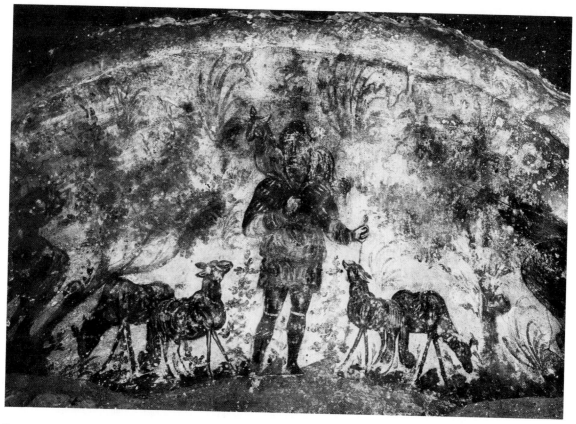

Fig. 22. Catacomb of Domitilla, cubiculum N72, Good Shepherd.

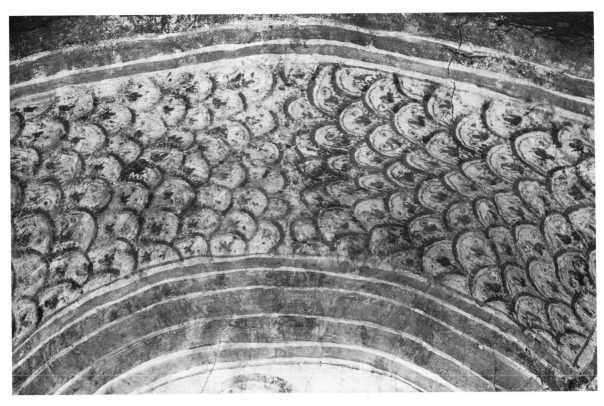

FIG. 23. Catacomb of Commodilla, cubiculum N5, decoration of right arcosolium vault.

FIG. 24. Via Latina Catacomb, cubiculum O, vault decoration.

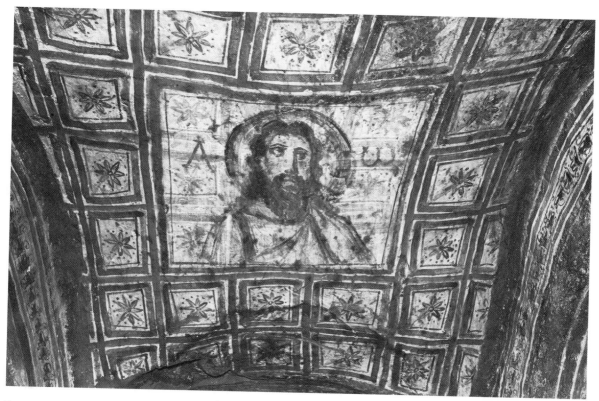

FIG. 25. Catacomb of Commodilla, cubiculum N5, painted coffered ceiling.

FIG. 26. Via Latina Catacomb, cubiculum I, painted coffered ceiling.

Fig. 27. Via Latina Catacomb, cubiculum N, vault decoration.

Fig. 28. Sta. Costanza, mosaic decoration of ambulatory vault (detail).

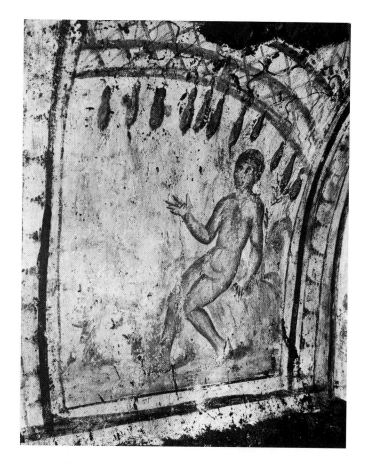

FIG. 29. Via Latina Catacomb, cubiculum M, resting Jonah.

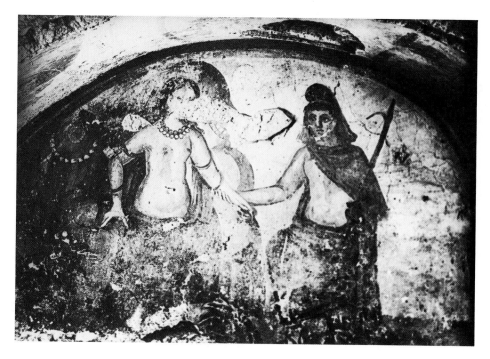

FIG. 30. Perseus and Andromeda, wall painting from excavation on Via del Teatro di
Marcello.

FIG. 31. Catacomb of Petrus and Marcellinus, plan of regions Y and Z.

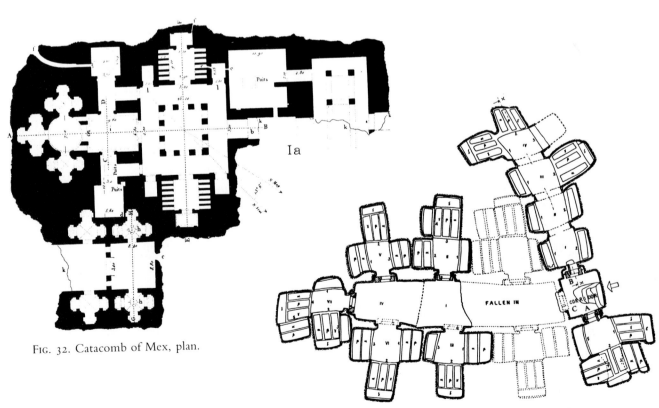

FIG. 32. Catacomb of Mex, plan.

FIG. 33. Beth She'arim, plan of catacomb n. 2.

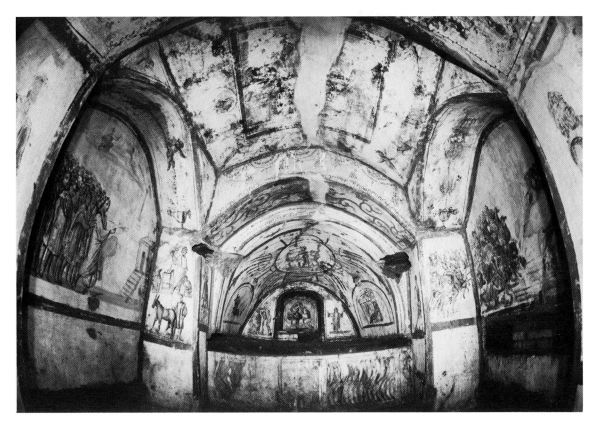

FIG. 34. Via Latina Catacomb, cubiculum C, general view.

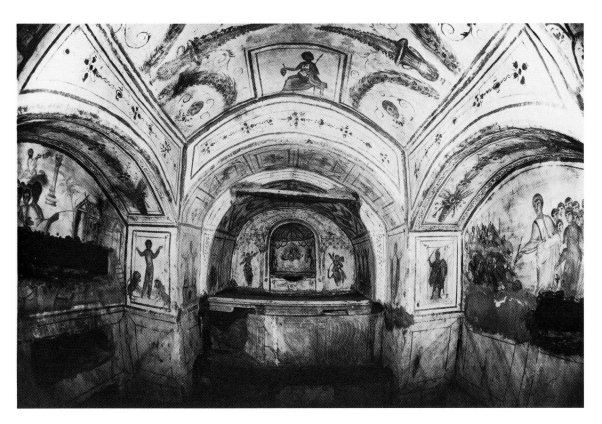

FIG. 35. Via Latina Catacomb, cubiculum O, general view.

Fig. 36. Via Latina Catacomb, cubiculum B, Ascension of Elijah.

Fig. 37. Via Latina Catacomb, cubiculum B, Dream of Jacob.

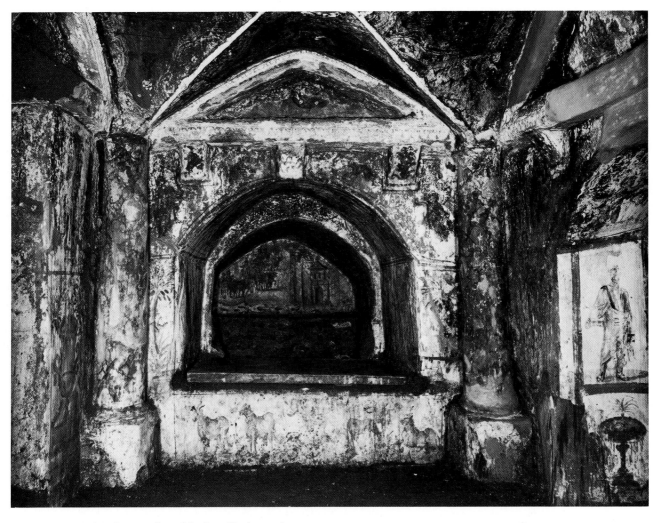

Fig. 38. Via Latina Catacomb, cubiculum B, decorative system.

Fig. 39. Via Latina Catacomb, cubiculum B, reconstruction
of decorative system of ceiling.

Fig. 40. Roman edifice, wall decoration. S. Giovanni in Laterano.

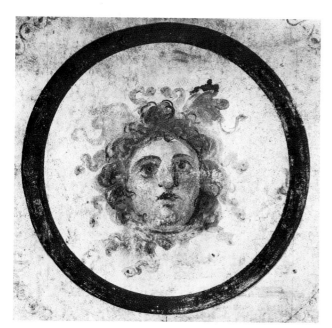

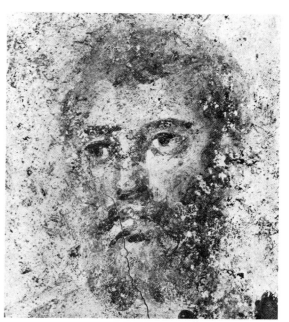

FIG. 42. Hypogeum of the Aurelii, head of standing figure.

FIG. 41. Tomb of Clodius Hermes, ceiling decoration (detail).

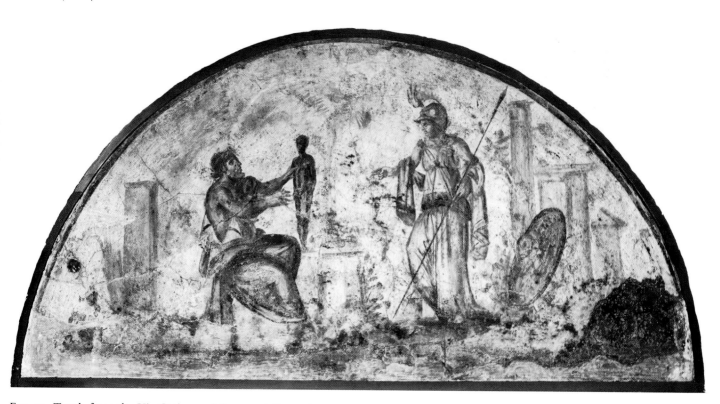

FIG. 43. Tomb from the Via Ostiense, Athena and Prometheus.

FIG. 44. Tomb from Caivano, landscape.

FIG. 45. Via Latina Catacomb, cubiculum B, Ascension of Elijah (detail).

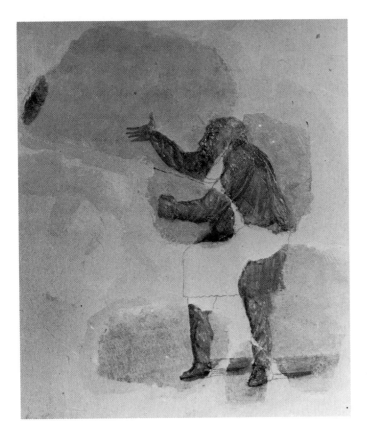

FIG. 46. Figure from the House of Asinius Rufinus in Acholla.

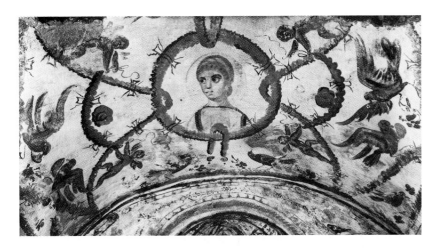

FIG. 47. Via Latina Catacomb, cubiculum O, portrait of deceased(?).

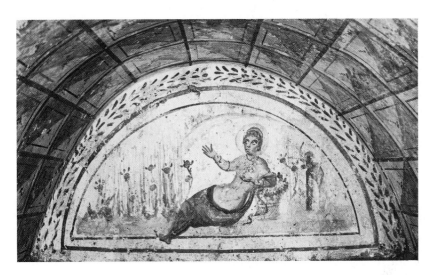

FIG. 48. Via Latina Catacomb, cubiculum E, Tellus.

FIG. 49. Via Latina Catacomb, cubiculum F, Christ and the Samaritan Woman.

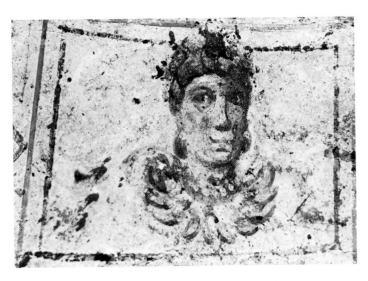

FIG. 50. Via Latina Catacomb, cubiculum I, head of Season.

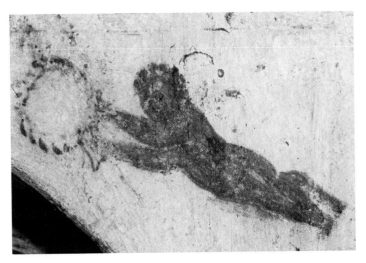

FIG. 51. Via Latina Catacomb, cubiculum N, putto.

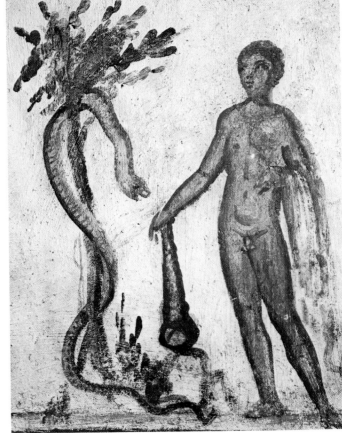

FIG. 52. Via Latina Catacomb, cubiculum N, Hercules and the Apples of the Hesperides.

FIG. 53. Hanghaus 2/24, wall decoration. Ephesus.

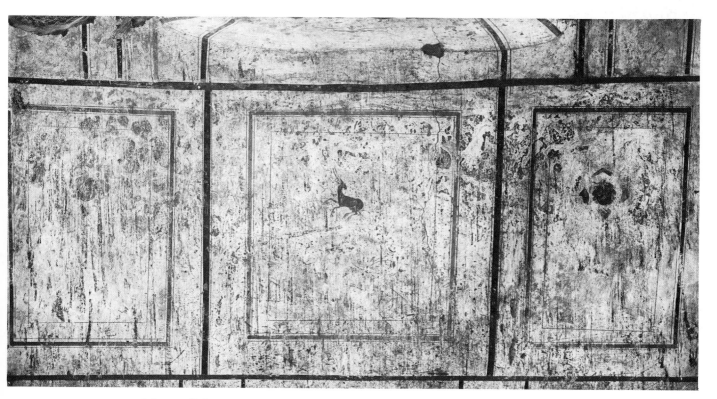

FIG. 54. Roman edifice, wall decoration. S. Giovanni in Laterano.

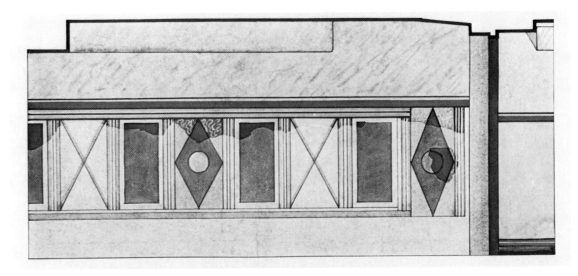

FIG. 55. Dura Europos Synagogue, reconstruction of first decoration.

FIG. 56. Dura Europos Synagogue, view of southeast corner.

FIG. 57. Hanghaus 1/b, wall decoration. Ephesus.

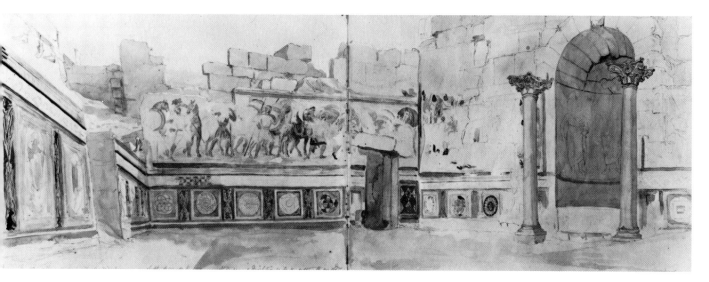

FIG. 58. J. G. WILKINSON, water color sketch of tetrarchic cult room at Luxor.

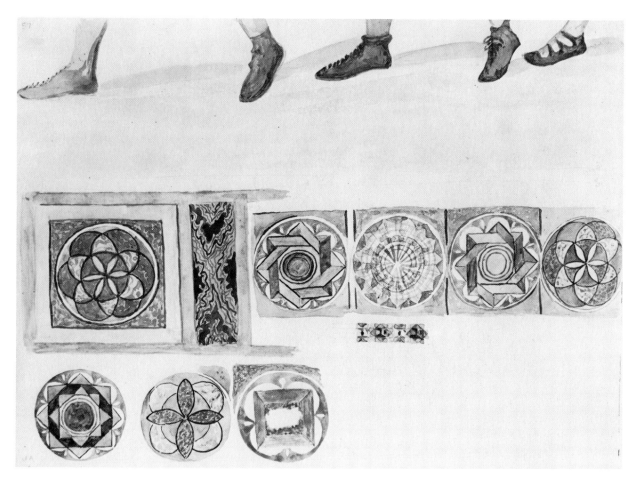

FIG. 59. J. G. WILKINSON, water color sketch of socle of tetrarchic cult room at Luxor.

FIG. 60. Roman villa, exterior decoration of room 43. Piazza Armerina.

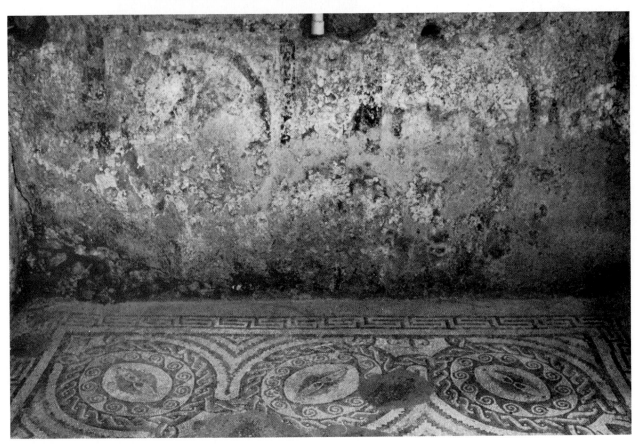

FIG. 61. Roman villa, wall decoration of room 6. Piazza Armerina.

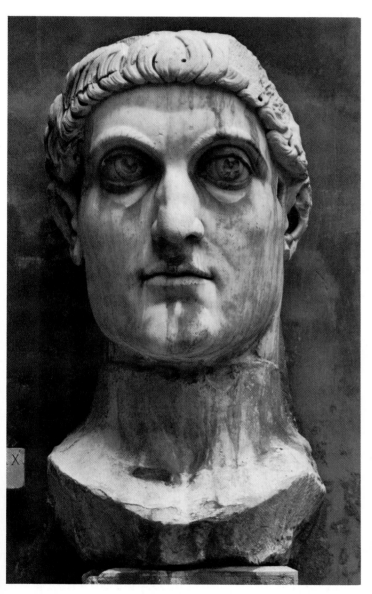

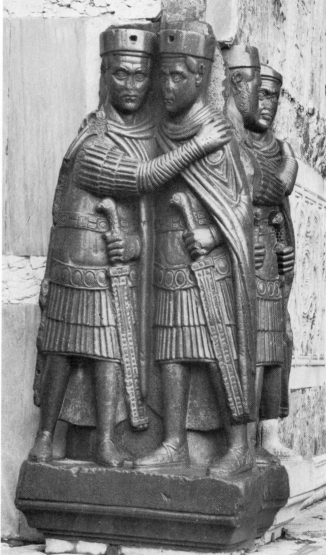

FIG. 62. Constantine.

FIG. 63. Tetrarchs.

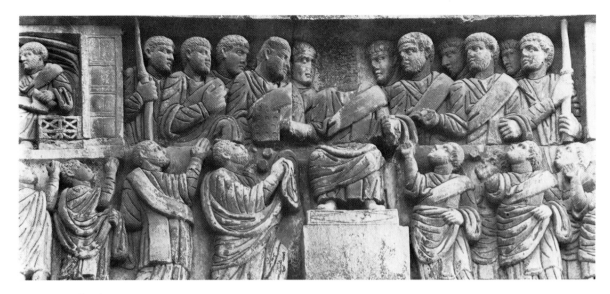

FIG. 64. Arch of Constantine, *Largitio*.

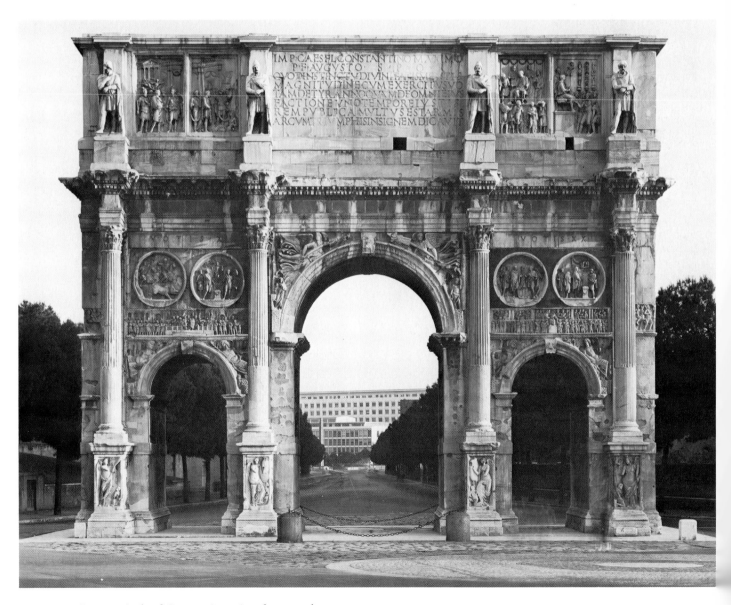

FIG. 65. Arch of Constantine, view from north.

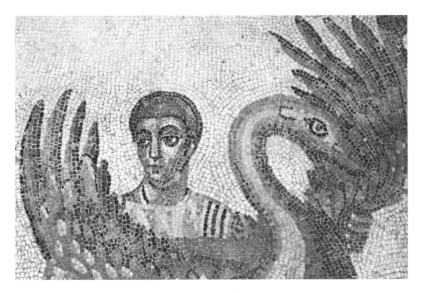

FIG. 66. Roman villa, Great Hunt mosaic (detail). Piazza Armerina.

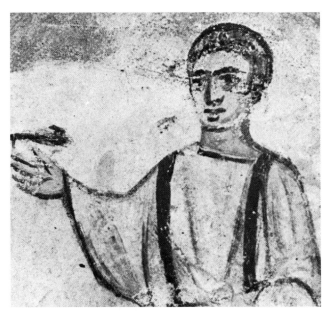

FIG. 67. Via Latina Catacomb, cubiculum F, Christ and the Samaritan Woman (detail).

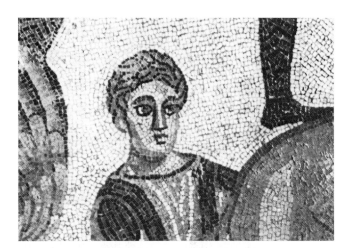

FIG. 68. Roman villa, Great Hunt mosaic (detail). Piazza Armerina.

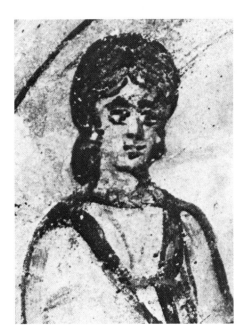

FIG. 69. Via Latina Catacomb, cubiculum F, Christ and the Samaritan Woman (detail).

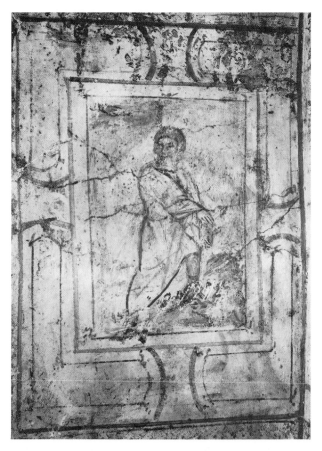

Fig. 70. Via Latina Catacomb, cubiculum I, view of decorative system.

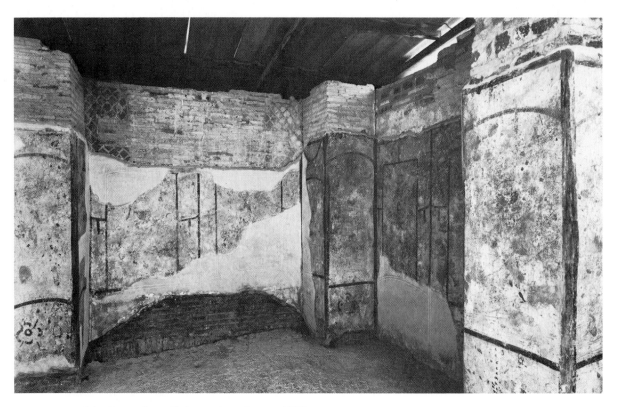

Fig. 71. Inn of the Peacock, wall decoration of room XIV.

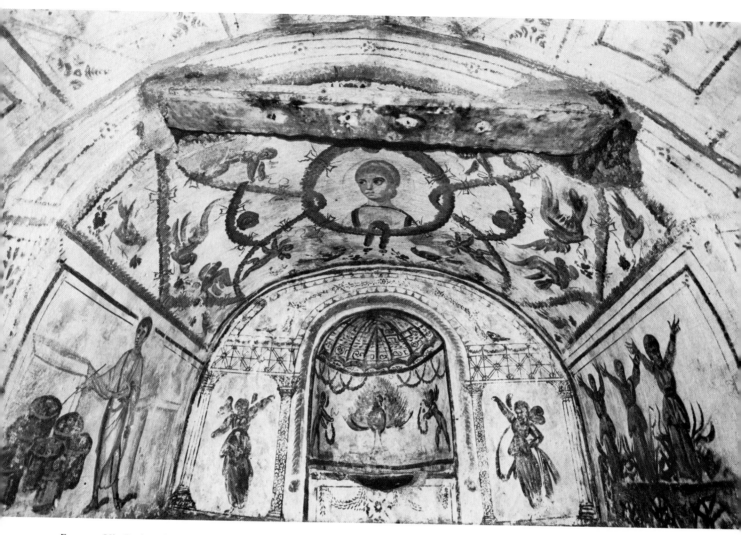

FIG. 72. Via Latina Catacomb, cubiculum O, view of arcosolium.

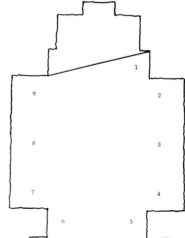

FIG. 73. Via Latina Catacomb, cubiculum C, plan showing the placement of
wall paintings and the presumed location of the diagonal beam across the arco-
solium opening.

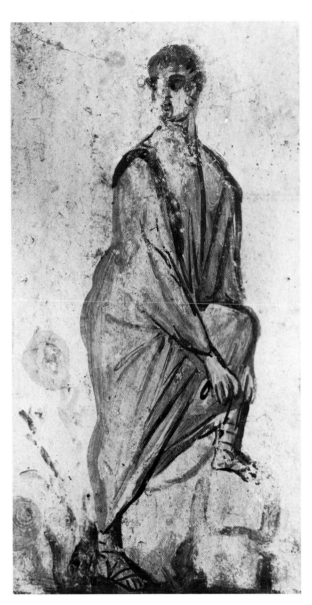 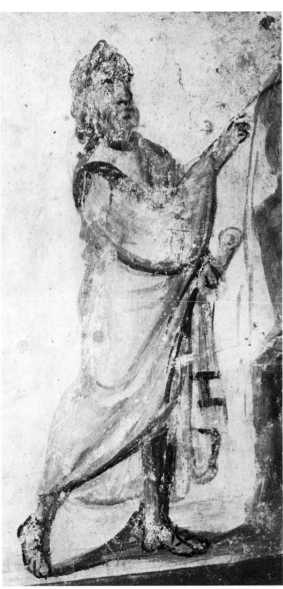

FIG. 74. Via Latina Catacomb, cubiculum C, Moses at the Burning Bush.

FIG. 75. Via Latina Catacomb, cubiculum C, Moses striking the rock.

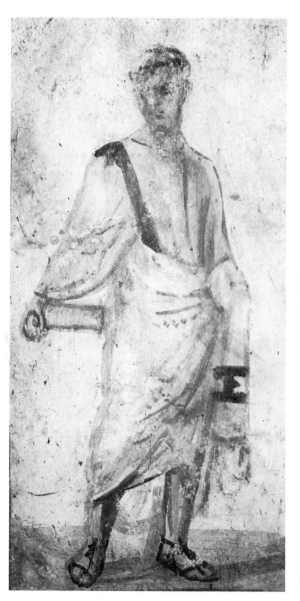

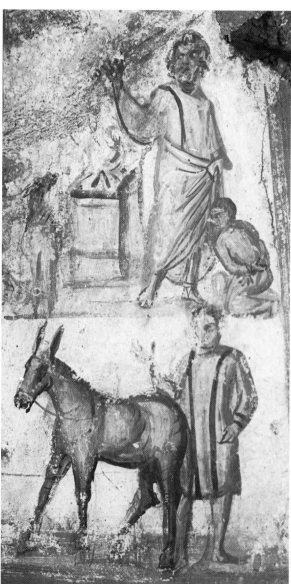

Fig. 76. Via Latina Catacomb, cubiculum C, figure with a scroll here identified as Joshua.

Fig. 77. Via Latina Catacomb, cubiculum C, Sacrifice of Abraham.

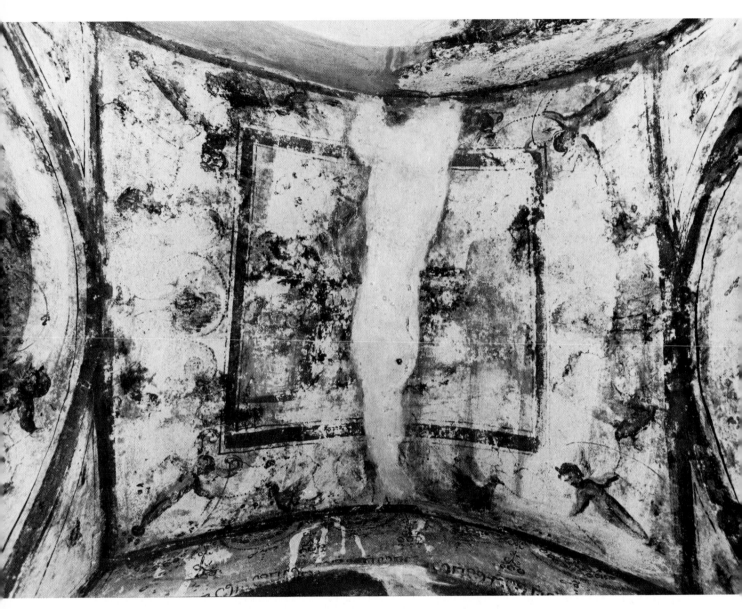

FIG. 78. Via Latina Catacomb, cubiculum C, seated Christ with scrolls and codex.

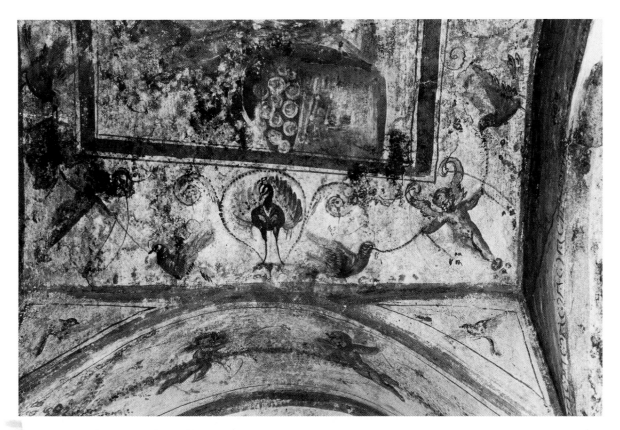

Fig. 78A. Detail, capsa with scrolls.

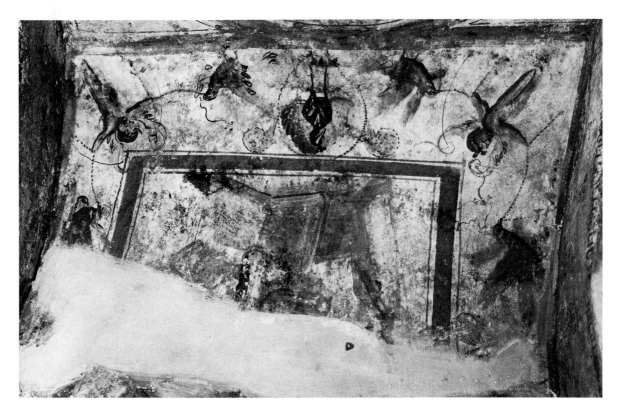

Fig. 78B. Detail, open codex.

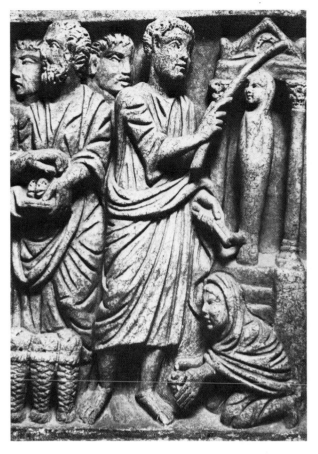

FIG. 79. Sarcophagus, Raising of Lazarus.

FIG. 80. Arch of Constantine, view of southeast corner.

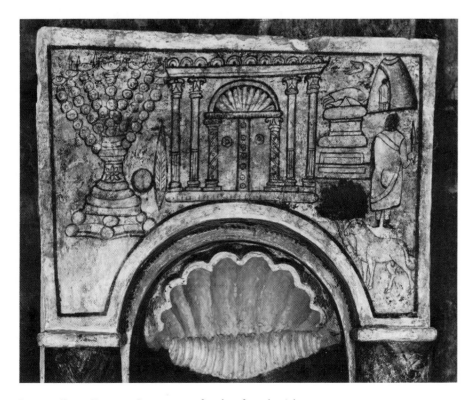

FIG. 81. Dura Europos Synagogue, facade of torah niche.

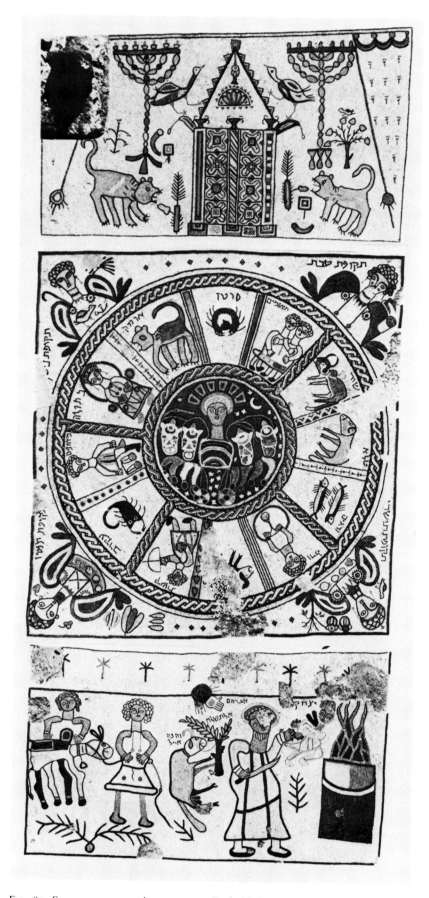

FIG. 82. Synagogue, mosaic pavement. Beth Alpha.

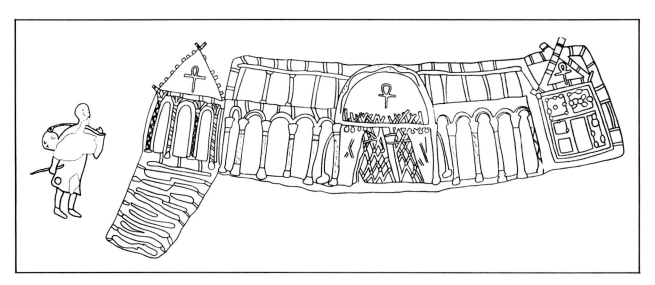

FIG. 83. Mausoleum of Exodus, line drawing of building here identified as Temple of Jerusalem.

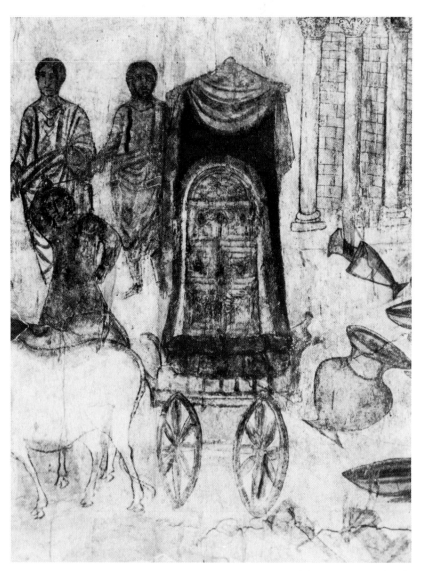

FIG. 84. Dura Europos Synagogue, the Ark in the land of the Philistines (detail).

FIG. 85. *Domus dei,* Utrecht, Bibliotheek der Rijksuniversiteit, Ms. no. 484 (Utrecht Psalter), fol. 75v.

FIG. 86. *Sion,* Moscow, Historical Museum, Ms. gr. 129 (Chludov Psalter), fol. 86v.

Fig. 87. Catacomb of Calixtus, cubiculum N45, the Multiplication of loaves.

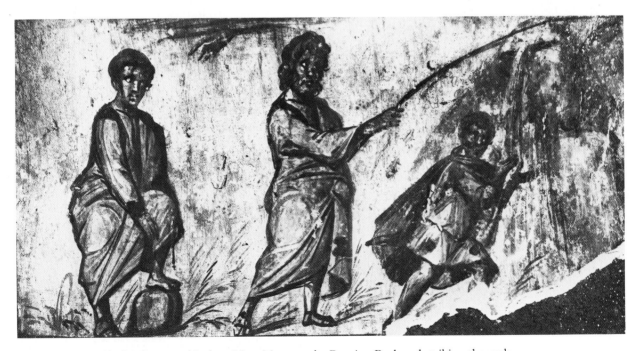

Fig. 88. Catacomb of Calixtus, cubiculum N45, Moses at the Burning Bush and striking the rock.

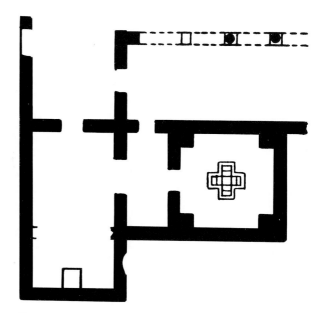

FIG. 89. Baptistery, plan. Corinth.

FIG. 90. Dura Europos Synagogue, torah niche.

FIG. 91. Via Latina Catacomb, cubiculum O, Persephone.

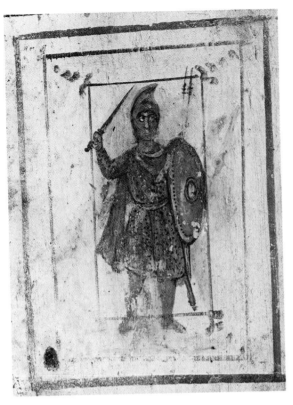

FIG. 92. Via Latina Catacomb, cubiculum O,
Egyptian soldier.

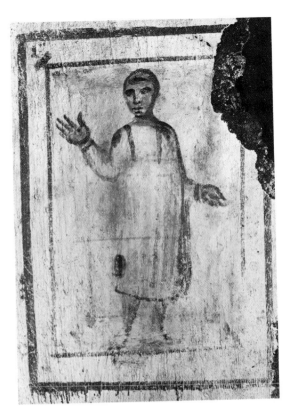

FIG. 93. Via Latina Catacomb, cubiculum O,
triumphant Israelite.

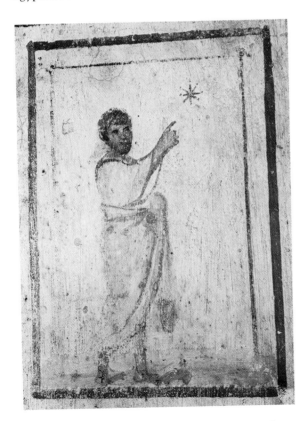

FIG. 94. Via Latina Catacomb, cubiculum O, Balaam.

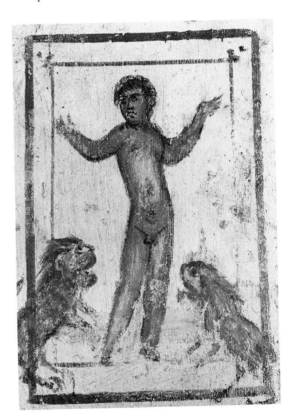

FIG. 95. Via Latina Catacomb, cubiculum O, Daniel.

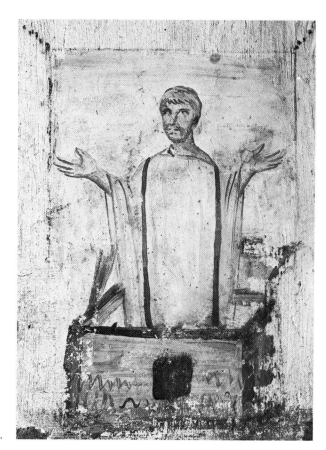

FIG. 96. Via Latina Catacomb, cubiculum O, Noah.

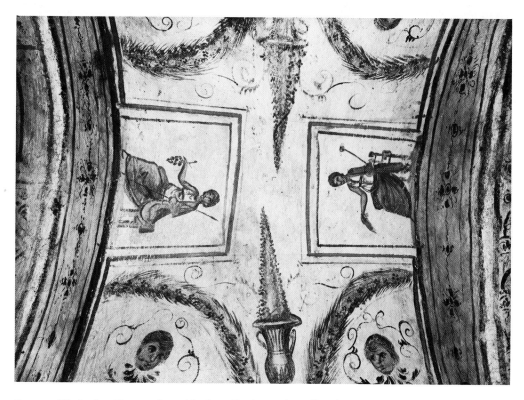

FIG. 97. Via Latina Catacomb, cubiculum O, decoration of vault.

FIG. 98. Sarcophagus of Junius Bassus, front.

FIG. 99. Sarcophagus of Junius Bassus (plaster cast), right side.

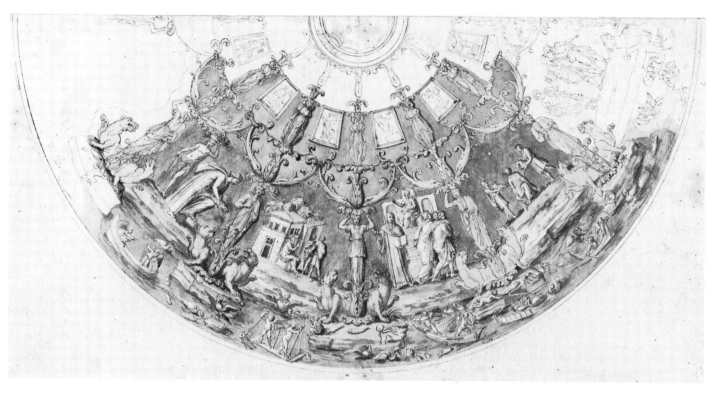

FIG. 100. P. S. BARTOLI, drawing of decoration in dome of Sta. Costanza.

FIG. 101. Sta. Costanza, mosaic decoration of ambulatory vault (detail).

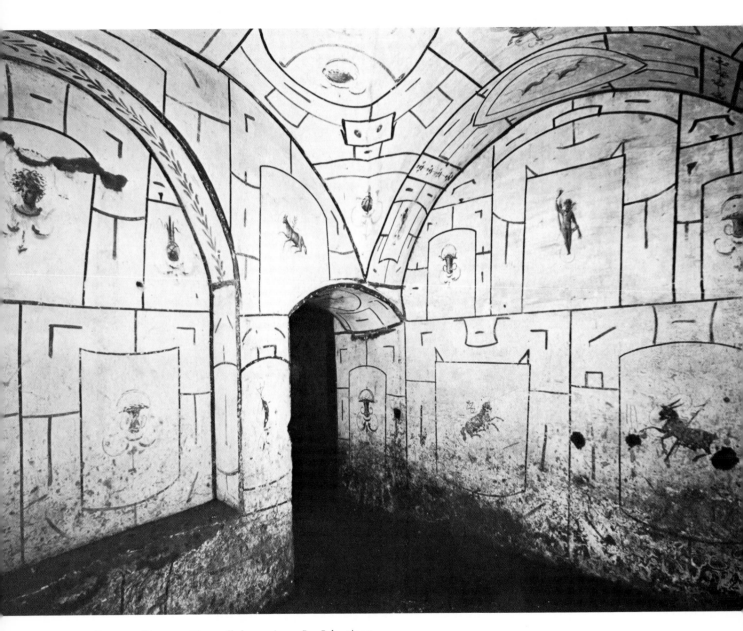

FIG. 102. Roman villa, wall decoration. S. Sebastiano.

FIG. 103. Catacomb of Petrus and Marcellinus, cubiculum N69, decoration of vault.

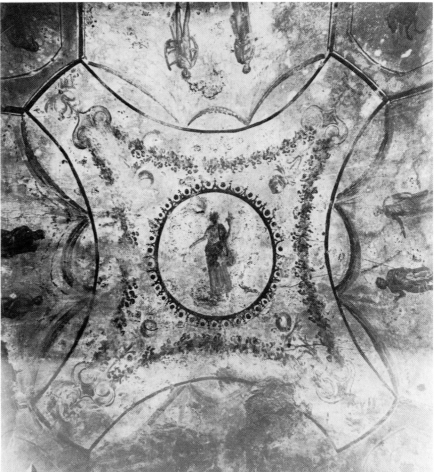

FIG. 104. Tomb of the Statilii and Alii, decoration of vault.

FIG. 105. Roman apartment house, room of the orant,
socle with ornamental motifs. Ss. Giovanni e Paolo.

FIG. 106. Tomb, decoration of rear wall. Silistra.

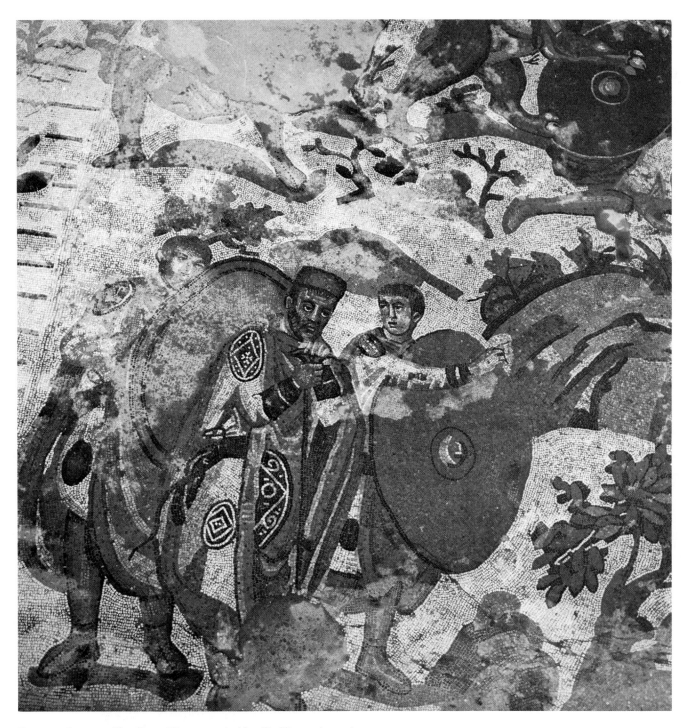

FIG. 107. Roman villa, Great Hunt mosaic (detail). Piazza Armerina.

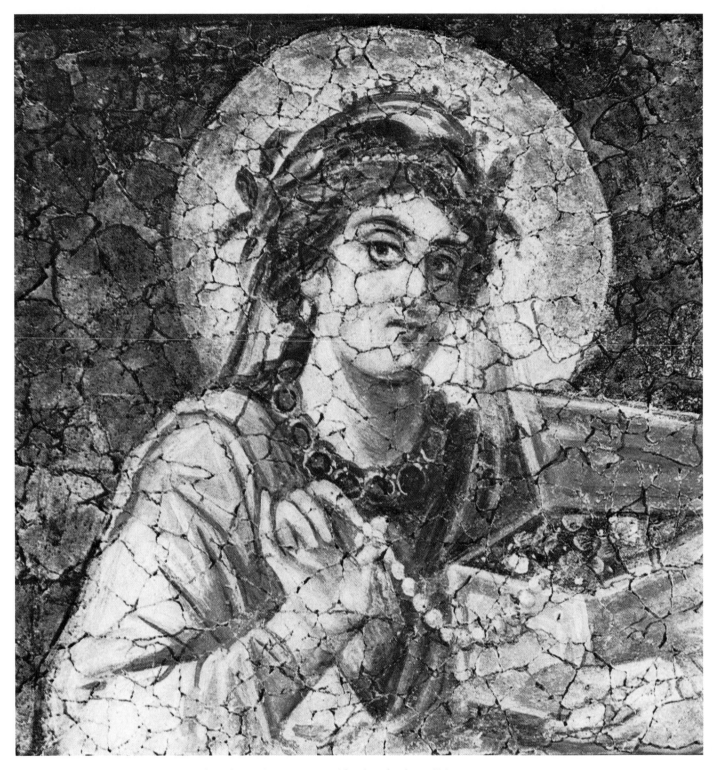

FIG. 108. Constantinian ceiling decoration, woman with a jewelry box. Trier.

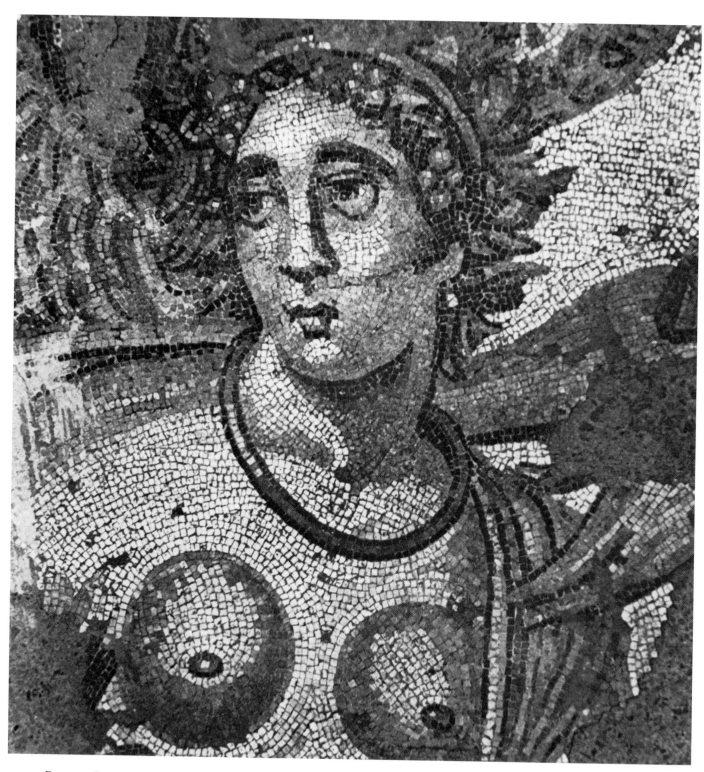

FIG. 109. Roman villa, mosaic in triconch (detail). Piazza Armerina.

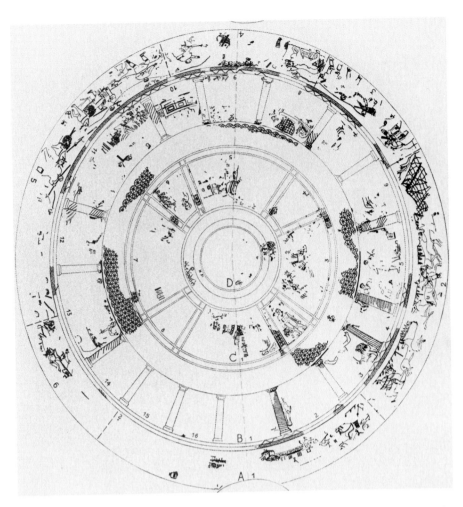

FIG. 110. Villa, drawing of remains of decoration in dome of rotunda. Centcelles.

FIG. 111. Villa, mosaic decoration in dome of rotunda (detail). Centcelles.

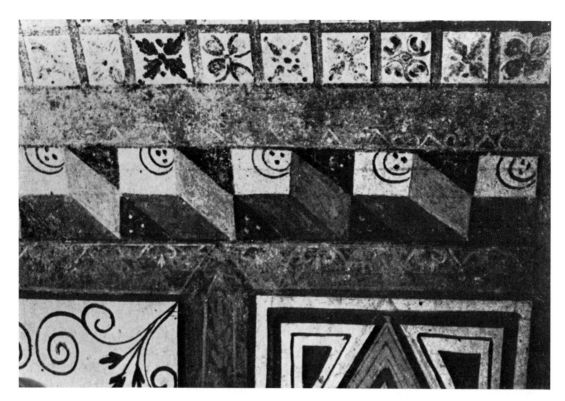

FIG. 112. Tomb, wall decoration (detail). Iznik.

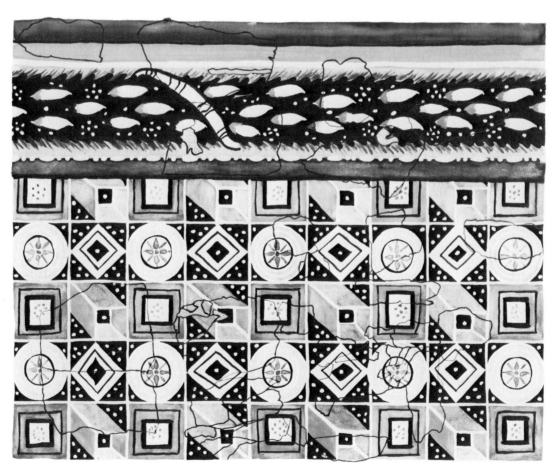

FIG. 113. Building A, water color drawing by CAROLINE HEMANS of restored ceiling over north aisle. Stobi.

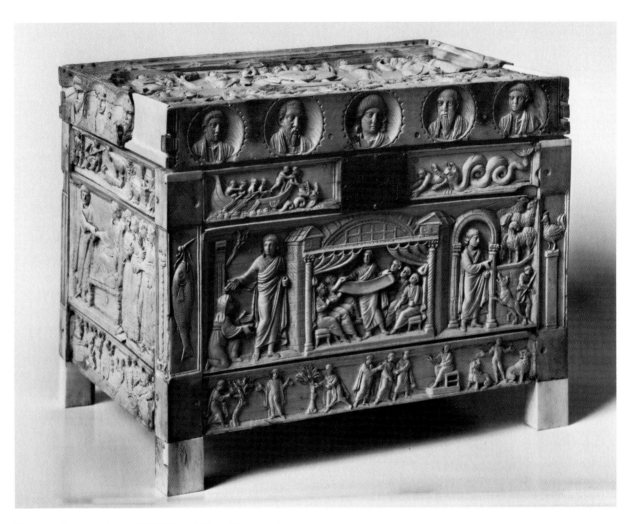

Fig. 114. Ivory casket with Old and New Testament scenes.